DATE			

GREEK SCULPTURE
The Archaic Period

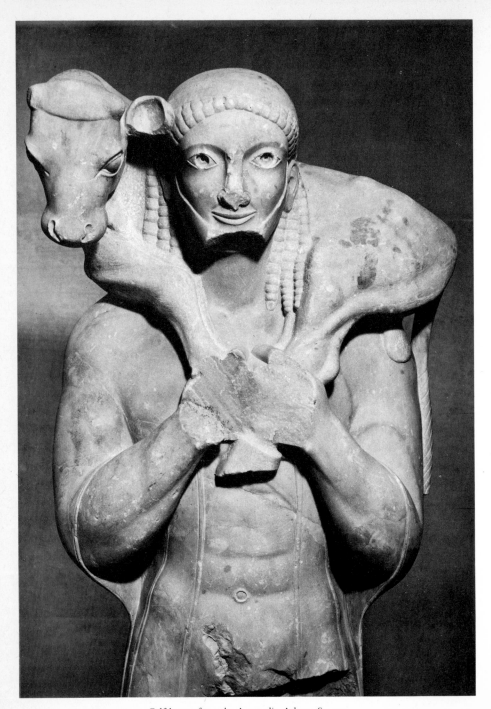

Calf-bearer from the Acropolis, Athens. See *112*

GREEK
SCULPTURE
The Archaic Period
a handbook

JOHN BOARDMAN

NEW YORK AND TORONTO
OXFORD UNIVERSITY PRESS
1978

Library of Congress Cataloging in Publication Data
Boardman, John, 1927–
 Greek sculpture.
 (World of art)
 Bibliography: p.
 Includes index.
 1. Sculpture, Greek. I. Title. II. Series
ND90.B62 733'.3 77–25202
ISBN 0–19–520046–2
ISBN 0–520047–0 pbk.

Printed in Great Britain by Jarrold and Sons Ltd, Norwich

CONTENTS

Chapter One

INTRODUCTION

'A critical history of Greek art would show how late the Greeks commenced to practise the arts. After the Persian war a new world opens at once, and from that time they advanced with great strides. But everything that was produced before the Persian war – a few of those works are still extant – was, if we judge of it without prejudice, altogether barbarous.' When the great historian Niebuhr wrote this, at the beginning of the last century, there were few existing examples of Archaic Greek art from the period before the Persian war, and most were not generally recognized for what they were. It is an art which has been learnt by patient scholarly recognition of the vases and bronzes exported to Italy in antiquity, and for its sculpture mainly from the finds in excavations of the last hundred years. Connoisseurship of style and the evidence of ancient authors combine to map clearly the development of Classical sculpture. For the earlier period, when regional independence in the arts was more marked, it is not surprising that it has proved hard to achieve a scholarly consensus about the development of styles, their origins and dates. This was a period in which the seeds of Classical art were sown, but the growth was not as inexorable or even-paced as the summary art histories might lead us to believe. There could have been no conscious striving towards realism until realism was understood as a possible and desirable goal. And there were many false starts or periods of preoccupation with sterile styles and techniques. The art historian seeks the rationale which will lead to a better understanding of why Greek art took the course it did. The archaeologist puzzles evidence of date, traces the sources and routes of foreign inspiration. The iconographer probes the convention of a narrative style which is to serve western art for centuries. This is hardly the subject for the specialist who cannot see how interdependent these approaches must be.

This little book attempts to present the evidence fairly, but also to propose a pattern by which the development may be the better understood. If it did not, the undertaking would have proved as boring for the author as the reader. Much is uncontroversial, but in places the manner of presentation is novel. The narrative concentrates on the history of style by period and region, as the material dictates, and it attempts to be as comprehensive as space allows rather than so selective as to exclude even mention of the majority of types, places and names relevant to the subject. As in the companion handbooks to Athenian

7

black figure and Archaic red figure vases, the illustrations are small but numerous, both aides-mémoires to the familiar and glimpses of the uncommon. Drawings have been used where photographs would be obscure or where composition is more important than nuances of style, and several fine new drawings have been made by Marion Cox to offer a fuller view of important complexes of narrative relief than most handbooks, even weighty ones, allow. Captions are fuller too, relieving the text of much discussion of subject matter and technical data. The notes serve to demonstrate sources of further information about all illustrated works (designated by italicized numbers in square brackets), and to list more detailed studies. Dates, of course, are all BC. Where sanctuary sites are named in captions the major deity may be assumed as the object of a dedication unless otherwise stated; and the major museum where a town is named. 'The Acropolis' is the Athenian. The material is always marble unless otherwise indicated and measurements are in metres. I hope that any apparently laconic treatment will be excused: it is in the interests of providing as much illustrative material as possible within the format of the series.

It is only the sculpture of the Greek homeland, islands and the eastern seaboard on the Aegean, 'east Greece', that is studied here. The Greek colonies in South Italy and Sicily, and to a lesser extent in Africa and on the shores of the Black Sea, have also something to contribute to the story, but their studios are derivative and have no important reciprocal effect on homeland styles. Consideration of these must be reserved for inclusion in a proposed sequel to this handbook.

Chapter Two

THE DARK AGES AND GEOMETRIC PERIOD

The Greek Bronze Age civilization finally collapsed in the twelfth century and left no heritage in stone sculpture for later centuries, no tradition to foster or revive through the Dark Ages that followed. A few works of Mycenaean Greece, such as the relief on the Lion Gate at Mycenae, stood to be admired, but were not copied. In a period when the technically more demanding arts were forgotten, together with the palace patronage which had encouraged them, the only craft traditions to survive were those dependent on the simplest techniques. At this level we can detect cultural and artistic continuity, and although this held little promise for the future it is worth observing.

In the later Bronze Age it had been a common practice, in Greece and Crete, to fashion figurines of clay, sometimes of considerable size, on the potters' wheel. A cylinder served as the body for a standing figure or an animal, and to it were added, free-hand, head and limbs, all being painted and fired as any painted vase, with the same pigments, the same patterns. Indeed, some of these figures were vases. The tradition in standing figures can be followed readily enough in Crete [1, 2], and the wheel-made animals are to be found in many parts of the Greek world, and in Cyprus, serving as votive offerings or as grave furniture. Illustrated are two of the more elaborate examples which can be placed not only from the circumstances of their finding but also from their decoration, which was applied by the vase painter and matches that on decorated vases. One is from tenth-century Athens, a stag [3], the other, a little later, from Euboea [4]. The latter is what a later Greek would call a centaur, and there are other man-animal monsters, sphinxes or bull-men. The style is pretentious, but most minor sculpture of the Greek Dark Ages is trivial and it required a new impetus, of wealth or foreign example, to engender a demand for a greater range of types, greater sophistication. The results are not startling but they prove decisive for the later history of Greek sculpture.

With the advent of the full Geometric period, and especially in the eighth century, the true renaissance of the arts in Greece begins. The population was growing rapidly and towns were already looking overseas for new resources, new land for their citizens, in the 'colonial' areas of Italy and Sicily; through trade and travel the near east was quickening the appetites and skills of Greek craftsmen. In Greece itself several major sanctuaries were established, some of local (as Athens, Samos), some of national importance (as Olympia, Delphi,

Dodona), which provided a market for votives, a focus for the artists' expertise.

The contribution of the east was a special one, as we shall see. Otherwise, sculptural works are small, though plentiful, executed in clay or bronze. The clay is hand-fashioned and fired solid, with far less use now of the potters' wheel. The bronze too is cast solid, in a clay mantle around the modelled wax original which is melted out in the firing. Each work, then, is unique and there can be no re-use of moulds. Many of the figurines or heads, both in clay and bronze, were destined for attachment to vessels, supporting the ring handles of cauldrons [5] which were popular and expensive offerings, or decorating the rims of open vases. The rather soft, plastic forms encouraged by the technique are soon controlled to present alert 'Geometric' features on which more and more detail is admitted, in either the casting or the later chasing of the bronze figures, and through the painting of the clay ones [6].

Other stylistic features are the elongation of necks and limbs and the geometricizing of parts of the body in a manner easily paralleled by the contemporary figures painted on vases. The painter offers strong broad shoulders to make a triangular torso, long strong thighs and tight buttocks, treating each part in its most characteristic 'frontal' view. The coroplast or bronze worker, with an extra dimension, observes the same formula and conceives his figures in parts – the torso may be broad from the front but wafer-thin from the side, the legs well muscled from the side, spindly from the front.

We know the figures principally from the offerings found at the sanctuaries I have named. The free-standing figures may represent deities – the warrior Zeus at Olympia; or animals – memorials or substitutes for sacrifice (often bulls) and thank-offerings for success (the horse was an important status symbol); or the worshipper himself, as warrior [7] or charioteer. The quadrupeds, horses and the occasional stag [8, 9], as well as birds, beetles, hares, are often set on rectangular (or, rarely, round) open-work plaques, which may be decorated in intaglio beneath. It looks very much as though these small offerings were to be suspended in the sanctuary. Like the men, the animals resemble those drawn on vases, with the flat sweep of the horse's strong neck emphasized and the muzzle sometimes stylized into a trumpet form. There are enough of these bronze horses for regional styles to be detected, in the Peloponnese and central Greece.

By the end of the period an inscription may name the donor, recipient and circumstances of the gift [10], if a free-standing figure is involved. By this time too we find more ambitious compositions, either in the pose of a single figure, a bowman or helmet-maker [11], or in groups [12, 13], where the subject is heroic, and we are reminded by them that Greek interest in narrative was beginning to be expressed by Geometric artists other than Homer. The components of these figures and groups obey the same formulae as the simpler figurines, but the freedom in their use is quite new. We might well think that this is an indication of a new and expressive departure in Geometric art which will be the key to dramatic new developments in the seventh century. And we would be wrong.

Chapter Three

THE ORIENTALIZING STYLES

Eastern styles in Crete and Greece

The earliest surviving stone sculpture in Iron Age Greece is from Crete: a fragmentary head [*14*], and a small relief from a frieze showing a goddess in a shrine helped by bowmen against a chariot [*15*]. They cannot be dated from their context of discovery but stylistically they belong to a series of objects – gold jewellery, bronze armour and statuary – which re-introduce to the Greek world long-forgotten techniques, apparently from the general area of Syria and the neo-Hittite kingdoms. Finds in tombs indicate that the style was centred on Knossos and flourished from the end of the ninth century, but hardly later than the end of the eighth. Probably the latest examples are the three bronze cult figures found in a small temple of Apollo at Dreros [*16*], which was built in the second half of the eighth century. These were made of sheets of hammered bronze fastened on to a wooden core, with traced decoration on the dress. Very like the 'Apollo' is a small cast bronze found recently at Afrati in an eighth-century context [*17*], which proves that the early date for the Dreros figures, suspected on other grounds though they are still often put in the mid-seventh century, is correct. In Knossos at least the explanation for this unusual series of objects seems likely to be an immigrant group or family who plied their craft for a century or more, and practised techniques novel for Geometric Greece but still not learned from them by their Greek neighbours, since their more sophisticated techniques disappear with them (fancy goldsmithing and the working of hard stone). The stone and bronze statuary mentioned, if not theirs, was clearly inspired by their work, and at a lower level we may notice that some of the new, curvilinear, non-Geometric patterns they used were copied by Knossian vase painters in a style we know as Protogeometric B (late ninth century). This represents the first major penetration of Greek lands by oriental art and artists, and it is interesting to note that, despite the quality and variety of the works produced, it had no following, although it may well have established a preference for a plastic style which was to be more enthusiastically adopted from the east in Crete and elsewhere in the seventh century – the 'Daedalic'.

Characteristics of the eighth-century figures are the long oval heads, domed skulls with long hook-locks for the men, pill-box hats for the women (a type of headgear reserved in Greece for priestesses or representations of deities and

called a *polos*), rather formless bodies, and for the women the cloak worn symmetrically over the shoulders, open at the front (it was fastened by two pins and a chain worn across the chest, as we see in later views of it).

Another immigrant studio in Crete, which may not have arrived so early as that already discussed, is best known from the bronze shields hammered and traced with concentric friezes of figured scenes and with animal-head bosses in the round, found in the Idaean Cave, at other Cretan sites and at a few Greek mainland ones. The style of the figures is more distinctly oriental, but it seems likely that the workshop was still open to near the middle of the seventh century and its later work betrays more Greek taste in composition, style and subject matter. The only sculptural interest it offers, apart from the shield bosses, is the strange bronze head vase from the Cave [18], very oriental in appearance although the concept seems Greek. This must be one of the latest products of the studio.

In Athens and Attica other immigrant goldsmiths worked jewellery related to the Cretan, but there were no sculptural side-effects, unless they are to be detected in the use of a new material, now introduced again to Greece, ivory. Minor worked ivories from the east had arrived earlier, but in an Athenian grave of about 730 is a group of ivory girls, in pose and nakedness copying the eastern Astarte figures, yet without their opulent physique [19]. Instead they are pared down to a truly Geometric sleekness, and their polos-hats carry a Greek maeander. Here, then, is a Greek artist who has learned a new technique with a new material, and practises it with distinction.

The only other orientalizing works worth noting in this context are bronze attachments to cauldrons – a function of many of the purely Geometric bronzes. Vessels imported from the east from the later eighth century on carried either cast attachments in the form of what the Greeks would later have called sirens, or lion (and perhaps griffin) heads in hollow hammered bronze. Examples are known with both cast and hammered attachments (in Olympia [20] and Cyprus), and the source may be Syria or beyond. What is of interest here is the stylistic change in the Greek copies of these works. The siren heads exchange their plump cheeks for Geometric angularity [21], the griffins, soon cast rather than beaten, acquire sinuous and graceful beaks, to become impressive decorative attachments [22]. The sirens appear mainly in central and south Greece, the griffins also in east Greece (especially Samos). The translation of these human and animal forms is an important commentary on Greek attitudes to minor sculpture as decoration, but we are still far from 'real' sculpture, or anything even nearly monumental.

The Daedalic style

A description of the Auxerre goddess [28] is our best introduction to the Daedalic style – we shall attempt to meet Daedalus himself later, at the end of the next chapter. The figure is a limestone statuette of a woman dressed in what we have already recognized as a Cretan manner, with cloak covering both shoulders and a broad, probably metallic, belt. The breasts are unusually well shaped over the high waist and the formless skirt covered with incised patterns defining areas of colour [128]. The hand carried across the breast is probably in a gesture of adoration, but may also derive from the eastern breast-holding fertility goddess. The other long-fingered hand is pressed to her side, the feet are big, lumpy. The face is triangular, rounding in the chin, rather flat-topped, the forehead defined by a straight row of curls. The hair is dressed in vertical locks with knob terminals, but also with horizontally ranged crimps. There was a lot of colour, including a scale or feather pattern on the breast.

The dress, shape of head and hair typify the Daedalic style no less than the strict frontality, and a frontal head alone is enough to identify it, either on its own or applied, for instance, to a sphinx or a male figure. The hair is more commonly dressed only with horizontal waves. It is often described as a wig (the *Etagenperücke*) and, although it certainly owes something to eastern and ultimately Egyptian representations of wigs or head-dresses, in Greece the convention is used to indicate long, carefully combed hair. The Daedalic style is expressed in stone, clay, ivory and jewellery, and may be taken to have flourished from the second quarter of the seventh century to its end.

The clues to its origins lie in its favourite figure – the frontal woman, in the medium in which it is most often expressed – clay relief, and, perhaps in the area where it is best represented – Crete. The frontal goddess, naked and with hands pressed to breasts and loins, is familiar in Syria in dozens of mould-made clay plaques representing Astarte. In Corinth such a plaque [23] was imported in the seventh century and at the same site we find a locally made mould for a figure of purely eastern type [24]; cf. [51]. The introduction of the mould to Greece, particularly in association with figures related to the Daedalic, is important. It enabled the mass-production of such figures, which in turn led to a certain stereotyping of the form and must have contributed to its long life. The naked goddess, whom we have met already in ivory in Athens [19], is also copied in Cretan Daedalic plaques [26]; cf. [27], but soon clothed. The female nude is not yet a proper subject for Greek art.

Crete's probable role in the development of the style is further suggested by its superficial similarity to the eighth-century orientalizing works in the island [16, the women], which are often erroneously classed as Daedalic, and by some Cretan clay heads of aggressively triangular outline, which are not mould-made but indicate a preference for this type; compare [25, 44]. Finally, it is a characteristic of Cretan seventh-century figures that while there are several of

women or goddesses wholly naked, all the men are clothed, rarely exposing their genitals (in the least 'orientalizing' works). This is virtually the reverse of the practice in the rest of Greece. It is probably another indication of the strong influence in Crete of the east, where the naked goddess was commonplace but male nudity abhorrent; and it also echoes the Minoan practice of semi-nudity for women, covered loins for men.

It may be, then, that the Daedalic style and its propagation owe much to the mould technique for clay reliefs (there are abortive attempts with two-piece moulds), but it is soon translated into stone. The Auxerre statuette [28] may well be Cretan and there are several other figures from the island, standing, seated and in high relief. Illustrated are two fragmentary seated figures (the earliest in stone from Greece) from Astritsi [29] and Gortyn [30], a prolific site. Between them they demonstrate the horizontally waved hair and elaborate painted decoration on the skirt. Each whole figure has been made in two pieces. From Gortyn too comes the relief slab [31] with another triad like the Dreros bronzes, but the girls are naked, in eastern fashion, and their hair more eastern, as [28], springing from high behind the temples. This is from an architectural setting, and so is a later assemblage from Prinias including seated figures, reliefs and relief dado slabs [32]. Finally, there is part of another possibly seated figure from Eleutherna [33]. Of these [29, 30, 33] are lifesize – all are limestone.

Crete is not the only source for the style, nor even Dorian Greece (the Peloponnese, Melos, Thera, Rhodes) although this has often been alleged, and the style is certainly best represented in this area. There is little in stone, however, outside the island. Best known are the reliefs from Mycenae, in the canonic style [35]: odder, in style and function, a relief from Boeotia [36], but from the Ptoon comes a Daedalic woman whose base carries part of what may be our first sculptor's signature (. . .]otos). In clay the style is better represented, especially in the Peloponnese, but the mould is not used only for plaques. In Crete, at Gortyn, we have fine examples of miniature clay sculpture in the round, as with the Athena [34] whose bell skirt follows the older Cretan tradition of wheel-made figurines, which continues, for figures mainly like this, in various parts of Greece through the seventh century. Daedalic and mould-made too are the heads of figures, often sphinxes, on clay relief vases (*pithoi*) mainly from Crete, and the style is represented also in jewellery, in Crete, Rhodes and Melos. In other materials and at greater scale we see it in a hollow cast head from Olympia [37], where a fine incised pattern for the hair answers the bolder rendering in stone. By now too Greek studios for ivories can work in this fully hellenized orientalizing style and the sphinx from Perachora is purely Daedalic [38], while the strange high-relief group of strippers in New York [39] may be an attempt at a myth scene.

It is time to consider dates. Two stumpy figures with Daedalic heads are the earliest examples in stone [40] which are datable, before the middle of the seventh century, from their context with pottery in a grave on Thera. In clay

the mould-made heads applied to (Proto-) Corinthian oil flasks are valuable because the vases are painted in a distinctive manner which is quite closely datable. The example [41] shown is of about 650. Some frontal heads painted on Corinthian vases are of less value for close comparison and profile views, notably on Cretan vases (less closely datable), are usually better developed than the profile views of the primarily frontal Daedalic heads. Other moulded heads on Corinthian vases indicate the style of the end of the century. There must have been many regional variations though a good sequence can be observed and has, by some scholars, been rather too elaborately defined. But the trend can be detected both in the datable pieces named and wherever there is a good series of types from a single site, like Gortyn. The tendency is from the angular to the more rounded in features, with a growing sensitivity to the volume and depth of the head (undervalued in the early plaques), and a reduction in the emphasis of certain features – size of eyes, lips, hands. The sequence in the Cretan series may be observed here as follows: [29–28–31–32–33].

The Daedalic was basically a decorative style, which is why it was so often enlisted for small works in ivory or metal, and rarely achieves lifesize in stone, in the second half of the seventh century. We have touched upon the reasons for the stereotyping of the style. In fact it still follows the Geometric formula for figures in the round or in relief, but new and sometimes foreign elements of pattern and detail are added to the conventional rendering of parts, bare or clothed. There is no challenge to nature here, little progress in rendering of anatomy, and the frontal aspect, which often left ears (only shown on later works and perhaps an egyptianizing feature) attached to hair rather than head as [32, 33], hardly encouraged experiment in this direction. It promised only stagnation, and there is no other major genre in Greek art which progressed so slowly in the Archaic period. The east had revitalized most Greek crafts with new techniques, new forms and figures, but it was going to require something more than the east could offer if the plastic arts in Greece were to move forward, or even recapture the vision, flair and freedom of some of the latest Geometric.

Other early Archaic statuary

The Daedalic style, however defined, hardly accounts for all Greek seventh-century statuary, large or small, not executed in marble. Even in limestone there are figures which, in their bulk, display a fine disregard for the rather two-dimensional frontality of the Daedalic – such as the chubby male from Tanagra [42] – although the heads of such figures will probably have roughly resembled the Daedalic in angularity of features and style of hair.

Smaller works display greater variety and differing traditions or sources. They demonstrate the growing command of techniques in bronze and ivory, and often a greater freedom in composition. Despite the differences in scale and material this all contributes to the Greek sculptor's emancipation from the

Daedalic and realization of the monumental, which we study in the next chapter.

Solid cast bronzes remain more informative than terracottas. More of them now are independent figures, with their own bases, not for attachment to a vessel or furniture. Two main sources well illustrate their range. Even in Crete we can find pieces that renounce the Daedalic, but probably because they owe more to rather different eastern traditions. It is hard to say whether the little lyre-player is an easterner or a Cretan [43]. His head resembles the pre-Daedalic, but the free pose reminds us of the latest Geometric bronzes. The little sphinx's snaky locks [44] are almost Minoan, but the one wing carried forward renders in the round an eastern convention more familiar on painted vases in Greece and Crete. And the ram-bearer [45] has the heavy Cretan features and Cretan loin-cloth, but is modelled with a feeling for depth which is foreign to the Daedalic. These two must be from quite late in the seventh century despite the features of [45] which should probably be explained as non-Daedalic rather than pre-Daedalic. They have been called Eteocretan, invoking an indigenous non-Hellenic style which might owe something to the island's Minoan past. The old blood and language may have survived, but it is less easy to discern the necessary continuity in the arts, and probably wrong to try.

In the Peloponnese Olympia remains an important source for bronze votives. The warrior [46] is the seventh-century descendant of the Geometric Zeuses, but with more detailing of features, more volume to limbs and torso and incipient observation of the pattern of flesh and muscle on the body. This is all carried a stage further in the Olympia charioteer [47]. The Boeotian [48] betrays its lateness in details but looks primitive.

Wood must have been a common material for early sculpture but it survives only in conditions of extreme damp or dryness. The waterlogged sanctuary of Hera on Samos has yielded a glimpse of riches lost to us elsewhere. In the smaller works we might expect the style and even subjects to reflect the influence of eastern ivory carving, a cognate art. While the goddess [49] is thoroughly Daedalic the group [50] looks more eastern for the rotundity of features, yet it is to Crete again that we turn for details of the dress – the tunic and shawl. In ivory there are distinguished successors to the Athens girls [19], and in some respects even less hellenized. The head from Perachora [51] is almost certainly an import but what of the god with a lion from Delphi [52]? The highly stylized beast is Assyrian, the fluid treatment of the body non-Greek, yet in the features the flabby oriental is being pared to near-Daedalic alertness, and although the scheme for the group is eastern there are no such ivory statuettes in Syria and beyond, and the theme of god and lion might suit Apollo, while the pattern on the base looks Greek or at least Anatolian. There must have been several ivory workshops in seventh-century Greece, perhaps staffed or instructed by easterners who could transpose something of their style and knowledge of eastern themes. East Greece, in touch with the kingdoms of Phrygia and Lydia,

must have been well used to this exchange. Ephesus is an important source of such work, continuing into the sixth century. Closely related to the Ephesian is the ivory fitting from a lyre [53], plumply oriental in concept of body, dress and the supporting monster: in the same tradition, then, as other strongly orientalizing ivories of the seventh century from Greece. Yet the only similar lyre-fitting known, also from East Greece and of about the same date, takes us into a different world. The youth from Samos [54] owes little enough to eastern forms, yet, for all the angularity of his head, is quite free from the restrictions of the Daedalic. He displays a crisp simplicity which the loving detail devoted to hair, hands, belt and features, does nothing to obscure. It is not, I hope, only the optimism of a Hellenist which can see in this tiny and decorative work the qualities of form and even monumentality that we can readily admire in the later, larger works of Greek sculpture. We shall see time and again that unity of form in Greek art, despite the rapid development of the Archaic period and later, transcends scale, material and techniques, leaving always something jewel-like in the colossal, something monumental in the minute.

Chapter Four

MARBLE AND THE MONUMENTAL
to about 570 BC

The first marble sculpture

The impetus for technical and stylistic changes in Greek sculpture in the eighth and first half of the seventh century came, as we have seen, from the near east, from lands whose wealth and expertise the Greeks had begun to seek again in the ninth century. For relations with Egypt in these years the evidence is slight, yet this is to be the source of the next major innovation.

The pharaoh Psammetichos I (664–610) invited east Greek and Carian mercenaries to serve him against his enemies, and this resulted in concessions to Greeks to settle and then to trade in Egypt. By 638 we hear of a Samian captain, Kolaios, already acquainted with the route south. In Egypt the Greeks saw lifesize statuary, and larger, in hard stone, for standing and seated figures, superficially not unlike their own less ambitious statues and statuettes, with some features already familiar to them from the egyptianizing arts of the near east. It would not have required many visits by many craftsmen, being Greeks and imbued with characteristic Greek curiosity and aptitude to learn, for these novel (to them) concepts in statuary and the means of their execution to be introduced to Greece itself. Basic features are size and material. The size appealed to that sense for the monumental which the Iron Age Greeks had so far expressed only in their architecture and pottery. Given that no Greek statuary answering these new concepts can be securely dated before this attested interest in Egypt, given the existence of the models for them in Egypt as well as other details of technique and appearance yet to be mentioned, and the absence of such models in the east where even major statuary is basically decorative or architectural rather than free-standing monumental, it is impossible not to associate this new era in Greek sculpture with influence from Egypt.

Hitherto stone sculpture in Greece had been made of the readily accessible limestone (*poros*) or sandstone which required nothing more complicated than a carpenter's tools and might even betray the woodworker's technique. The harder material, marble, crystalline rather than granular in composition and requiring some new tools and quite different techniques, was no less easy to obtain, with white, grey and bluish varieties accessible to surface quarrying in the islands and many other mainland areas. The islands are the earliest important source, notably the Cyclades. Naxian marble we know from Naxian works and

quarries in the island – it is coarse grained, sparkling. Parian marble is more sugary in texture and potentially translucent. In both islands we have Archaic work from the quarries [55], blocked out and left unfinished after accidents in working or transport. The Parian, unlike the Naxian, is often referred to with approval by later authors or named in inscriptions. Pentelic marble from near Athens has a tighter, opaque structure and a distinctive rust-coloured age patina, but is used much before the mid-sixth century, and then sparingly until the fifth, and there are other varieties to be noticed, such as the bluish neighbouring Hymettan. It is important, however, not to be misled by descriptions of crystal-size and translucency. In early days it was probably the marble's characteristics in working rather than its appearance which determined use, since the finished surface was never highly polished and was in fact often painted – even on the flesh parts where we might have expected the quality of the marble to have been best exploited. So our observations about crystal-size relate to working rather than appearance, and these were the criteria by which the sculptor judged and ordered his stone. The fact that analysis of modern sampling from the sources named shows wide varieties of crystal type in the same area is irrelevant. The sculptor knew what to expect of his 'Parian', 'Naxian' or 'Pentelic' and uncharacteristic stone would not have been acceptable, whatever the label. At any rate, the artist would normally have chosen his stone in the quarry at this period and worked much of it there. We have to judge his choice of material by the standards of antiquity, not of the present day, and the fact that he *could* have got similar material elsewhere does not matter if we have good reason to believe that he *did* not.

In Egypt the hard stones were worked mainly by the laborious process of pounding and abrasion: their copper tools were useless and iron almost unknown. But the Greeks were already using iron for knives and chisels, and this enabled them to make more rapid progress in their carving and in the improvement of techniques and tools to suit the harder material. The iron point, held vertically or at an obtuse angle to the surface, removed quite large flakes of stone. For the early marble statues this is followed by work with a flat chisel, which was especially important in rendering detail, the finish being achieved by abrasive, probably emery (obtainable on Naxos) in the form of powder or rubbers. Drills worked with a bow, and wedges (of dry wood, then swollen with water) were used to split the blocks from the quarry beds, but the drill was also used to render details and help remove chunks or channels of stone by breaking through a line of close-set drilled holes. This must certainly have been the practice from the beginning since only thus could arms be freed from flanks safely, as on [63]. This use of flat chisel and drill has only recently been demonstrated on early Greek marble statues (by Mrs Adam), earlier scholars denying their use so soon.

The Egyptian role in all this has been challenged by some recent writers. Certainly it can be exaggerated, but we may review briefly other apparent

links, apart from the purely technical and the example of sheer size. The pose for male figures – the *kouroi*, youths, to give them their familiar title – had been familiar in Greece already. In fact most such stone figures in Egypt stood with the withdrawn leg vertical, not properly balanced. Moreover, they were normally dressed in at least a loin-cloth, while the Greek are naked, but for a number of island figures wearing only a belt. However, the male (and female) figures now stand with clenched fists, like the Egyptian, and not stiff-fingered, and the men may have in the fist an unworked mass which recalls the short baton held by many Egyptian figures. This could easily have been omitted to leave an agreeable, tighter geometric pattern of the fingers. Seated figures, not necessarily themselves inspired by Egyptian art, although this is not impossible, may also now sit with palms outstretched on their thighs, in the Egyptian manner.

In our period Egyptian sculptors laid out preliminary sketches for their figures on the smoothed face of the unworked block according to a grid which determined the placing and size of parts of the body, with twenty-one squares or units from eye line to the soles of the feet. For any figure of lifesize or more some such sketch is an absolute necessity and a grid predetermining proportions was an obvious aid. One Greek kouros may have been laid out in a similar grid (drawing, and [63]), and Diodorus (i, 98) has a story of two mid-sixth-century Samian sculptors, Telekles and Theodoros, making halves of a statue separately by this system (twenty-one units plus one-quarter cubit from eyes to crown: this part being a variable in Egyptian figures, often occupied by a crown or head-dress), and fitting them perfectly. Clearly, the Egyptian practice was known, and could be used, but most other complete Archaic Greek figures appear to obey no such strict scheme, although absolute height was important and proportional changes, tending to the realistic, can be observed (see next chapter). This is hardly surprising, given the Greek genius for learning, adapting and improving foreign techniques. That subtler principles of proportion could and did concern them is clear from the existence of books on the subject written by Classical sculptors such as Polykleitos.

So far as we know, the early monumental statues which have survived were all commemorative – votive or funerary. We do not know whether any were cult statues, yet the need for such works, and the claims of the monumental temples whose members were soon to be executed in stone and rendered into 'orders', again under the probable inspiration of Egyptian practice, could have played an important part in encouraging the new sizes, styles and techniques. Of earlier cult images we know nothing. Descriptions in later authors suggest that they were crude, often wooden and aniconic, deriving their sanctity from legend ('fallen from heaven') or the finery with which they could be decked out: those, for instance, to be clothed in a robe or having one laid on their knees on ceremonial occasions, like Athena at Troy (*Iliad* vi, 302 f.). And it seems that many temples were furnished with these primitive idols well into the Roman

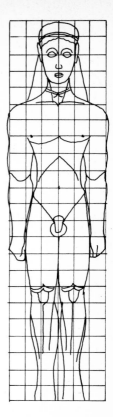

period, so the demand, except for installation in brand-new structures, may have been less than we imagine. If any major new works in wood were executed in the earlier Archaic period we have no reason to believe that they could have been different in appearance from the Daedalic – a style not originally dependent on wood – nor is there any clear evidence for significant influence on seventh-century statuary from any carpentry styles, other than the purely technical. Any early wooden statues might, however, have been large. The probable base for the wooden cult statue of the early Heraion on Samos was a stone cylinder with a sinking 0·57 square. The bases for early marble statues are generally shallow blocks with a sinking for the plinth, the marble slab cut with the feet and rounded off close to them, fastened in position with lead. Sphinxes and human figures could also be mounted on columns, Ionic or Doric according to local architectural practice. An exceptional kouros base is boulder-like, with heads at each corner, signed by Euthykartidas of Naxos [56]. It is no later than 600, one of our earliest sculptor's signatures, and important in telling us that the sculptor was also the dedicator, and so a man of substance.

21

Kouroi

The battered torsos and heads of the early stone kouroi leave us unable to distinguish easily, let alone date closely, the first of this important new series which is to be the yardstick of sculptural progress through the sixth century, and the first realization of true monumental sculpture in Greek lands. It is clear, however, that the type is established from the beginning – an upright stance, with straight or lightly flexed arms at the sides, fists clenched. One leg is slightly advanced, usually the left. We step off naturally with the left foot so this enhances the impression of energy and movement as well as providing a more secure support for the heavy mass of the solid marble body balanced on two slim ankles. Moreover, the Greeks preferred profile figures to the right with the farther leg advanced, and the preliminary sketch on a block for a kouros would dictate this pose. The hands, after the earliest, are empty. The belt worn by the early island figures is the only dress beyond a hair fillet or necklet, and exceptionally the boots for [70], and the belt is the same type as that worn by the Daedalic women. Bronze warriors wore helmet and belt alone, well into the seventh century [46]. The kouroi are not warriors, but this is a closer parallel than remote and irrelevant eastern belt-wrestling practices, which have been mentioned in this context, and we shall shortly remark a possible Cretan connection.

What are the kouroi? They used to be called Apollos but none are cult statues, or even certainly representations of a deity, although the type can be converted to this use by raising the forearms to hold attributes [150]. In sanctuaries of male deities they are dedications offering more permanent and silent service to a god than could mortal flesh. Most of this class are from Apollo sanctuaries, the only notable exceptions being from Sounion (Poseidon), while the very few from sanctuaries of goddesses – Athena (Athens) and Hera (Samos) – do not seriously upset this pattern, and some fragmentary candidates might be from figures of other types or groups. In their other function, as grave markers, the kouroi replace cruder slabs, which may tend to the anthropomorphic (see Chapter Eight). Without pretending to portray the dead they summon up remembrance of the youth and vigour admired by their kin and friends, who are often named as donors of the monument, and now lost to them. So both usages are in a way substitute and commemorative. Only grave kouroi, and a few of them, may acknowledge variations in age, with some barely adolescent, but none more than young-mature, and none admitting by dress their calling – warriors, for instance, although the epitaph may have them 'fallen in battle'. An Archaic cemetery peopled with these intent pale figures must have been an unnerving place.

For the appearance of a complete early kouros from the islands we may turn to the famous bronze statuette from Delphi [57]. In proportion and details of limbs and belt he exactly matches his more battered marble comrades [58, 59],

and we may deduce that the earliest of them had Daedalic heads, like the bronze. The head looks very Cretan, and most scholars have taken the bronze to be Cretan. There are no Cretan stone kouroi but the belt is an old Cretan one so the bronze is perhaps a hint that Cretan statuary skills were enrolled in the early island studios, and the belt might then be a concession to that Cretan shyness we have already noted. The Crete-Delphi association was a strong one – in religion (the worship of Apollo Delphinios) and in dedication of statues (Pindar, *Pythian* 5, 39–42, of wood). Crete's devotion to the dressed female type in statuary and her lack of marble may explain the absence of early kouroi in the island. Cretan artists had the tradition in statuary, the tools, and the connections with Egypt requisite for the inception of monumental marble sculpture. All they lacked was the material and it may well have been Cretans that manned the early island quarry-studios, since the islanders themselves lacked these prerequisites.

There are several different sources for our early marble kouroi, all, except the Samian and Boeotian, using Cycladic marble. There are regional differences, which probably did not emerge strongly until after 600, when local studios achieve some independence of style though still mainly dependent on island sources of stone.

In the islands the belted fragments from Delos give a fair idea of the new type, slim, small-buttocked, barely modelled, the hair in beaded tresses [58, 59]. The Naxian colossus [60] which stood near four times lifesize, is one of the latest, with the hair spreading in realistic curled locks on to the chest, and the head, to judge from drawings, already a full oval. Thera has also yielded an important early series, from a cemetery rather than a sanctuary [61]. One of these wears a belt, the only marble example outside Delos but proving that the belt is not a peculiarly Apolline feature. In Ionia Samos takes the lead with a number of thrice-lifesize kouroi in local marble, from the Heraion, preserved only in fragments.

Athens enters the story around 600 with the Dipylon head [62] and its companion, the complete but far inferior New York kouros [63] which is probably from a countryside cemetery in Attica. Here we can study in detail some characteristics of the early kouroi, though few others of this date may have been so carefully finished or are so pattern-conscious, and this is the figure whose proportions seem to have been determined by a canon of Egyptian type. Previously, anatomy patterns had been barely observed on figures, whether drawn or in the round, though ribcage, pectorals and shoulder blades were commonly worked on lifesize bronze corselets and hinted at in some figurines [46]. On the New York kouros details are designed almost as independent patterns – volute ears, beaded hair with even the knot of the fillet stylized; the lightly grooved and relief patterns of the front of the body, neck and sinewy legs; the shoulder blades, the hands, wrists, elbows, knee-caps. Individually they are unrealistic but totally effective translations into pure pattern, not of carefully observed anatomy, but of those details and groupings of pattern, each laid out in

a rigid frontal view, which the artist conceives to make up the whole man. But their organic interrelation has yet to be understood, and the sum of parts achieves monumentality less by any perceived unity than by the almost spectral hint of life, imparted by the pose and size. In execution the figure has not shrugged free from the rectangular block of stone from which it was hewn. This is clearest in the face, with the broad flat cheek. But the sharply intersecting planes of the face, especially around the eyes, and the linear patterns achieved by neat grooves, sharp or shallow, indicate the many new possibilities in rendering the body. After years of inhibiting convention or trivial though delicate decoration, a first step is taken towards a fully satisfactory expression in stone of the Greek view of man, of his relationship to his fellows and his gods, the acknowledgement of a rightness, restraint and proportion, which are as applicable to conduct as to statuary, the *kalon kai agathon*.

The kouroi from the Poseidon temple at Sounion [*64, 65*] in south Attica are slightly more developed than the New York kouros. The forelocks on the hairband are like shells, the hollow-beaded tresses like wind-rippled sand. Grooved anatomy patterns on back and stomach are more aggressively decorative, chin and forehead more emphatic.

The crude pair on the stele from Boeotia [*66*] show what can happen away from the major marble-working centres, with proportion and pattern badly scaled. And the kouros from Boeotia [*67*] with its comparatively late egg-shaped head and more naturally lobed ears reveals similar faults of design. The head [*68*] is better, a country cousin to [*62*].

The kouros type was adapted for the unfinished ram-bearer from Thasos (a Parian colony), its hair recalling the New York kouros, its sleek figure the earlier island kouroi [*69*]. Another adaptation is the stocky pair, Kleobis and Biton, dedicated by the Argives at Delphi [*70*]. From the front the low brows and hair bunched behind the ears seem sub-Daedalic, but from the side we notice the more natural ears, the extremely thickset bodies and tough flexed arms which, with the traces of the boots they wore, recall the purpose of the dedication, commemorating their strength in pulling a chariot along the Argos road. The slight differences between the twins are trivial yet some have sought to explain the more battered one as the work of an Ionian apprentice. Kleobis and Biton give us, nearly, their sculptor's name – . . .]medes of Argos.

Korai

The marble statues of women served the same purposes as the kouroi. Rather fewer of them are demonstrably funerary (from Attica; possibly Samos, Chios and Thera) and in goddess sanctuaries they may serve Artemis (Delos, Klaros), Hera (Samos), Nymphs (Samos), Athena (Athens, Miletus), Demeter (Eleusis).

Their importance in the development of Archaic Greek sculpture comes only after the period studied in this chapter, since the early marble examples are

wholly Daedalic in appearance. The earliest complete statue is Nikandre's dedication on Delos [*71*, right], but for all the similarity in style we have only to set her beside the Auxerre statuette [*28*; *71*, left] to realize what the increase in size can add in presence and monumentality. Her date, relative to Auxerre, is hard to determine since the raw rectangularity must be in large part due to the difficulty of working the less familiar, harder material. Closer to Auxerre in detail was an even larger kore from Samos, of which only one substantial fragment survives [*72*]. This and similar early pieces on Samos are in imported marble but after about 600 local sources are used.

For a view of the heads of these figures we turn to other Daedalic work of smaller size, then to the moulded clay heads on Corinthian vases with their more developed features and oval outline. And, since korai are rare in these years, for other female statuary to the lifesize seated figures in soft stone or the smaller figures studied in the next section. When we come to the sixth century a head from Olympia [*73*], but of limestone, shows us how the female features match in general outline those of the latest kouroi so far considered. It appears to be from the seated Hera which, with a standing Zeus, was the cult group in the Temple of Hera (Pausanias v, 17.1) and probably made for the new temple in the early sixth century. The rather stark features suit its size and function.

Perirrhanteria

Over a dozen seventh-century marble perirrhanteria are known [*74–79*] – shallow water basins, some with knobbed handles, supported by three or four female figures who, in most cases, stand on or beside lions, holding them by tail and lead. The women are up to one metre high. The type is derived from Syria or Cyprus, where we find dishes carried by figures or sphinxes, and deities standing on lions or lion-bases. In Greece the basins come from sanctuaries and have been found in Laconia (five), Olympia (two or more), Isthmia (near Corinth), Delphi, Rhodes, Samos, the Ptoon (Boeotia). Early dates have been proposed – early enough to make them Greece's first marble sculpture – but this is improbable. The figures are not Daedalic, but the sharp features, smooth and well-modelled bodies, and the podgy lion heads seem all characteristic of Laconia where many have been found. The material of many too is a grey marble which can pass as Laconian, but it is commonly held that some were made where they were found (Rhodes, Samos) despite the general unity of style and dissimilarity to other local work. This overall concord of style suggests a short period of production although the general form and style is repeated on some marble lamps with relief heads (which include some Daedalic) and the ensemble is recalled on the Athens Acropolis in the sixth century. The Laconian or laconizing basins need be no earlier than the last third of the seventh century. Sparta may seem a surprising home for this alternative to the Daedalic style, in marble and on such foreign-looking objects, but the concept is borrowed for

smaller Daedalic objects in clay and we may take this as further evidence for Laconia's special links with the east and with some Ionians (Samos), otherwise best shown by her ivories. Another Laconian oddity in marble, perhaps also inspired by the east, is the kneeling goddess [*80*].

Artists and authors

Contemporary texts tell us little or nothing about statuary. Homer has no word for 'statue' (later *andrias*, as on [*60*]) and *agalma* refers to workmanship on any scale. Later authors like Pausanias comment on the crudity of early wooden figures and have no real conception of the early development. At first there may have been a distinctly magical aspect to major statuary, and the Rhodian Telchines, said to have made the first images of the gods (Diodorus v, 55), were wizards who could also control the weather and change their shapes. The word *kolossos*, which does not necessarily imply 'colossal', could refer to a substitute for men (compare [*40*]). The figures of Daedalus were said to see and walk, even talk. We have met his name already, applied by modern scholars to the seventh-century orientalizing style. '*Daidalos*' means 'cunningly wrought' and there is a Daedalus creating wonders in the myth history of the Bronze Age (aeronautics with Ikaros, etc.). Many lifelike and Archaic but not primitive works were attributed to Daedalus, and when Diodorus (iv, 76) says his figures have open eyes, separate legs as if walking and arms free of the body, clearly the early stone kouroi are indicated, nothing earlier, although many alleged '*daidala*' are wooden. Diodorus (i, 97) also associated him with Egypt saying that his statues have the *rhythmos* of the Egyptian, which makes sense, and he made a famous folding stool; Egyptian furniture was introduced to Greece around 600. Many make him Cretan, like his Bronze Age predecessor (the two are not distinguished in the sources), which also makes sense in terms of the island's seventh-century record and possible contribution to the island kouroi. Others have him Athenian. A contemporary, Smilis of Aegina (Pausanias vii, 4) was said to have made the cult image of Hera on Samos. Of Daedalus' pupils Dipoinos and Skyllis, said to have been born in Crete, were working in the Peloponnese in the second quarter of the sixth century, and Endoios in Athens in the second half. These were real artists: Daedalus may be a personification of those early monumental styles from which their work derived, or, if the view taken here of the Delphi bronze [*57*] is correct, a Cretan artist who understandably acquired a reputation as teacher of the first sculptors of truly monumental works in Greece.

We get hardly closer to the anonymous artists of the works which have survived. Homer knows palace craftsmen and itinerant *demioergoi*. In Archaic Greece an important sanctuary like Olympia might attract resident artists, as the Bronze Age palaces did, and some have seen a Laconian Geometric studio for bronzes established there. The guild or family which brought eastern fashions

to Crete before 800 was certainly foreign. Within Greece the sources of stone, especially marble, were inevitably at first the homes of the sculptors' studios, but we have already detected independent local styles, as in Attica, so it was possible for the individuality of an artist to be stamped on the works of a school, wherever he may have learned his craft or still have to acquire his material. Euthykartidas signed his work on Delos [56] but primarily perhaps as its dedicator. With . . .]medes' signature at Delphi we meet a proud claim of creation, not gainsaid by the dedicators, and the sixth century will see a growing awareness by artists of the individual quality of their work, perhaps not without some thought for advertisement.

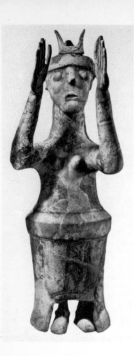

1 Clay figure from a shrine at Karphi (Crete). More probably an adorant than a goddess. She wears a Minoan horns symbol on her cap, and the type is traditional in Crete, including the raised hands gesture. The feet are made separately and hung in the skirt. (Heraklion Mus.; H. 0·67) About 1000

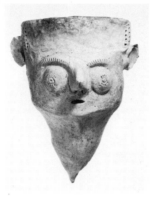

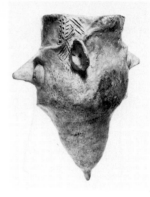

2 Clay janiform head, from Piskokephalo (Crete). The features were painted and the conical lower part was probably for insertion in a wooden body over half lifesize. (Oxford AE 1102; H. 0·295) About 900

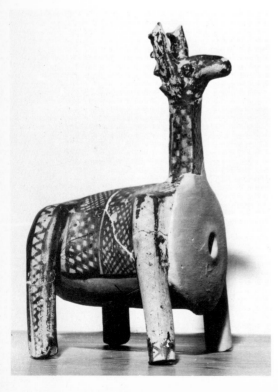

3 Clay stag, from a grave in Athens, decorated in the Protogeometric style. (Athens, Kerameikos Mus. 641; H. 0·26) About 925 (dated by context)

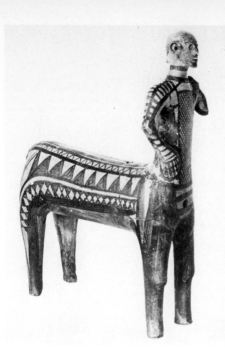

4 Clay centaur, found part within a tomb, part over another tomb, at Lefkandi (Euboea). A deliberate painted nick in the right foreleg has been associated with the story that the centaur Chiron was wounded in the leg by Herakles with an arrow, but a myth figure in the round so early is unexpected and we would look for more explicit statement of the action. (Eretria; H. 0·36) Before about 900 (dated by context)

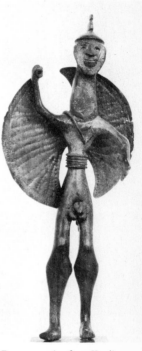

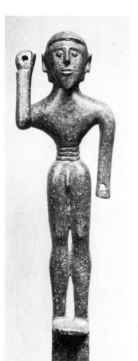

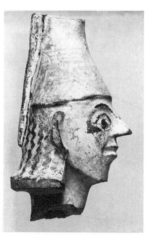

6 Clay helmeted head, from the Amyklaion sanctuary (Laconia). (Athens; H. 0·115) About 700

7 Bronze warrior from Karditsa (Thessaly). His spear is missing but he wears helmet, belt and 'Dipylon' shield (a light wicker or hide shield, stylized into this shape by the Geometric artist). (Athens Br. 12831; H. 0·28) About 700

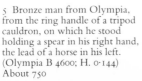

5 Bronze man from Olympia, from the ring handle of a tripod cauldron, on which he stood holding a spear in his right hand, the lead of a horse in his left. (Olympia B 4600; H. 0·144) About 750

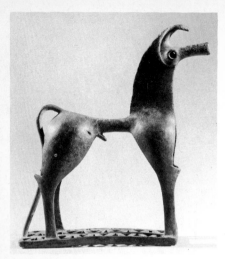

8 Bronze horse. The base is an openwork of triangles. (Berlin 31317; H. 0·16) About 750–700

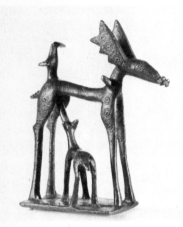

9 Bronze antlered deer with fawn and bird, from the Kabirion sanctuary near Thebes. Greek artists often show deer with antlers, into the classical period. (Boston 98.650, Pierce Fund; H. 0·07) About 750–700

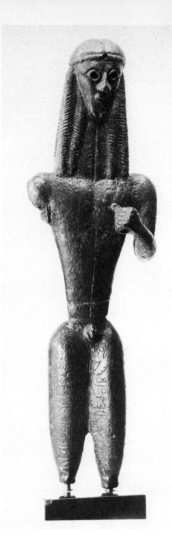

10 Bronze man from Thebes. The dedication by Mantiklos is written in two hexameters on the thighs. 'Mantiklos offers me as a tithe to Apollo of the silver bow; do you, Phoibos, give some pleasing favour in return.' (Boston 3.997; H. 0·20) Early 7th c.

Μαντικλος μ'ανεσεκε ϝεκαβολοι αργυροτοχσοι
τας {δ}δεκατος· τυ δε Φοιβε διδοι χαριϝετταν αμοιϝ[αν]

11 Bronze helmet-maker. This is unusual for this period in having no base or signs of attachment. The subject suggests a craftsman's dedication. (New York 42.11.42, Fletcher Fund; H. 0·052) Early 7th c.

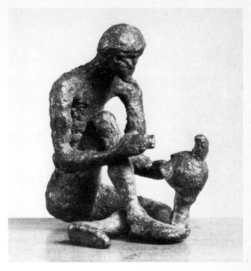

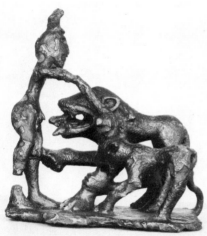

12 Bronze hunter and dog attacking a lion with prey in its mouth, from Samos. The helmet lends a heroic air to a heroic occasion (there were no lions in the Greek islands although Homer knew their behaviour well). Beneath the base is an intaglio swastika. (Once Samos; H. 0·09) About 700

13 Bronze hero fighting a centaur, from Olympia (?). Both are helmeted; he plunges a sword into the monster's flank. Possibly Herakles and Nessos. (New York 17.190.2072, Morgan Gift; H. 0·11) About 750–700

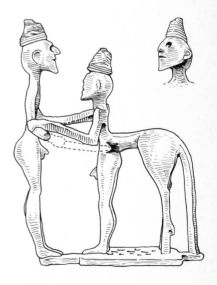

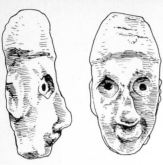

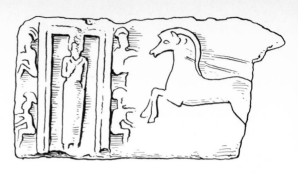

14 Limestone head from Amnisos. The eyes had been inlaid, probably in bone. (Heraklion 345; H. 0·16) 8th c.

15 Limestone relief from Chania. A goddess stands frontal in the gateway of her temple or city. Pairs of archers, one above the other, protect her. They wear helmets of eastern type and the horse from the attacking chariot resembles the Assyrian, somewhat geometricized. The relief may be from a building. There is a comparable scene on a bronze belt of this style from Knossos. (Chania 92; H. 0·39) 8th c.

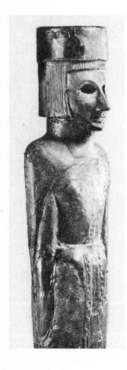

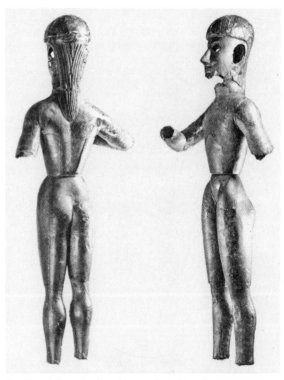

16 Bronze statues (one of two female and the male) from Dreros. Probably cult images which stood on the corner basis of the 8th-c. temple of Apollo. The god's hair is worked in long hook-locks; the restoration of his arms is uncertain. The bronze sheets were pinned together over a wooden core having been hammered into shape, a technique familiar also for gold figures of this style (called *sphyrelaton*). The eyes had been inlaid. (Heraklion 2445–7; H. 0·40, 0·80) About 700

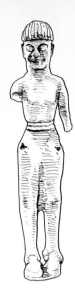

17 Bronze statuette from
Afrati, in a deposit of
the second half of the
8th c. Compare the
'Apollo' *16* especially
for the head and hair.
(Heraklion) Late 8th c.

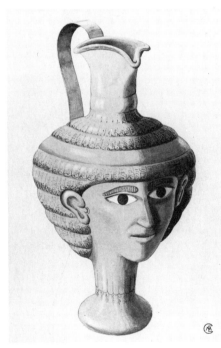

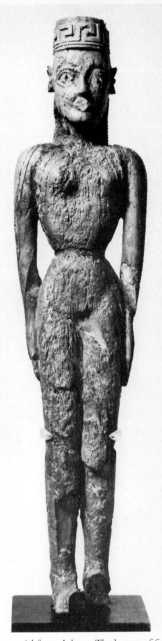

18 Bronze head vase from the Idaean Cave
sanctuary of Zeus. The patterned hair, brows and
shape of head are eastern. Neck and handle are
restored in the drawing. (Oxford AE 211 and
Heraklion; W. 0·114) Mid-7th c.

19 Ivory girl from Athens. The largest of five
similar figures in a grave dated by its pottery to
about 730. It also contained three faience lion
figurines and worked bone. The figure may have
served as a handle, like eastern counterparts. The
proportions resemble the (clothed) Dreros figures
16. (Athens 776; H. 0·24)

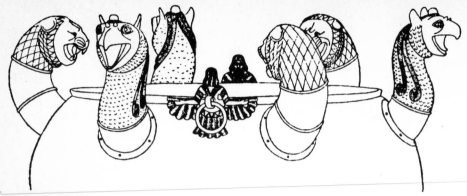

20 Bronze cauldron from Olympia with beaten lion and griffin heads and cast siren attachments. (Olympia; lip diam. about 0·65) Early 7th c.

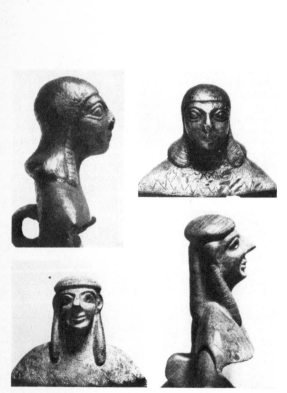

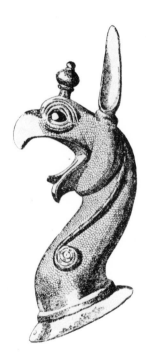

22 Cast bronze griffin from a cauldron, from Olympia. A later refinement of the hammered griffins. The series continues into the 6th c. (Olympia) Mid-7th c.

21 Heads from bronze siren attachments to cauldrons, from Olympia. The imported eastern type above a Greek version. The series of these figures is of the latest 8th and early 7th c. (Olympia)

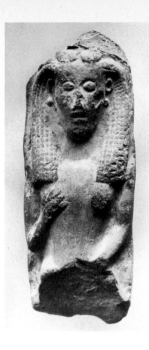

23 Clay plaque from
Corinth. Imported from
Syria. Astarte, with
hands to breast and
loins. (Corinth MF 4039;
H. 0·10) 7th c.

24 Clay mould (cast) from Corinth.
Made locally but from an eastern
original. (Corinth KH 1; H. 0·06)
7th c.

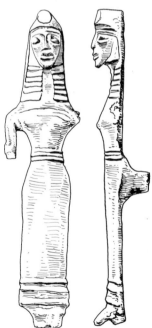

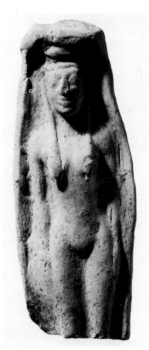

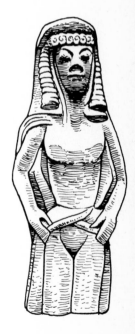

25 Bronze handle from Gortyn,
temple of Apollo.
(Heraklion 2448; H. 0·17)
Early 7th c.

26 Clay plaque from Crete.
The *polos* hat had been squashed
before firing. Aphrodite (?).
(Oxford AE 403; H. 0·14) Mid-7th c.

27 Clay figure (plaque) from
Axos, sanctuary of a goddess
later identified as Athena.
A goddess bares her belly in
a ritual, fertility gesture.
(Chania; H. 0·13) Mid-7th c.

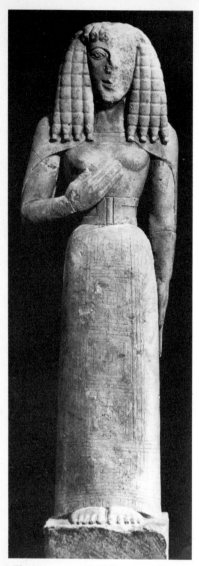

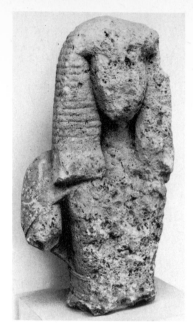

29 Limestone seated figure from
Astritsi. (Heraklion 407; H. 1·04)
About 650–640

28 The 'Auxerre goddess', limestone, formerly
in the Auxerre Museum, originally perhaps from
Crete. Incision and traces of painted lines
indicate a coloured scale pattern on the chest,
squares along the cloak border and concentric
squares on the skirt. (Louvre 3098; H. 0·65)
About 640–630. See also *128*

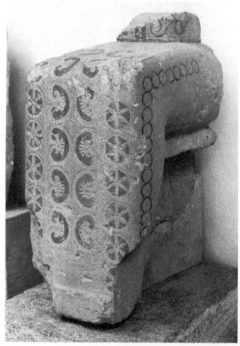

30 Limestone seated woman from
Gortyn, sanctuary of 'Athena'.
Traces of red paint on the belt
and skirt patterns. (Heraklion
380; H. 0·80) About 650–630

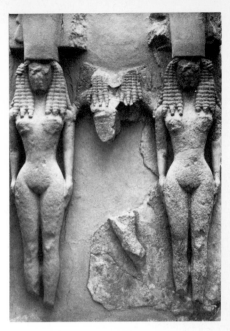

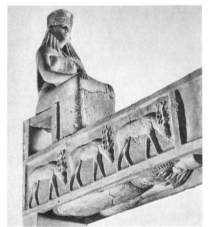

31 Limestone relief from Gortyn, temple of Apollo. A god striding between two naked women, wearing *poloi*, his hands on their shoulders. One of two similar slabs which probably stood as dado blocks at the front of the temple where there seem also to have been half-relief sphinxes (another eastern feature) in the doorway. (Heraklion 379; H. 1·50) About 630–620

32 Sculpture from Prinias. See next page

32.1

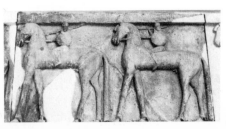

32·3

32·2

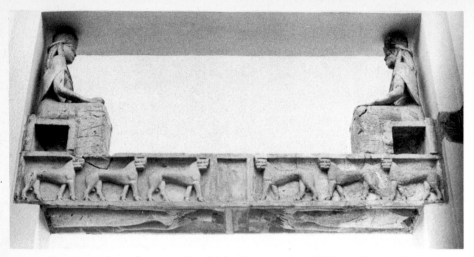

32.4 Limestone sculpture from a temple at Prinias. The restoration is highly problematic. The seated women face each other over a lintel carved with animals in front and perhaps behind, with frontal standing women on the underside. The lower parts of the faces of both the seated and relief figures are restored. They were set either on the façade or over the cella door. The riders frieze was more probably a dado in the porch, in the eastern manner, than a crowning frieze, in the later Greek manner. The horses' long legs look primitive but this is a recurrent Cretan feature for the creatures and set low the extra length would be foreshortened. (Heraklion; H. of seated woman (231) 0·82; of frieze (232) 0·84) About 620–600

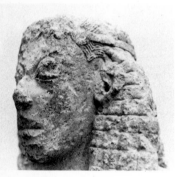

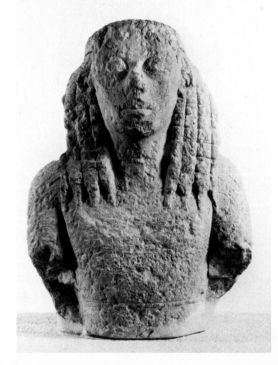

33 Limestone seated woman from Eleutherna. (Heraklion 47; H. 0·57) About 600

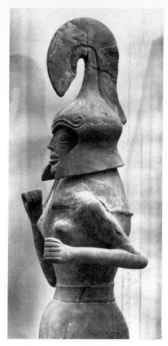

34 Clay 'Athena' from Gortyn. She
holds spear and shield, and wears a
helmet, made separately. The body is
wheel-made, the face moulded.
(Heraklion 18502; complete H. 0·36)
About 660–650

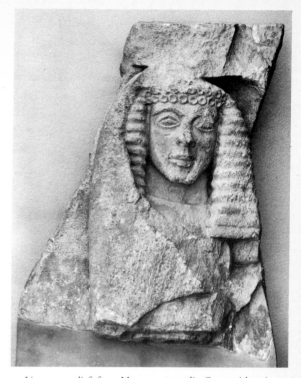

35 Limestone reliefs from Mycenae acropolis. On one (above) a
woman draws cloak over head, a gesture of modesty and rank.
The reliefs must be from a building, probably a dado frieze of slabs
in the Cretan-eastern manner. Other fragments are from fighting
scenes and one (below) is plausibly restored as two sphinxes lifting
a body, perhaps the Keres on the battlefield, but there was no
certain unity of theme in the frieze. (Athens 2869; H. 0·40 and the
restored fragment Athens 2870, H. of slab about 0·90) About 630

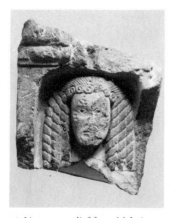

36 Limestone relief from Malesina
(Boeotia). Provincial Daedalic – the
oval face and high forehead indicate a
late date. Apparently to be restored
as a bust only, like an eastern 'woman
in the window', so probably votive.
(Louvre MND 910; H. 0·34) About 600–590

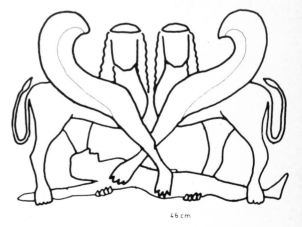

46 cm

37 Bronze head from Olympia. Hollow cast, probably from a
complete figure which served as a support, perhaps for a bowl
(there is a hole at the crown of the head). The hair is shown
by incised vertical wavy lines at the back but in horizontal
layers at the side. The eyes were inlaid. (Karlsruhe F 1890;
H. 0·087) About 640

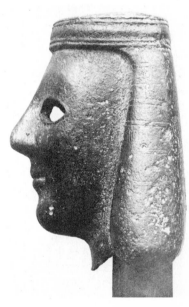

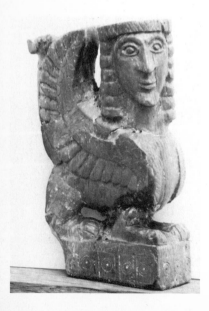

38 Ivory sphinx from Perachora,
sanctuary of Hera Limenia.
(Athens 16519; H. 0·08) About 650

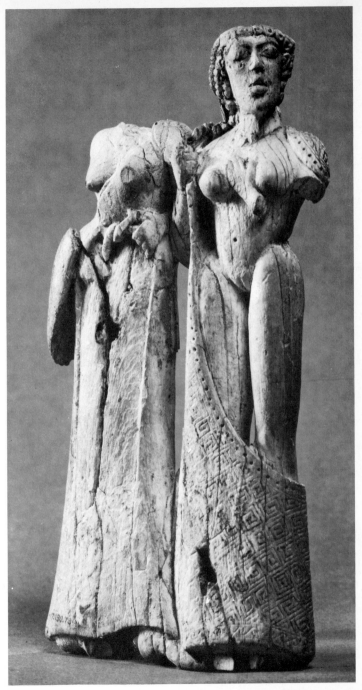

39 Ivory group in high relief. Two girls, one tying (or untying) her girdle, baring her upper
body, the other with her cloak falling from her. A similar pair, baring themselves, are seen
on a contemporary painted metope from Thermon. They may be the daughters of the Argive
king Proitos, maddened by Hera. (New York 17.190.73, Morgan Gift; H. 0·137) About 630

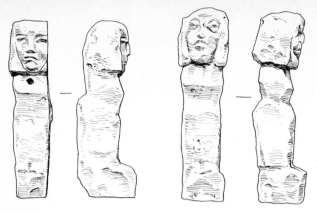

40 Limestone figures from Thera. The bodies are roughly blocked out. They were found in a mass cenotaph ('Schiff's grave') dated by the pottery found in it, and may have been substitutes for bodies lost at sea or in some other disaster. (Thera; H. 0·19, 0·18) About 660–650

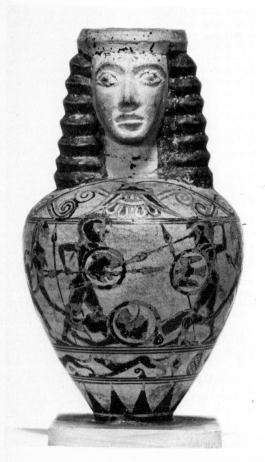

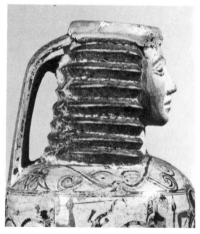

41 Protocorinthian oil flask (aryballos) from Thebes. The head is mould-made. The painted decoration, by the Boston Painter, can be closely dated. (Louvre CA 931; H. 0·068) About 650

42 Limestone figure from Tanagra (Boeotia). The rounded bell-like treatment of the dress resembles late 7th-c. figures on vases. This is probably a man (inscribed '...imarou' (?)), holding an animal. (Thebes; H. 0·48) Late 7th c.

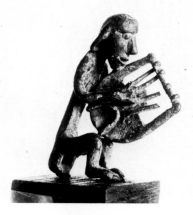

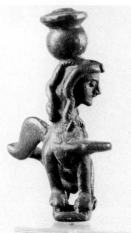

43 Bronze lyre-player from Crete (?). (Heraklion 2064; H. 0·055) Early 7th c.

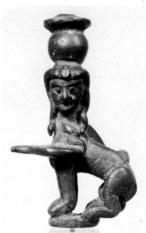

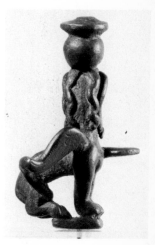

44 Bronze sphinx from Crete (?). This was fastened to an object and something is broken away from above the bud-like terminal. One wing is carried forward and turned flat. The raising of the hindquarters is in fact a 6th-c. feature for stone sphinxes, cf. 224. (Berlin 31342; H. 0·078) Late 7th c. or later

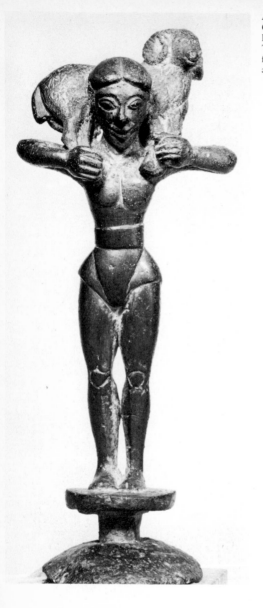

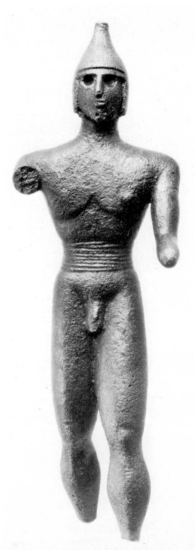

45 Bronze ram-bearer (*kriophoros*) from Crete. For the action, appropriate to Hermes as well as a shepherd, see 69. The stalk and mass below the base are from the casting channel and usually cut away. (Berlin 7477; H. 0·18) About 620

46 Bronze warrior from Olympia. (Olympia B 1701; H. 0·17) About 650

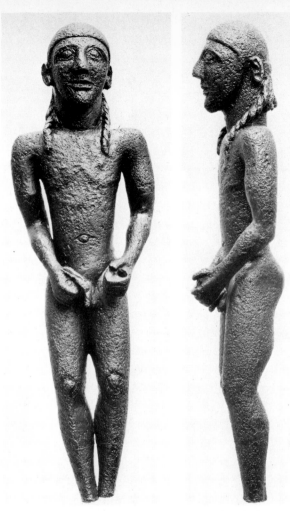

47 Bronze charioteer from Olympia. This has been thought Attic work. (Olympia B 1700; H. 0·23) About 650

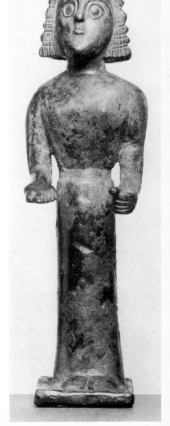

48 Bronze woman from Thebes. Said to have been found with *10* but decidedly later, her hair style is Daedalic. The clenched hand had something in it, the other is held open, palm up (Baltimore, Walters Art Gallery 54.773; H. 0·18) Third quarter of the 7th c.

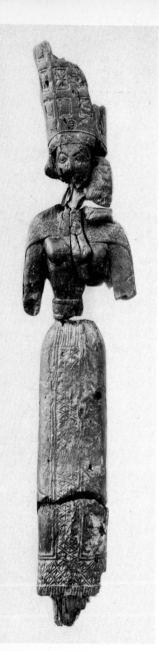

49 Wooden goddess from Samos. The high *polos* is open behind and is perhaps to be taken as Hera's tower-headdress, *pyleon*. The shawl and dress are as the Cretan, also the disposition of the pattern, cf. *28*. The forearms, made separately, were held forward. The tenon below is for fixing into a larger object rather than a base in the later manner of stone statuary. (Samos inv. H 41; H. 0·287) About 630

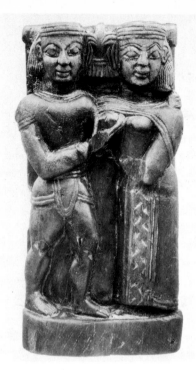

50 Wooden plaque from Samos. A man embraces a woman, holding her breast. A flying bird (eagle or omen) between their heads. This is often taken for a 'sacred marriage' (*hieros gamos*) scene with Zeus and Hera. Its findplace might support this but the scheme is oriental. (Once Samos, now disintegrated; H. 0·191) About 630–600

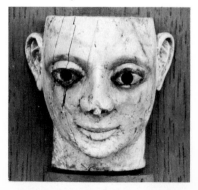

51 Ivory head from Perachora, sanctuary of Hera Limenia. Eastern work. (Athens 16520; H. 0·04) About 700

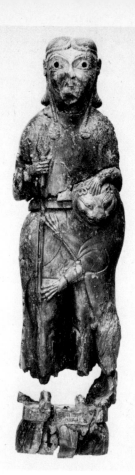

52 Ivory group from Delphi. The scheme resembles eastern reliefs of a hero with a lion, the long spiral curls, skirt split to the belt and the style of the lion are also eastern. Apollo's association with lions is attested later, but would be unusual in this form at this date unless by reference to his sister Artemis, as Mistress of Animals. The base carries a pattern met in east Greece and Lydia but not closely datable. (Delphi; H. 0·24) First half of the 7th c.

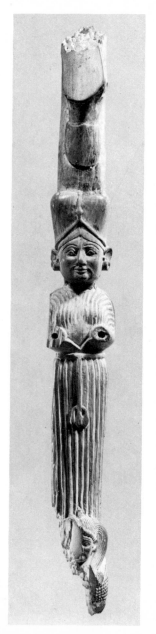

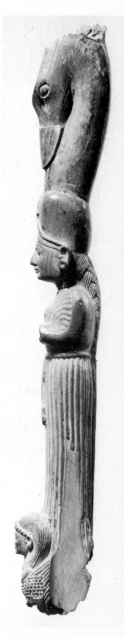

53 Ivory woman standing on a sphinx or siren. From the arm of a lyre, as 54. (Berlin 1964.36; H. 0·225) About 600

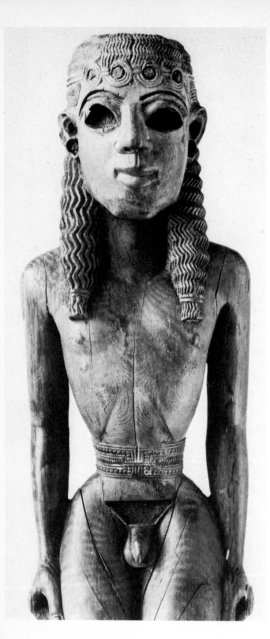

54 Ivory youth from Samos. Eyes, brows, ear lobes (with earrings) and pubic hair were inlaid. The figure was one of a pair set on the corners of a lyre. The head profile is distinctive; cf. 51. (Athens; H. 0·145) Late 7th c.

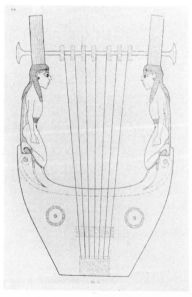

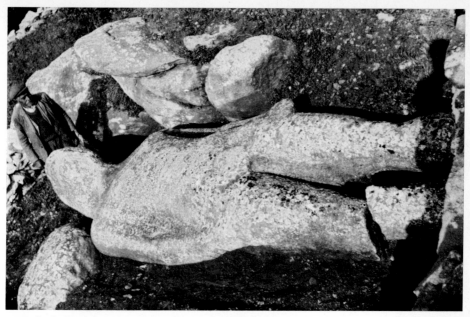

55 Unfinished kouros on the path from the quarries, Naxos

56 Kouros base from Delos. Ram, lion and gorgon head bosses. Signed 'Euthykartidas the Naxian made and dedicated me'. (Delos A 728; H. 0·58) About 600

Ἐυ̣ξ̣υκαρτιδης :
μ’α{ː}νεϟε̄κε : ho
Naϟσιος : πο-
-ιε̄σας

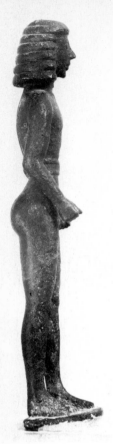
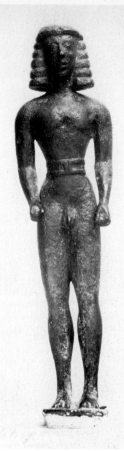

58 Kouros from Delos. (Delos A 334; H. 0·69) About 625–600

57 Bronze kouros from Delphi. (Delphi 2527; H. 0·197) About 630

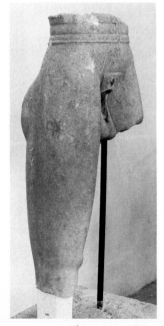

59 Kouros from Delos. The more advanced anatomical detail (pubic hair, divided scrotum) indicate a later date than the comparatively featureless 58. The penis was made separately, now missing. (Delos A 333; H. 0·85=about 2·80 complete) About 580

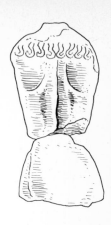

OΑΡΥΤΟΠΙΘΟΕΜΙΑΜΔΡΙΑΣΚΑΙΤΟΣΦΕΓΑΣ

[τ]ο αϝυτο λιϑο εμι ανδριας και το σφελας

60 Kouros from Delos. Two fragments
and perhaps a hand (on Delos) and the toes
(in London) remain. A sketch after
Cyriacus of Ancona who saw it in AD
1445, shows the head too. The locks and
belt were modelled, the holes are perhaps
for later embellishment. The base into
which the statue with its plinth was set
declares 'I am of the same stone, statue and
sphelas'. *Sphelas* should mean base: the
allusion remains enigmatic but could refer
to the monolithic character of *each* colossal
part. A later inscription describes it as a
dedication of the Naxians. It was knocked
over by the bronze palm tree dedicated by
Nikias in 417, which stood 27 m away. Its
top had perhaps been blown on to the
statue in a gale. (Delos; H. 2·20, 1·20=
about 10·0 complete) About 580–570

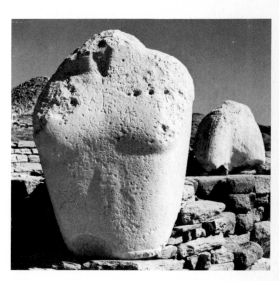

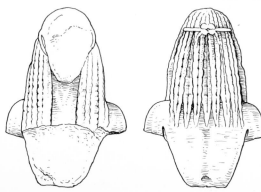

61 Kouros from Thera cemetery (?). The
face and most of the chest are broken
away. (Thera; H. 1·03=about 2·50
complete) About 625–600

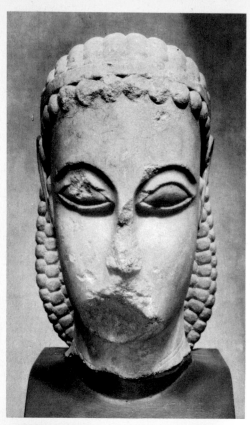

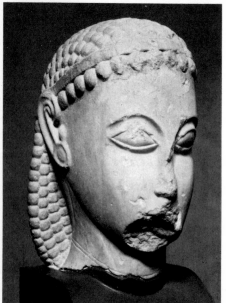

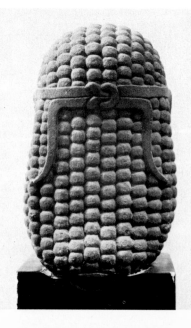

62 Kouros ('Dipylon head') from Athens.
From the same workshop as 63 but the hair
is gathered at the nape and its beading
interlocks instead of lying in horizontal
rows. One hand is also preserved and closely
comparable fragments from the Agora
(*Kouroi* no. 7). (Athens 3372; H. 0·44) About
590

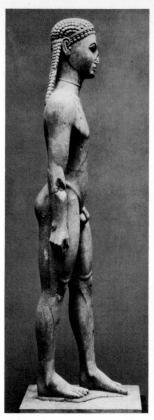
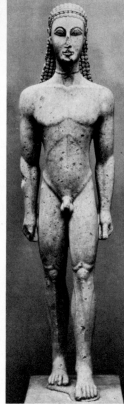
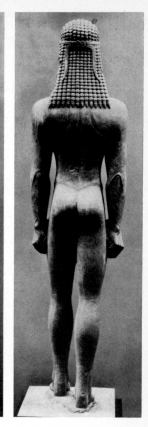

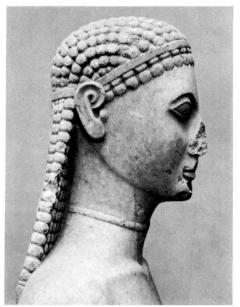

63 Kouros from Attica (?).
(New York 32.11.1; H. 1·84)
About 600–590

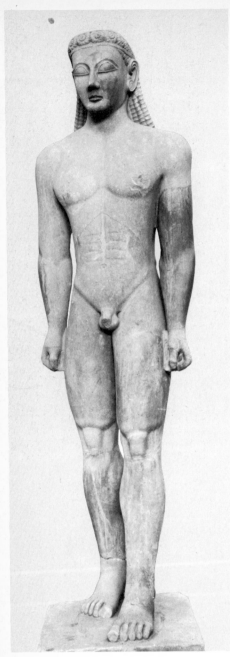

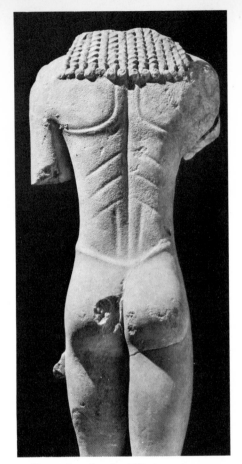

65 Kouros from Sounion. This shows the same elaborate groove and ridge patterning typical of the Sounion figures. (Athens 3645; H. 1·65) About 590–580

64 Kouros from Sounion. Left arm and leg, right shin, most of left eye, nose and mouth restored; the feet may not belong. Closely related to 63 (notice ears, eyes, torso front). Found in a pit in the sanctuary of Poseidon with parts of at least two other kouroi and, in all, four bases. They had presumably been buried after a disaster – perhaps the Persian invasion of 480. (Athens 2720; H. restored 3·05) About 590–580

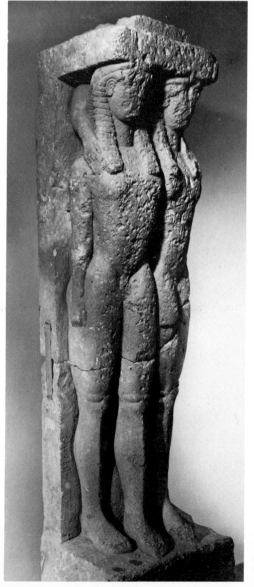

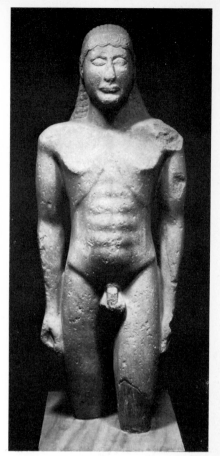

67 Kouros from Orchomenos (Boeotia).
(Athens 9; bluish marble, probably local; H.
1·27=about 2·0 complete) About 580–570

66 Limestone stele from Tanagra. Inscribed
by each figure 'Dermys', 'Kittylos', and on
the base 'Amphalkes put (this) up for D. and
K.'. Each has one arm round the other's
shoulder, set impossibly high. The gesture
appears in sculpture for Egyptian couples.
(Athens 56; H. of figures 1·47) About 580

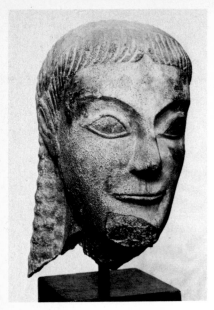

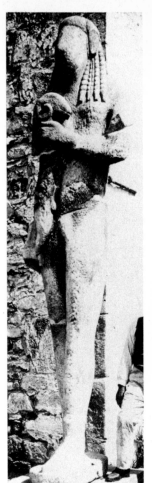

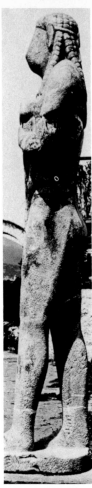

68 Limestone kouros head from the Ptoon (Boeotia). (Athens 15; H. 0·33) About 580

69 Ram-bearer from Thasos. This identifies more closely with the dedicator, since the figure carries an offering. The statue is unfinished, blocked out with the point and only the hair more fully worked. The arrangement of the hair and placing of ears look unskilful rather than primitive. (Thasos; H. 3·5) About 580

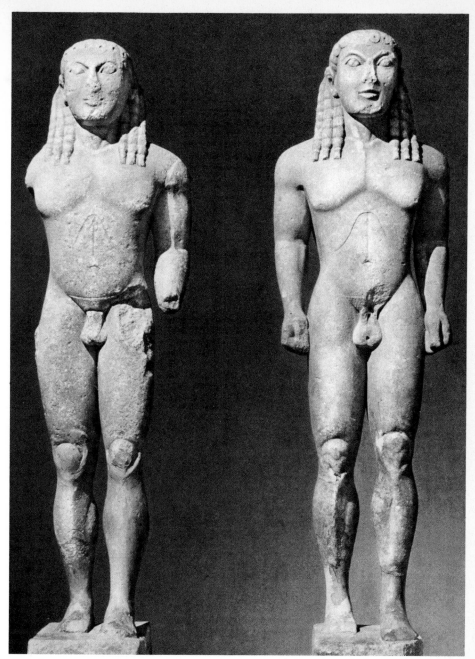

70 Kleobis and Biton from Delphi. See next page

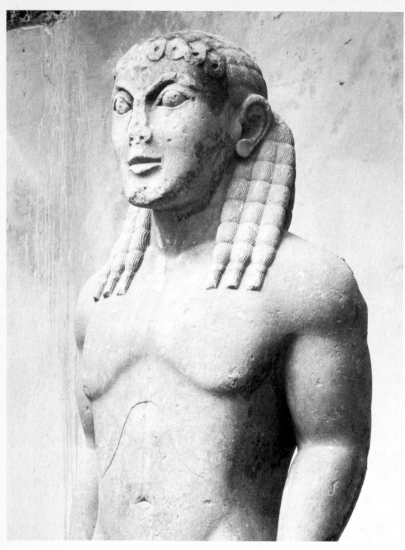

70 Kleobis and Biton from Delphi (see previous page). They probably stood side by side. The young men had taken the place of oxen to pull their priestess-mother's cart from Argos to the temple of Hera. For their piety and strength she begged from the goddess the greatest boon for mortals: and they died in their sleep. Herodotus (i, 31) goes on to say that the Argives sent statues of them to Delphi. We do not know when the alleged feat was performed, but the pious and uncontroversial dedication was made just after the First Sacred War when Argos and Dorians in general were unpopular at Delphi. The fate of the brothers is strangely paralleled by the fate of the brother architects (Agamedes and Trophonios) of the first stone temple of Apollo, completed about this time. Inscriptions run across the tops of the plinths naming them, alluding to the story, and naming the artist, Argive Poly?]medes. The figures are booted. The chunky style is taken by many scholars to be characteristic of the Peloponnese. (Delphi 467, 1524; H. restored 1·97) About 580

[Πολυ?]μεδες εποιfε hοργειος ΜΕDΕΜΕΓοΙΕΕΘΑΡΓΕΙοΜ

72 Kore from Samos. Fragment of neck and upper body.
(Samos I. 95; H. 0·42=about 2·5 complete) About 640–630

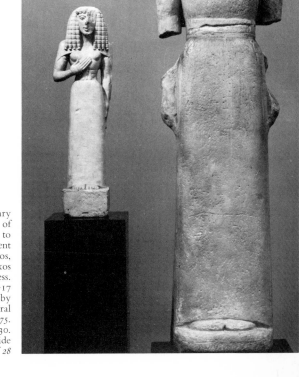

71 (right) Kore from Delos, sanctuary
of Artemis. Inscribed along the left of
her skirt. 'Nikandre dedicated me to
the far-shooter of arrows, the excellent
daughter of Deinodikes of Naxos,
sister of Deinomenes, wife of Phraxos
n(ow?)'. She was no doubt a priestess.
The figure is nowhere more than 0·17
deep. The surviving hand is pierced by
a drill hole 0·06 deep, to hold a floral
or possibly the lead of a lion, as 74, 75.
(Athens 1; H. 1·75) About 640–630.
This is the cast in Oxford, set beside
the cast of 28

ΝΙΚΑΝΔΡΘΜΑΝΕΘΕΚΕΜΒΚΕΚοΡΟΙΙΟΧΕΑΙΡΘΙΡΟΡΘΔΕΙΝ
ΘΤΤΛΙΣΑΨΞΧΟΞΟ ΒΧΟΧΟΒΞ ΟΙΡΟ ΒΤΛΡΟΧΟΕΒΞΟΙΡΟΑΜΟΤΟΒΛ ΤΒ
ΘΒΛΑΒΣΟΡΛΛΟΧΟΣΝ

Νικανδρη μ'ανεδεκεν h⟨ε⟩κηβολōι ιοχεαιρηι, φορη Δεινο-
-δικηο το Ναhσιο, εhσοχος αλhōν, Δεινομενεος δε κασιγνετη,
Φhραhσο δ'αλοχος ν⟨υν?⟩

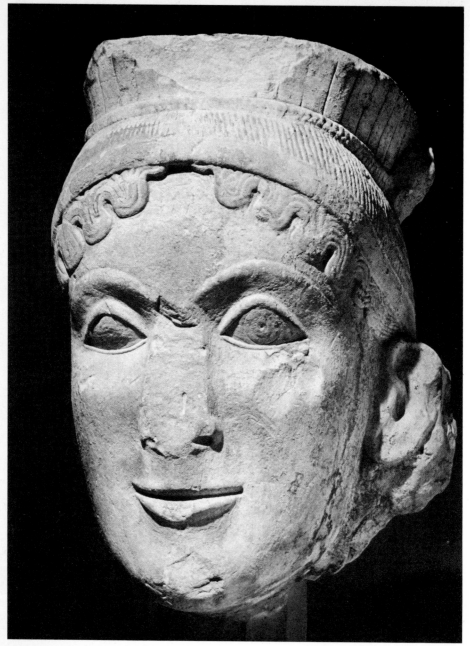

73 Limestone head of Hera from Olympia, temple of Hera. There were traces of red on the hairband, and yellowish red on the hair. The ear and mass beside it suggest that she was seated on a high-backed throne. A scrap from what may be the base can be restored with a man between lions, an orientalizing composition seen in the east (with a demon) on a base from Carchemish. (Olympia; H. 0·52, over twice lifesize) About 580

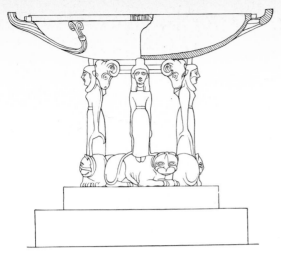

74 Perirrhanterion from Isthmia, sanctuary of Poseidon.
The women stood on lions, holding them by lead and tail.
Much restored. (Corinth; H. 1·26 without stepped base)
Late 7th c.

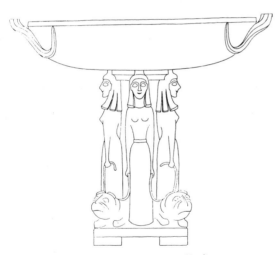

75 Perirrhanterion from Samos. (Berlin 1747;
H. restored 0·52) Late 7th c.

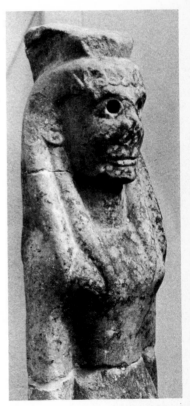

76 Perirrhanterion from Olympia, figure
support only. The centre support was in
the form of a Doric column.
(Olympia; H. 0·475). Late 7th c.

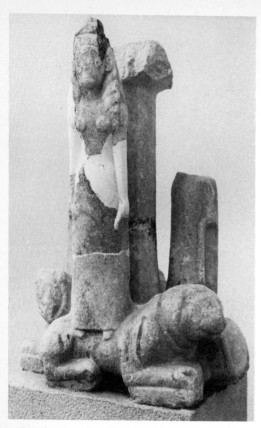

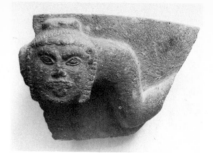

79 Perirrhanterion from Sparta. Head and
handle attachment from the basin.
(Sparta 1658; H. of head 0·105) Late 7th c.

77 Perirrhanterion from Kameiros (Rhodes).
(Rhodes; H. 1·0) Late 7th c.

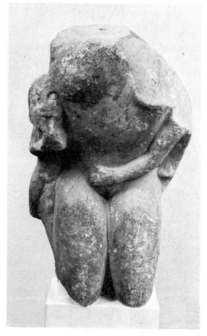

80 Naked goddess kneeling, flanked by a pipes
player, and another figure at her other side,
from Sparta. Probably a goddess of fertility or
childbirth (the piper drowns the cries).
(Sparta 364; H. 0·48) About 600

78 Perirrhanterion from Sparta. Only the lions are
preserved. (Sparta; W. 0·52) Late 7th c.

Chapter Five

THE MATURING ARCHAIC STYLES
to about 530 BC

Sources

Most major statuary of the Archaic period was intended either for commemoration of the dead or for dedication and decoration in a sanctuary. The grave markers and dedications betoken a degree of personal or family wealth readily comprehensible in states whose agriculture and trade remained largely in the hands of rich families supported by dependents and slaves. The quality of the dedications was partly determined by the splendours of the sanctuary in which they stood and which they had to match. The more grandiose architecture of the national sanctuaries could be financed from offerings of individuals or states, as at Delphi or Olympia. In other cities major works depended on the resources, vision and sometimes the ostentatious pride of their rulers. This is the age of 'tyrants' in many Greek cities. Their wealth and authority enforced by arms provided the impetus for major architecture and other works; and their courts, which complemented rather than suppressed the life-style of aristocratic families, themselves became a focus for the activity of artists of all sorts in a manner recalling the Bronze Age palaces and anticipating the Hellenistic kingdoms.

The two prime sources for sculpture of our period were the seats of two of the most powerful 'tyrannies'. The Hera temple on Samos had already a long and distinguished history, but a new and massive temple was being built in the second quarter of the sixth century, and in the third the tyrant Polykrates commissioned many public works including a rebuilding of the temple. These are years in which the sanctuary, town and cemetery are richest in statuary recovered by excavation.

In Athens the Acropolis had been devoted to religious affairs by the late 560s, a new temple had been built and the state festival of Athens, the Panathenaia, reorganized. The later tyrant Peisistratos had played some part in this, perhaps. He dominates, with his sons, the years down to 510 and this is an extremely rich period for sculpture and architecture on the Acropolis. While Peisistratos was still alive the new glories of the Acropolis were mainly architectural, with their accompanying sculpture, and it seems that for some of the time he and his sons shared the sacred rock with the gods and lived upon it. After his death in 527 the proliferation of dedications begins in earnest. The buildings and statues were

overthrown by the Persians in 480/479, but the returning Athenians buried the broken marble statuary and bases on the Acropolis, whence they were recovered by excavation at the end of the last century. It seems to have been an act of tidiness rather than piety on the part of the Athenians since, from the bases found, we know that at least half the dedications were bronze. Virtually no bronze statues of any size were found, nor could Xerxes have taken them all away. Some may have survived undamaged; the broken ones were perhaps melted down – broken marbles are useless.

This is the richest single source for this period and tends to overweight our view of Archaic sculpture in favour of Athens, well supplemented as it is by finds in the city cemetery and in the smaller graveyards in the Attic countryside, where many rich families lived. The Acropolis finds also give us a vital dating point for late Archaic art although it is possible that some of the architectural sculpture found had been already discarded or replaced before the Persians arrived and at least one Archaic marble statue may have survived the Persians [135]. The circumstances of discovery of grave monuments in Attica will be discussed in Chapter Eight.

Elsewhere in Greece finds have been sporadic but plentiful, from cemeteries and sanctuaries: besides Olympia, Delos and Delphi the shrine of Apollo Ptoos should be mentioned, on a high hillside 20 km north of Thebes and the source of nearly 120 fragmentary kouroi, and the great Ionian sanctuary sites at Ephesus and Didyma. But of other cities whose wealth and importance is attested by historians we still lack any significant range of finds (Corinth, Thebes, Sicyon, Argos, Chios), and since our evidence is so partial the attempt to identify local sculptural styles, except through minor arts where they often can be defined, is found to be a highly speculative one.

One phenomenon at least which has a historical context can be detected simply from observation of styles and signatures – the diaspora of east Greek artists from before the middle of the century on. Oppression by Lydia followed by the fall of Sardis (546) and the advance of the Persian empire to the Aegean taught many east Greeks the wisdom of seeking new homes in mainland Greece or farther west. Their influence can be traced where our evidence is fullest, in Athens, and it goes far beyond that dissemination of style which casual itinerant sculptors, commissioned or themselves seeking employment, would have effected.

In this chapter we consider first, generically, the two prime figure types, kouros and kore, then the main regional styles. The architectural sculpture and reliefs are reserved for Chapters Seven and Eight.

Kouroi and realism

In the sixth century the kouros type, with no change of pose and little in proportions, proceeds inexorably towards the more realistic though still

immobile creations of the end of the century. The parts of the body become more accurately rendered. Ears are no longer volute patterns but begin to look like ears. The unnatural twist which put the forearms facing forward though the fists were turned in is properly adjusted. Patterns of muscle and sinew which had been rendered by groove and ridge are carved in subtler realistic planes and the patterns themselves take forms closer to life – a double division between ribcage and navel, not triple or more, and over the knee-caps a proper asymmetry of muscles. All this accompanies a growing skill at integrating these pattern elements into a more plausible whole, as the sculptor frees himself from the technical limitations which had imprinted on the finished statue the strictly frontal/ofile aspects in which it had been conceived, and as, in other works of sculpture (relief) and art (drawing), he begins to face the problems of relating figures to each other in action or in the ambience of a narrative.

Stated in these terms sculptural progress can be measured through growing anatomical knowledge, as it is in Miss Richter's book, and it is easy to fall in with the assumption that the sculptors were deliberately striving after realistic effects. But you cannot consciously strive for a goal you do not recognize. An artist who wanted to carve or draw an ear or eye realistically had only to look across the room at his fellows and copy what he saw: he could hardly have been inhibited by the consideration that such realism was not due for another fifty years! Wholly representational art was neither understood nor sought by Archaic Greek artists, who, sculptor and painter, were observing still the old Geometric formula for composition of parts, observed individually and frontally, and were presenting images and compositions to be 'read', not compared with life. They went far along the path to achieving realism, however, not by design, not by accident, but by a sort of Natural Selection. An artist draws or carves as he has been taught. He will introduce varieties of rendering in the interests of better realizing his concept of, in this case, man, through the patterns and conventional forms he has been taught. Thanks to the example of foreign arts his work already bears something of the stamp of realism – far removed, in detail at least, from the near-abstraction of the Geometric age. Those innovations which more closely approximated to nature were instinctively judged, rather than positively identified, as more effective realizations of the desired end, and with a better command of technique and appreciation of mass the product was bound to be more realistic. But the figures are still no more than effectively communicated symbols for life or live action, read part by part, figure by figure, as a poem is line by line, and another century must pass before the artist realizes that he can produce replicas of man and action, so successful as to deceive the eye into confusing art with nature for the first time in western art.

We observe progress, therefore, only partly in terms of anatomical accuracy. Differentiation of age in the forms of the body is only tentatively expressed and relies generally in differences of dress or pose: this is clearest on the grave stelai.

Expression of emotion too relies on complex conventions of gesture, when it comes to the action figures of architectural sculpture or reliefs. In the faces we look for no more than a grimace of lust, pain or terror. The 'Archaic Smile' may have owed something to the difficulties of carving the transition from mouth to cheek (otherwise managed by a straight vertical cut beside the lips) but it was retained not because the expression was recognized as one of good cheer (inappropriate in much funerary art) but because it made the features look more alive, and it was abandoned once technique and observation combined to render the mouth more acceptable – that is, realistic.

If we understand what it was that the artists were trying to achieve, and that realism was almost the accidental by-product of their progress towards the most effective symbols or images of their men and gods, we shall be more patient of their mistakes along the way, and we shall better appreciate the quality of their achievement, especially when it is measured against the record of sculpture in the near east and Egypt, where the break-through from the conceptual to the observed in art never really happened. There was, of course, no particular reason why it should, and we admire it in Greek art for what it enabled the artists to express and what it taught later ages. The Archaic kouroi, many of them dull enough figures in their own right, teach us how the Greek artist made his way to a representational style, based primarily on the male nude, which dominated the visual arts of the western world for nearly two and a half millennia.

Korai

The break with the Daedalic korai and their foldless dress is so complete as to suggest that the sixth-century kore can be regarded as a new sculptural type. An interest in the pattern of drapery we shall see developed first in east Greece, in Chios then Samos and the Cyclades, and the sculptural styles and new modes of dress introduced to Attica to flourish in the great series of Acropolis korai. This too marks the point at which the dress patterning ceases to be mainly surface or two-dimensional decoration and is expressed in depth, making the dress as such a subject of independent interest to the artist, and at the same time leaving him freer to consider more effective modelling of the body apart from the dress, or, eventually, as it is revealed and accentuated by the dress. The progress can easily be grasped by looking at the different treatment of the lower parts of the figures [87—0–1–0].

The story is a comparatively simple one, in these terms, and the sculptural type is rare in Greece outside the areas named, which is not true of the kouroi. Few korai are demonstrably grave markers, none demonstrably deities, and most can be taken as symbols of unwearying service to the goddesses whose sanctuaries they adorn. Few are now made more than lifesize, and many are only a half or less. They stand with their left foot slightly advanced (early ones

with toes in line, and in east Greece with the right foot forward first) gathering their skirts in a natural gesture which the sculptor exploits to display folds at first, then folds and the outlines of the limbs beneath. They are often holding an offering – fruit, fowl, hare – in the free hand. In the Attic series there is a marked tendency to favour either the double-diagonal effect of slung mantle and withdrawn skirt, or verticality, with symmetrical mantle and the skirt's folds undisturbed, even when clasped, rather than any combination (odd exceptions occur). The foot plinths are generally oval, set in blocks or occasionally stepped bases, and on the Acropolis there is the clearest evidence for korai mounted on columns, from the mid century on, the columns bearing Ionic or related capitals and at the end of the century hemispherical ones. Dedicatory inscriptions appear on the bases or column shafts, and in east Greece often on the dress of the figures themselves.

The development of the sixth-century korai is expressed more in treatment of drapery than of anatomy, so we must try to understand their dress. This is not always easy since its appeal to a sculptor was the pattern of folds it presented, and pattern was more important than the details of dress-making. There are no fitted garments, only rectangles of cloth, skilfully cut, buttoned or pinned, and the commonest of these for korai (rarely for men in sculpture) is the Ionic *chiton*. Here the cloth is stitched into a cylinder, the top partly closed with two sets of buttons leaving room for head and arms, so that the buttons fall along the upper arm, producing a decorative splay of folds from each. A belt at the waist produces baggy sleeves below the buttons and an overfall (*kolpos*) of material pulled over it and generally obscuring it except on many of the earlier east Greek korai. Sculptors show the upper part of the chiton in rippling creases gathered round shoulders and breasts, the lower part in flat sweeping folds, but it is all one garment. On top may be a small *himation* ('mantle' here), a long rectangle fastened with buttons, not across the short sides but towards the ends of a long edge, and then usually worn like a sash, its upper edge rolled, under the left arm and over the right shoulder, so that the buttons overlie the chiton sleeve. Generally it looks as though the sculptor is simply showing the chiton buttons through the mantle, splaying folds and all gradually giving place to the vertical folds of the mantle. Often the distinction in dress is thoroughly confused. Worn thus the longer mantle ends hang from the right arm, with another gathering of folds below the left arm, being caught up at the centre. Occasionally (in the pediment of the Apollo temple at Delphi [142]) we see the mantle buttoned at both shoulders and this, if real, must be a two-piece; or there may be simply a pin or button at one shoulder leaving a short 'sleeve' at that side. A larger mantle may lie over all (*epiblema*), in east Greece sometimes carried over the back of the head and generally covering only the back and flanks and virtually foldless [87], but it can even be worn like a toga, more like a man's himation. The *peplos* is a heavier dress, again a simple rectangle, open or stitched at the side, belted, and folded down from the neckline with a bib-like

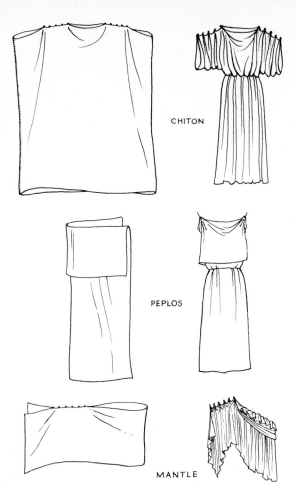

CHITON

PEPLOS

MANTLE

overfall to about the waist, pinned at the shoulders and so sleeveless. A few mid century and earlier korai wear a peplos *over* the chiton, and in the fifth century it will largely replace the chiton, at least as the sculptor's preferred dress for ladies.

East Greek sculpture and sculptors

There is a deceptive dearth of kouroi from east Greece but Samos has yielded a valuable series, including even some from the sanctuary of the goddess Hera. The artists did not share the mainlanders' preoccupation with pattern-anatomy, and the more fluent forms which long remain characteristic of Ionian figures

leave their naked males looking almost self-consciously undressed beside their sinewy cousins from Attica and south Greece. Leukios' dedication is a good example of this [81], followed by others, mainly fragmentary. Several heads, however, have survived, and these display a rather surprising and distinctive spherical form with the hair brushed back in a 'quiff' over the ears [82]. On many of these Ionian heads (mainly south Ionian – Samos, Miletus and down to Dorian Rhodes [83]) the eyes are narrowed, slanting, the eyeball only lightly defined within the lids. Whether the addition of colour would have made the heads more realistic or more other-worldly than mainland kouroi is hard to say. The spherical form is possibly one inspired by eastern sculpture (see below). On more northerly Ionian works the crown of the head is higher, even pointed, but the same hair-style may be seen, as it is on a lifesize kouros from Kyzikos on the Sea of Marmora. This is a head type which was carried into the arts of the western Mediterranean and Etruria, and it is often associated with Phocaea, whose citizens emigrated first to Corsica then Italy (Velia).

If the Ionian artists' interest did not lie in anatomy pattern we would expect to find it occupied with dress. That this was the case is abundantly clear from the kore series, as we shall see – indeed the easterners lead Greece in this. But they even clothe some men, rather unpleasant figures [84] whose pattern of dress resembles that of the seated figures from Didyma [94, 95]. Like them they may be the dedications of dignitaries whom they 'represent', not permanent staff for a sanctuary nor grave markers.

The first intimation of the new dress patterning for korai in east Greece comes with the two large fragments in Chios [85, 86]. The lines are simply incised, radiating from the sleeve buttons in triple wavy lines, crossing decoratively rather than realistically at the back where the belt shows as a recessed rectangle. The next phase is well demonstrated by an important group from Samos which takes us to beyond the mid century. The folds are modelled now, often close-set and contrasted with the broad plain areas of mantle and epiblema to exploit the contrasts of texture. Cheramyes' kore [87] is the prime example, where we have the contrast of plain epiblema, covering the back and tucked in to the belt at the front, striated chiton skirt, and the oblique folds of the mantle countered by short vertical grooves at the lower front edge. Another feature, apparent in varying degrees on other Samian korai, is the cylindrical body, splaying to the plinth where the hem is cut back to show the toes. The form is less likely to be inspired by tree-trunk sculpture than by large wheel-made figures of clay, well known in Ionia, but it is likely that her head was spherical too, like other Samian figures. This combination so closely matches Mesopotamian sculptural types which had persisted into the contemporary neo-Babylonian empire, that it is not easy to escape the conclusion that the sphere-and-cylinder forms were influenced by eastern figures, though thoroughly transformed in Greek hands, the decorative dress attracting interest in its own right while the bodies come to acknowledge the sculptors' success

with the naked figures of kouroi. This orientalizing phase was avoided in Attica where the early korai are hardly more than transvestite kouroi.

The Ionian cylindrical forms are well displayed in the famous ivory priestess from Ephesus [88] and the Samian style is represented at Miletus [89] where we are better supplied with heads showing, rather later, refinement of the old spherical forms [90]; in a figure from Erythrae (opposite Chios); and in rather sleeker versions at Cyrene in Libya where the connection is harder to explain unless it is via the patronage of Sparta which was actively interested in both Samos and Cyrene in these years. We shall turn to comparable works in Athens and the islands in a moment. The remarkable group made by Geneleos [91–93] and dedicated in the Samos Heraion includes typical korai, a seated figure and a reclining one (the dedicator) which expresses the soft, boneless quality of much Ionian sixth-century sculpture, with fluent masses on to which the dress is, as it were, poured like chocolate sauce. Remembering the carving technique involved, and that this is not hand-modelled clay but chiselled marble, we can better appreciate the artist's achievement in creating these sinuous forms.

The reclining figure seems a peculiarly east Greek type, represented by votives elsewhere (Myus and Didyma). The seated figure in the Geneleos group, Phileia, is as rigid as her seventh-century predecessors. A notable series of seated figures, perhaps more than fifty originally, of which fifteen have survived, flanked a processional way to the temple of Apollo at Didyma, near Miletus, independent dedications by local rulers and priests (the Branchidai). Most are of men, rather over lifesize, but there are a few women late in the series, which ranges in date from about 570 to about 530. One of the earliest [94] has its head still, the spherical form familiar from Samos and Miletus. The flat overlapping folds of the himation present linear patterns similar to those of the more supple Samian. Later figures develop the dress pattern in a manner analogous to the Samian and the dedication of the Carian ruler Chares [95] is still a very wooden precursor of a finer Samian statue, the famous Aiakes [96]. This was found in the town of Samos, not the Heraion, and if the Aiakes is father of the tyrant Polykrates it is likely to be earlier than his son's 'reign' (from 532 on). If so it shows that the new (for Ionia) observation of anatomy and distinctive corrugation of folds were already well developed in Samian sculpture in the 530s. Here, at last, the figure is conceived and rendered as a separate mass from the throne, but the pose remains static (contrast [135]).

A comparable development in the rendering of dress on korai at this time is shown by a figure from the Heraion [97] who still reveals her belt in the old manner, but whose mantle and bulgy overfall have the new corrugated folds, while the pose (still with right leg forward, however) and dress declare the new generation of Ionian korai whose influence had already been felt in Attica. The very latest of the Didyma seated figures are of just this period, with others, of women, from the cemetery at Miletus.

We revert now to the islands and Attica. Two korai from the Acropolis [98,

99] display a treatment of dress which is quite un-Attic, but very close indeed to the Samian of the Geneleos period. But one has her head, and this is very different from the Samian, being instead a high oval, rather flat-topped and small-featured. The close similarity of this head to that of the Naxian sphinx at Delphi [100], allowing for the creature's rather earlier date and monster eyes, suggests Naxos as the origin for the two Acropolis korai, and indicates that the island workshops at this time shared views on dress with Ionia, but kept to a distinctive local head type which is far closer to the early Attic.

There is something of this style in heads of kouroi from the Cyclades – one from Thera [101], at least for its profile and outline of features, and later even in the kouros from Melos [102] which has a slim grace quite foreign to the east Greek kouroi with which we began this section. Both Thera and Melos are Dorian islands, not Ionian, but by now race counts for nothing in affinities of style. The medial position of the Cyclades, in matters of style as of geography, finds us describing its kouroi in the section on east Greece, its later korai with Attica (below). The studios of the marble islands, Naxos and Paros, were busy still, but it is not clear whether the 'dry, linear style' attributed by scholars to Naxos, the softer 'Ionian' to Paros, is wholly justified by the evidence. Thus, a kouros head from Naxos combines the old horizontally layered hair with forehead ringlets from which the hair is brushed back almost in a Samian manner.

Finally, another dedication in the Cyclades, Delos this time, brings us back to Chios, where our account of Ionian korai began. Pliny knew of a Chian sculptor called Archermos, who was of a family of sculptors – grandfather Melas, father Mikkiades, sons Boupalos and Athenis. Archermos worked on Delos and Lesbos, he tells us, and another ancient scholar says he was the first to make a Nike (Victory) with wings. The earliest free-standing statue of a winged woman (Nike or Artemis) has been excavated on Delos [103]. She is shown in the Archaic kneeling-running pose and is stylistically datable about 550, which chimes with Pliny's suggested date for Archermos. Near it was found a base with an irregular cutting in its top, which could well have taken the drapery mass hanging below the Nike's legs, and with an inscription naming Archermos, Mikkiades and Melas. The figure *must* go with the base but the tantalizing inscription appears to make Archermos the sculptor, Mikkiades the dedicator (as he is also for a work on Paros) and Melas possibly an ancestor or a founder hero of Chios, a poetic indication of the dedicator's home; and the lettering is of Paros, where no doubt the studio was. Scholars have seen discrepancies between the dates of the base and figure, which are not strictly valid, and have worried that such a sober peplos-wearing figure could be Ionian, or by a hand whose later probable work (or his sons') in Athens seems so different. When the French found the figure's arms after the last war she was revealed as wearing a chiton beneath her peplos, and her peplos was very gaily painted. The head certainly has little in it to match the later Ionian figures, but

the difference in date counts for a lot, and it is clear from other evidence (clay figures) that north Ionia (Chios, Clazomenae, Smyrna) did not share Samos' penchant for the spherical cranium. The Delos figure's head is readily related to island korai of 550–540, or the 'ex-Cnidian' caryatid [209] from Delphi (the forehead wavy hair), and seems an acceptable predecessor to later Chian korai. We may rest confident that she is the Nike of Archermos and it is easy to see how Pliny's source created the artist's sculptural ancestry from a misreading of the inscription. There is a head from the Athens Acropolis (Acr. 659) comparable with the Nike, but the base found there and signed by Archermos is later, and the work of Archermos or his sons will engage us again.

Of other named Ionian sculptors Eudemos and Terpsikles are known from the Didyma statues, but the outstanding figure was Theodoros of Samos, a colleague of Rhoikos in the construction of the Hera temple, and named (Pausanias) with him as the first (*sic*) to cast bronze statues. Diodorus makes him a son of Rhoikos and, with his brother Telekles, the exponent of the Egyptian method in measuring statues (see p. 20). His reputation was in bronze work and this brings home to us just how little we can know of the best sculpture of the period; nor can we tell what of the marble statuary on Samos might be his work or of his studio. The family names are confused but the jeweller and gem-engraver Theodoros who worked for Polykrates is likely to be the same artist.

Attic sculpture and sculptors

This is a particularly rich period for kouroi from Attic cemeteries. The pattern forms of the bodies are no less emphatic for their more skilful modelling. The earlier figures have rather distinctively high, shallow heads in profile view. The hair seems brushed back from the forehead in flame-like locks over the fillet on the Volomandra kouros [104; cf. 105], a style matched in contemporary vase painting, but on the Munich kouros [106] these locks seem part of the fillet's decoration since the spiral forehead curls are also shown. Later the heads are deeper, and on [106] the spirals spread unusually over the crown and the hair is cut short behind. But this figure's stomach has still the unnatural triple division and its back is patterned in grooves in the old manner, while others wear their hair still at shoulder length. The features of the new kouros from Merenda [108a] are exceptional for the impression of youthfulness which the artist has conveyed through the small eyes and lips set in the softly modelled face. The body of this remarkable statue seems also more deliberately adolescent than the generalized young-maturity of most kouroi. The marker for the grave of Kroisos [107] is another exceptional statue, the body more robustly modelled, the face with traits which we shall recognize as most distinctively Attic on attributed works yet to be described.

The korai of Attica in this period are better represented in the cemeteries than on the Acropolis. First come chiton figures with foldless dress: one recent find,

from A. Ioannis Rentis, still has wig-like hair and palm flat against her side – a throwback to the seventh century in pose. After these the Berlin kore [108] is generally recognized now as a grave marker, and Phrasikleia, recently found at Merenda, certainly is. They have much in common – jewellery, the elaborate crown and sandals, feet together, simple vertical lines of dress though the former has an over-garment whose close folds are contradicted by the overlapping at the front edges. The Berlin kore's oval head and heavy features, hands and feet look back to earlier Attic kouroi, but she belongs to the 560s. Her counterpart on the Acropolis is [109]. Phrasikleia [108a] has the slimmer features and body of kouroi nearer the mid century, like the Volomandra [104]. She makes no concession to the bulgy overfalls and fold patterns of Ionian korai, though the new swinging folds are understood in her hem line. (We await definitive publication of her and the kouros found buried in a pit [108a] with her, but her base has been known since 1729: 'Marker of Phrasikleia. I shall ever be called maiden (kore), the gods alloting me this title in place of marriage: [Aris]tion of Paros made me'.)

σῆμα Φρασικλειας· ⟨ΕΜΑΦΡΑ⟨ΙΚΛΕΙΑ⟨

κορē κεκλēσομαι ΚΟΡΕΚ ΕΚΛΕ⟨ΟΜΑΙ

αιει, αντι γομο ΑΙΕΙΑΜΤΙΛΑΜΟ

παρα Ϙεōν τουτο ΓΑΡΑΘΕΟΜΤΟΥΤΟ

λαχοσ' ονομα. ⱴΑΧΟ⟨ΟΜΟΜΑ

The Lyons kore [110] from the Acropolis is little earlier than Phrasikleia. She wears a crown too, which shows that this is an indicator of date and place, rather than function. But the new dress style is Ionian, with a pure pattern of folds allowed to develop along her left flank and over her bottom, and the grasp of the skirt allowed to display the shape of her legs, while on Phrasikleia it remains a conventional gesture contributing to a display neither of folds nor anatomy. But the dress of the Lyons kore clings to the body still and has no real mass of its own. Her fleshiness is Attic strength rather than Ionian sensuousness, and her honest sonsy face is pure Athenian (cf. [108], and the Rampin Master, below).

The sculptors are quicker to adopt new dress and posture for the Acropolis korai than for the grave figures but there is a lingering sobriety seen, for example, in the Peplos kore [115] or [111] which is at or after about 530, and which abjures the cross-slung mantle and splay-folded skirt for a vertical accent, achieved by hanging the mantle symmetrically, like [118].

We have remarked one or two stylistic attributions to single sculptors and shall turn shortly to some whose names and works are known, or whose unsigned works can be assembled. Study of the signatures and names themselves is revealing. A sculptor is not necessarily his own scribe and we can

identify single scribes cutting dedications or signatures for several sculptors, possibly in one studio. We have about seventeen Archaic sculptors' names from the Acropolis (in some twenty-five signatures), seven from the Attic cemeteries (in some fifteen signatures), yet only Endoios and Philergos appear in both groups, the latter as collaborator of Endoios both on the Acropolis and on a grave kouros base. At least a third of the named Acropolis sculptors are known to be or strongly suspected of being non-Athenian (e.g., Gorgias of Sparta, Kallon and Onatas of Aegina, Euenor of Ephesus, Bion of Miletus, the Chians); of the cemetery sculptors only Aristion declares himself a Parian. It seems that more 'guest artists' were employed for dedications, and that the student of Attic style might then do well to start with the cemeteries not the Acropolis. Several names are decidedly non-Athenian, several are apparently sobriquets rather than given names – Philergos = 'energetic'; Eleutheros = 'free(d)'; Phaidimos = 'brilliant', etc. – a phenomenon we observe also with the vase painters (*ARFH* 9f.) and which is explained by the strong non-citizen (metic) and non-Athenian element in Athens' artists quarter.

Phaidimos

We have three signatures of Phaidimos: on a stele base for the grave of Chairedemos, to which part of a spearman relief has been doubtfully attributed; on a kore base for the grave of Phile (name or adjective 'dear'?); and on a stele base for the grave of Archias and his sister. On the last two his work is described as 'beautiful' (*kalon*) and on the last the sculptor himself as 'skilful' (*sophos*) – he had no problems of self-confidence, and his assumed name means 'brilliant'. (The sort of man to make his way to the front of any queue? – cf. *ABFH* fig. 46.4.) The bases date from about 560 to 540. 'Phile's' feet are little enough on which to base attributions, but her distinctive square toenails have led scholars on the one hand to the gorgon stele [*231*] and an Acropolis kore (Acr. 582); on the other to the Calf-bearer [*112*]. The latter is the more plausible attribution and the scribe of its dedication served also for two of Phaidimos' bases. This would then be one of his earliest works (560s). The hair and heavy arms recall the earlier Attic kouroi; the dress has no mass but its hem limits a colour area on the naked body; the features depend still on linear effects. The calf's tender, indeed succulent body and its head, brought forward into the plane of the man's head, and providing a brilliant pattern contrast with it, validate the claim in the artist's name.

The Sabouroff head [*113*] has also been associated with the Calf-bearer, but any plausible link with Phaidimos himself must be too tenuous to take seriously. It is a strikingly individual characterization, yet no portrait. The rough-picked hair, moustache and beard, with its original colour, provided a texture contrast with the smooth flesh areas, a technique repeated on a few later works (as [*145*]) and one entailing, though not necessarily dictated by, some economy in

carving. It has been thought to be preparation for additions in plaster, which is improbable here and on some other figures impossible.

The Rampin Master

Payne saw that the Rampin head in the Louvre joins the body of an Acropolis horseman [114]. The lace-like carving of hair and beard, the delicacy of the features makes this one of the most memorable and individual of Archaic heads. The face and profile led scholars to attribute to the same hand the famous Peplos kore [115] despite the probability that she is some fifteen years later. The simplicity of her over-garment contrasts with her rich hair and the painting of her dress, just as the plain block-like modelling of the horseman's torso does with his hair and the mane of his mount. One could hardly imagine a more Athenian pair, with that subtlety in contrast of planes around the eyes and mouth which were the hallmark of yet earlier Athenian sculpture. The hint of the kore's girlish body beneath the heavy cloth, her soft arms, head gently inclined towards the side where she holds her offering, these have all to be enjoyed before the statue itself rather than in the most skilful photograph. Another kore head was attributed to the artist by Payne [116]. Its features are most like the horseman's and it may be a little earlier. The famous fragment of a grave stele with a boy shouldering a discus [117] goes with them (notice the profile, ear lobes). Much of the artist's work seems of the mid century or just before, and its Atticness is further demonstrated by similarities even to works like the Berlin kore [108]. But the Peplos kore is later, of the 530s, and the master's influence can be seen in a contemporary kore, no less distinctive in features and dress [118]. The master's real name surely lurks among those we read on bases which lack their stelai or statues, and which so deny us the chance to identify their handiwork elsewhere. He deserves a better fate since he had no equal in mid-century Athens.

Aristion of Paros

Phaidimos shared the services of a scribe for his bases with the sculptor Aristion of Paros and with Aristokles, each known from only one extant signature, the latter's being later in the century [235]. The association could be that of a studio, but might be slighter if such scribes were freelance. Aristion worked in the third quarter of the century and since he signs himself 'Parian' he may have learned his craft on the marble island and plied it in Athens. He signed a base for a column monument, perhaps two others for kouroi, and the famous kore Phrasikleia from Merenda [108a]. Whatever his training or origin his style is purely Attic and the kore has much in common with the Berlin kore in stance and dress, and with the Volomandra kouros in features. The elaboration of jewellery and painted dress pattern is the more effective for the foldless

simplicity of the dress and the adolescent body of the girl whom, as her epitaph tells, death took before a husband. To modern eyes she is perhaps the most beautiful of the korai.

Other areas

At the Ptoon sanctuary in Boeotia the rather inorganic local style, executed in local marble, flourished still [119] but there is strong island influence too and intermittent arrivals from Attica, including dedications by rival factions: by a son of Alkmaion and later by a son of Peisistratos (the bases only preserved). We may recall the work of Attic vase painters emigrant to Boeotia (ABFH 183).

In the Peloponnese there are two important regions yielding sculpture of this period, the north-east and Laconia. Corinth is so far best known for its minor arts in clay [120] and bronze, though there are some good stone animals (see Chapter Nine) and the sculpture of Corfu [187] is Corinthian in style. The elegant kouros from Tenea [121] near by is by the first Archaic sculptor to succeed in creating a lifelike figure within the conventions and patterns of the kouros pose. The understated anatomy, and balance of strength and slimness in this small (five-foot) youth makes it one of the finest of the century.

Nearby Sicyon has, on paper, a more distinguished record. Kleisthenes' tyranny had made the city wealthy and influential. She dedicated treasuries at Olympia and Delphi and we have the sculptures from the latter [208]. The Cretan sculptors Dipoinos and Skyllis, 'pupils of Daedalus', worked there in the second quarter of the century, withdrew because of some alleged injustice and returned only after the city had been plagued, and advised by Delphi to bring them back to complete their work – a group which may have shown the struggle between Herakles and Apollo for the tripod, a story which was used to symbolize the First Sacred War at Delphi in which Sicyon was prominent.

Spartan studios seem to have been singularly active in these years, to judge from text references to artists, and especially in bronze work which we can best admire in cast attachments to vases and mirrors, and in statuettes. A large hollow-cast head gives an idea of the quality of larger works [122]. In stone the surviving work is distinctly cruder, with the primitive and puzzling pyramidal base and its two-figure groups [123], and some other series of reliefs [253–4]. There are also, however, scraps of marble relief sculpture which seem Ionian in style or subject, as [124], and we know that the Ionian sculptor Bathykles of Magnesia designed the sculptural setting for the cult image of Apollo at Amyklai, near Sparta. The Spartan sculptor Gitiadas made a bronze Athena for her temple (Athena Chalkioikos – 'of the brazen temple'), its dress also apparently covered with bronze plates carrying panels with myth scenes. Pausanias describes the figure and we may get an idea of it from coins [125].

Coins also tell us something of a cult statue elsewhere in Greece, the Apollo made by Tektaios and Angelion, pupils of Dipoinos and Skyllis, for Delos [126].

It looks like a long-haired kouros flanked by sphinxes (rather than griffins), and we can detect the three Graces and the bow which ancient authors saw in its hands. Later inscriptions suggest it may have been gilt.

By this time there is increasing use made of precious metals in statuary. We learn this mainly from texts, and even in the seventh century the Corinthian tyrant had dedicated a Zeus of beaten gold, 'of good size', at Olympia. But from mid-century Delphi, with debris from a destroyed treasury excavated beneath the Sacred Way, we have pieces of two-thirds life size gold and ivory statues – the flesh parts ivory, gold plates on the dress – of the most refined workmanship, probably Ionian in origin [*127*], which presage yet more ambitious works in these materials in the following century. From the same find has recently been composed a lifesize silver bull!

Proportions and techniques

Pattern and proportion were of prime importance even in the most fully representational styles of later Greek art. In the Archaic period it is especially the kouros figures that might demonstrate the application of principles of proportion and measurement, as they do the progress in realistic representation of anatomy. The possible debt to the Egyptian grid system of twenty-one units for figure height has already been mentioned. The Greeks came to prefer a statement of proportions in terms of their measuring system, itself appropriately and naturally based on the human body, with a basic unit of a foot. But in the Archaic period Greek mensuration was extremely imprecise. A coherent system could be used for one building or perhaps in one studio but there were as yet no national or city standards. The deduction of a 'long foot' of 32·65 cm and a 'short foot' of 29·4 cm, or of regional variations, over-simplifies the issue, and these rather indicate the range of measures in use, a range properly matched by the variations in the convenient human extremity on which the unit is based. Greater (cubit, fathom) and lesser (palm, finger) units were readily related to the foot, as they were in a far more systematic way in Egypt and the near east. Metrological analysis of kouroi has been hampered by great expectations, while arguments based on careful measurement of minor details projected from the round into two dimensions, never quite persuade. The artist no doubt laid out the figure on the surface of the uncut block, but hardly in great detail, and approaching the final worked surface any such guide had long disappeared and even a guiding sketch would be ignored in favour of the artist's own response to his material and the realization in it of his concept of the finished figure. From unfinished statues it seems clear that he worked in systematically from all sides of the block, and that in the final stages it was a matter of reducing from a larger, roughly detailed mass, rather than exact predetermination of details by measure. Egyptians seem to have worked mainly from one side at a time, re-drawing their guide lines as the work progressed. At

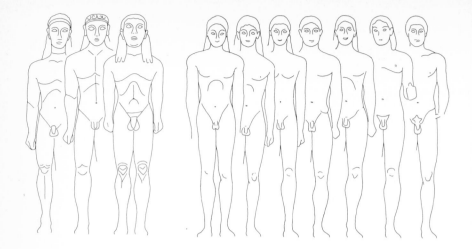

any rate, once the larger figures had been roughed out in the quarries it was perhaps too late for detailed grids and the precisely mathematical placing of parts. So we can only glimpse the principles of measure and proportion which lay behind any statue.

A plot of the relative heights of complete or safely completable kouroi, and of the approximate proportions of head to body produces a fairly simple and intelligible plan of development. It shows that the variety in their heights did not depend on the observable variety in life, or provision for the superhuman for monumental or heroizing effect. Apart from the truly colossal all the complete kouroi are six-, five- or seven-footers, in the vague terms of the Greek foot which I have already explained. On a frontal human body the neatest expression of any basic module is not the length of foot but height of head. An 'ideal' man is and was six feet tall. The earliest complete kouros is a six-footer with a big one-foot head [63]. But in life a man's head is nearer one-seventh of his height, and as the artist's experiments led him closer to the creation of man-symbols realistic in proportions as in details, two solutions were presented: to put the one-foot head in a seven-foot body [102, 106]; or to abandon the foot-head for the 1:7 proportion in a six-footer, and it is this solution which naturally won the day for the majority of figures ([104, 107, 145, 150] and Merenda). Reduce the complete kouroi (five- to seven-footers) to one height and the rapidly achieved standardization of proportions after the early and the outsize is clearly apparent (see drawing).

Outsize kouroi have eccentric head:body proportions – 1:8 for Thasos [69] (12 feet), 1:6·5 for Sounion [64] and 1:9 for Samos/Istanbul [82, head] (both 10 feet).

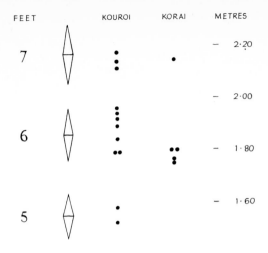

FEET	KOUROI	KORAI	METRES

Kleobis and Biton [70] are seven-footers with residual outsize heads (1:6·5) if this is not rather a result of seeking a deliberate visual impression of strength in the upper body. The five-foot Tenea kouros [121] and the five-and-a-half-foot Calf-bearer have 'normal' heads.

Plausible identification of other significant measurements and proportions is possible, provided that obsession with meaningless or minor measurements is suppressed (there are similar pitfalls in the study of vase shapes). Thus, it seems that in the Aristodikos [145] the head height (0·28) was used as a module for the rest of the body, and there were other basic proportions to observe such as the crotch at half-height. Gradually the ruler is abandoned in favour of more realistic systems of proportion between parts of the body, systems which were to occupy classical sculptors and become subjects for treatises.

Progress in rendering of anatomy and observation of proportions may have gone at a different rate in different cities and studios, but the freedom with which artists travelled, the display of works in the national sanctuaries, and the concentration of expertise in the few sources of marble, mainly the island quarries where the figures were blocked out, probably helped ensure an overall unity of pace; and if they did not, we do not have precise enough dating evidence for individual statues to prove it.

The progress we have considered was accompanied by progress in technique. Woodworking techniques had given place to the use of the point, flat chisel, drill and abrasives for the early marble figures. A heavier broad chisel, the drove, could be used for flat areas. In the second quarter of the century the Greeks invented the claw chisel, usually five-toothed and about 1·5 cm wide,

79

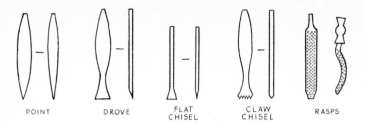

POINT DROVE FLAT CHISEL CLAW CHISEL RASPS

but smaller are known. This could be used at varying angles and its effect was almost to plane away the marble; and held vertically it made a sharp re-entrant edge. The rasp could be used more freely to smooth away the rougher tool marks, and the drill was called on more and more for subtler details of hair and dress or undercutting. The sculptors generally took pains to remove all traces of tool work but it is often apparent in the less accessible or ordinarily invisible parts of many figures.

There was no compunction, as was felt in later periods of western art, to complete a figure from a single block. The seated Daedalic figures were often two-piece, and in the sixth century the projecting arms of korai or even minor parts of limbs, could be made separately and dowelled into place, or even glued (the beard tip of [235]). Nor was there any absolute avoidance of supports or struts, to safeguard arms held away from the body [145] or as pillars below the bellies of horses.

The coarser or shelly limestones were coated with stucco, on which the paint often survives better than on marble, but it is unlikely that parts modelled in stucco were added to marble figures (e.g., hair; see on [113]) though this has been suspected. Materials might be mixed and the Lindos temple chronicle refers to an early fifth-century wooden Gorgon with a marble face. The most lavish technique was the chryselephantine, practised already in the Archaic period [127]. Spears, swords, even helmets might be added in metal and this was the rule for most jewellery and attachments to diadems, while on reliefs, such as that on the Siphnian Treasury at Delphi [212] whole wheels might be made separately and parts receding on to the background were only painted [130], though this is an exceptional technique. Inlaid eyes were made of bone, crystal or glass. On the heads of free-standing statues, especially korai, discs on metal spikes (meniskoi – 'little moons') were fitted to protect the features from being soiled by birds: cf. [129].

The use of colour on Archaic statuary was more general than casual acquaintance with surviving pieces might lead us to believe, more general than we might wish to credit, but the traces left on statues buried soon after completion (as on the Acropolis), the figures of fired clay, and early Archaic vase painting leave us in no doubt. Most clothing was painted though on the

later korai we see more often patterns alone added on the pale marble. Male flesh was probably painted red or brown for the earlier figures, including kouroi, and is seen still on the Ephesus column reliefs [217] and the Acropolis scribes [164]. Female flesh was probably whitened and on the later males there was no doubt still some tinting. All this apart from the obvious painting of hair, eyebrows, eyes, lips, nipples, pubic hair. Relief backgrounds were usually dark blue or red. The colours may not have been intense, and in brilliant sunlight would have been muted, but it is hard to say how easily we could have judged subtleties of carving, let alone texture of finish, on the original fully painted works. Modern restoration with colour never quite convinces and it is probably safer to restore in black and white and let the modern eye, used to this convention in photography, make its own adjustment. The results of both methods, and modern paintings, are offered here [128–33].

Turning to metalwork, we found the early bronzes cast solid, the originals being probably of wax, coated with a clay mantle to serve as mould. Early in the seventh century the model may be given a core of other material which can be worked out of the final cast, lightening it and saving bronze. The ultimate refinement is to make the core nearly the size of the desired figure, coat it with wax with finished detail to the required thickness of the bronze, then make the clay mantle, fixing it to the core with rods, melting out the wax, pouring in the bronze. This is the technique, still experimental, of the Piraeus kouros [150] which yet encloses the iron skeleton on which the model was built. Its wrists and hands are solid and there is less use of inlay (as for the eyes, a practice well known in marble) than for most later, large bronzes on which a redder copper might be used for lips and nipples. Later too this *cire-perdue* technique was refined with the use of piece moulds.

The use of hammered-sheet bronze, as in the Dreros figures [16] and some other early orientalizing works [20], was later confined mainly to vessels, the figure attachments to which are cast separately, or to decorative relief plaques, but there are some examples of large figures in this technique at Olympia – a near-lifesize bust of a winged goddess [134] – and we may recall Gitiadas' Athena or the comparable treatment of gold sheet on the chryselephantine figures.

THE LATER ARCHAIC STYLES
to about 480 BC

Attic sculpture and sculptors

This is a period of stress and change in Athens: harsh tyranny after the death of Peisistratos in 527 until his family was finally expelled in 510, then the construction of a new 'democracy', its success at Marathon in 490, closing with the sack of the city by the Persians in 480. It is tempting to associate sculptors with rival factions (see below) or the overthrow of gravestones and buildings with reverses of political fortunes. This is fair speculation but difficult to carry to proof, and the general dearth of public and private monuments after about 500 is not easy to explain on grounds of politics and only partly explicable in terms of assumed sumptuary legislation. We start with two names, then return to the basic sculptural types.

Endoios

Endoios, another of the alleged pupils of Daedalus, was almost certainly an Athenian. Pausanias says he made seated Athenas for Athens and Erythrae (in Ionia; of wood) and another for Tegea (of ivory); and Pliny, the statue of Artemis at Ephesus (wood or ivory). The Athena is recognized by many in an Acropolis marble [135], so battered that we might well believe that it survived the Persians and was seen by Pausanias (though it is possible that its state is due to re-use as building material in late antiquity). The contrast with the earlier seated figures of Ionia [94–96] is dramatic. Her arms are sharply bent, one leg drawn back, ready to rise from her stool with a realistic air of imminent motion, shared to some degree by the slightly earlier Dionysos [162]. A column shaft from the Acropolis bears a joint signature of Endoios and Philergos, and appears to have carried a kore [136] who holds her dress as does [153]. Another Acropolis dedication, a relief showing a potter holding two cups, may well bear his signature too [137]. The face is sadly damaged but the cap-like treatment of the hair shows that this is appreciably later than the Athena and the kore. The head is enough like those on the famous ball-player base [138] for scholars to attribute this to Endoios too. The base was probably for a grave kouros, and was found near the Piraeus Gate in Athens where another base signed by Endoios was recovered. This carried a lost kouros for Nelonides and the base also bears traces

of a painted seated figure. From the same area come pieces of a large kouros to which scholars ascribe the famous 'Rayet head' in Copenhagen [139].The kouros might have stood on an Endoios base, or one signed by Philergos (Endoios' collaborator in the kore) which was also found close by and was made for the Samian Leanax. The general correspondence of the Rayet head with the ball-player basis and potter relief (note, for example, the hair and thick ears) suggests that it is from Endoios' studio if not hand. It is one of the earliest heads to display the trim hair-style of the latest kouroi, here cut in crescent locks, not the combed zigzag coiffure of the potter. The delicately striated hair and Rayet-like features of an exquisite small bronze youth from the Acropolis [140] show that this too belongs stylistically with works executed or influenced by Endoios. Finally, we have the master's signature on a base for a stele commemorating Lampito, who died far from home (presumably Ionia).

The sum of these works helps define a style which is with less certainty traced in architectural sculpture – the marble pediment from the Acropolis [199], and the work of the artist of the north and east friezes of the Siphnian treasury [212.1, 2], the garbled artist's signature on which is now read as Attic. That Endoios helped execute or plan at least the former of these is by no means unlikely.

Antenor

Antenor was remembered in antiquity for executing in bronze the group of Harmodios and Aristogeiton, the tyrant-slayers. The death of the tyrant Hipparchos was in 514, the group erected some time after the tyrant family was expelled in 510, but it was taken to Persia by Xerxes, replaced by one made by Kritios and Nesiotes after the Persian Wars, and returned only after Alexander's conquest of Persia. The surviving fragments of base were probably cut for the replacement and are not from the old base, re-used, which would make Antenor's group very late indeed. Its significance lies in the fact that it is an early example of a civic commemorative group for a very recent event and that it positively identified the two men, though not, of course, in portraits. Antenor's signature appears on an Acropolis base to which the over-lifesize kore [141] almost certainly belongs. This is virtually the last of the truly monumental Attic korai, a seven-footer like many kouroi, wearing her Ionian dress with a near-masculine swagger which contrasts vividly with her contemporary [151]. It is quite the same treatment of body and dress that we see in the female figures of the marble pediment in the temple of Apollo at Delphi [142], which Antenor may have designed. The Webb head in London [143] resembles the kore head: the head is a Roman copy and has been thought a replica of his Harmodios.

Antenor's work on the Delphi pediment, paid for by the exiled Alkmaionids, and then on the tyrant-slayers, seems to indicate some rapport with anti-tyrant patrons. Endoios, on the other hand, is busy in Peisistratid Athens and in Ionia,

where the tyrants had close friends, and for Ionians in Athens, perhaps especially Samians. But there is no call to look for more politics than this in the careers of Archaic sculptors, who had far less opportunity and range for free comment about the contemporary scene or even myth than did the vase painters. We shall meet other sculptors' names in a later chapter. Other, anonymous, works must provide the fuller picture of progress in the art in Attica of these years.

Several wholly or nearly complete kouroi well demonstrate the range and quality in the last phase of the type. The Keos figure (from the island off Attica) is old-fashioned still in hair and anatomy but already shows the new confidence in handling the body masses [144]. Aristodikos [145] is near perfect. In balance of limbs and detail of modelling of the figure the artist shows fuller understanding of the structure of the body, but he has yet to learn how it moves, and how the movement of one limb may affect the balance and pose of the whole. It remains almost embarrassingly inert. It is at this point that we might reflect how further progress became possible. Aristodikos is a carefully planned and measured figure, the head height apparently serving as a module for other parts of the body. Sculptors who plan their works thus are also draughtsmen, and it is in the drawing – on vases – of years even earlier than Aristodikos, that we see in Athens that artists, and not necessarily other artists, are experimenting with the expression in two dimensions not only of free action poses but of the balance and stance of individual figures, and we meet deliberate study of accurate anatomical detail. Already they are observing what will inevitably take longer to render plausibly in three dimensions (cf. *ARFH* figs 22–53 *passim*, the Pioneers). Intimations in statuary that this relaxation of frontality was due are slight asymmetries in figures, inclined heads like that of the Rampin horseman [114], and early attempts to correct foreshortening of features.

We see the triumphant expression of the Attic sculptor's solution in a statue of some twenty years later than Aristodikos, the 'Kritian boy' from the Acropolis [147]. He is not so much the last of the kouroi as precursor of the Classical athlete statues. We cannot be quite certain that he was standing when the Persians sacked Athens, and the way the break at the neck is chipped has suggested to some that the head is a replacement, but the probability is that he was made little before 480. The contrast with Aristodikos is striking, yet the change was inevitable, given the success the sculptors of the kouros series had achieved in re-phrasing the theme ever close to life. Not only is the proportion and surface treatment correct, but so is the underlying form and comprehension of the architecture of limb and muscle. From now on a statue can bid not merely to symbolize or stand as substitute for man but to imitate him. The decisive physical changes are slight, but enough to break the rigid vertical axis on which all earlier free-standing statuary had been based. The right knee is flexed with the weight of the body mainly on the left leg; as a result the right hip is lowered, the buttock relaxed; the shoulder slackens to this side too and the head inclines

84

gently in the same direction: like a sigh of relief for the history of western art. The 'Blond boy' from the Acropolis [148] carries his head even more emphatically tilted and the fragment of his loins displays the tough, muscled patterning of late Archaic art with the new pose, left leg and buttock taut. The pose is similar but the Kritian boy is barely adolescent (like his immediate predecessor [146]), the Blond boy near manhood, and his head and the treatment of hair and plait are even closer to the Classical and the sculptures of Olympia. The head has much in common with that of Euthydikos' kore [160] which is somewhat earlier, and could be by the same artist whom some have thought Peloponnesian by training. This could well be true, given the eclectic character of the Acropolis display. This characterization of different ages in head and body is not entirely new in Archaic art but it is another feature in which the Olympia Master will excel.

For the last of the kouroi from Attica two singletons, the first a kouros translated to a worshipper holding an offering [149]. The almost tailored pleating of his cloak, the emphatic muscles and trim pubic moustache all show how much pure Archaic pattern still meant. And secondly a puzzling bronze. The Piraeus Apollo [150] is lifesize, our first complete example in a technique which we know had been practised already for some years in Greece. The kouros type is adapted here for a cult image as it had been on Delos [126]. The style sits uneasily with the Attic series, and the circumstances of its discovery do not demand Attic origin – with some other pieces in the find it may be from Delos. That scholars have thought it archaizing, or a copy of an earlier Archaic marble, is some indication of the problems it poses and of our continuing ignorance of high quality work in the more precious material.

The record of korai in Attica is far richer, thanks to the Acropolis finds and several fine examples from Eleusis. [151] is generally regarded as one of the most strongly ionicizing although the rather pointed skull is not so much north Ionian (Acropolis examples are discussed in the next section) as a version of the Attic high oval – she might be a daughter of the Volomandra kouros [104] with similar pinched cheeks. The hair is particularly elaborate, folded waves across the crown, scaly at the back, twisted at the front, the forehead with the now familiar flames and ringlets. Observe the varied treatment of the linear wave patterns on dress, differing on each shoulder and on the breast. Moreover, the complexity of the painted decoration on the dress is unrivalled on Acropolis korai. Where the cloth clings the body is positively sensuous. Our korai have hitherto been female, as [108], or at the best ladies, as [115]; this is a real woman. Her dress is disposed in the new conventional manner. The artist of [152] and [153] (surely the same hand) is more enterprising. One is contrary in combining symmetrical mantle with the withdrawn skirt; the other discards mantle and preserves the vertical line by holding her skirt forward, not to the side, despite a certain illogicality in the fall of the skirt from her hand over the unruffled overfall. The facial similarity of these two korai to a kouros [180] and a kore

85

head from the Ptoon suggests that the artist worked also in Boeotia, might even have been Boeotian.

We have seen already how the hair may be gathered in a sweep before the ears, on [*111*] and on the beautiful [*154*] where the ruff of locks spreads like a flower over her cheeks. [*155*], a colourful but dully modelled piece, carries this style further, and on later korai [*158–160*] the hair is brought across the forehead in one mass to dip over each temple. [*156*], an undervalued figure, wears a full himation like a man.

By the end of the century the features, in detail and expression, have become far more natural [*157*] and the decline of the Archaic smile can give place in the fifth century to an expression which can appear calm [*158*], dull or even sulky [*160*]. The last earned the sobriquet 'la Boudeuse', but we are not to impose our recognition of nuances of expression on Archaic Greek art as readily as we try to on, for example, the Mona Lisa. She is Euthydikos' kore, for we have the dedicator's name on the column capital which carried her. She is petite, hardly more than a metre tall – we are far from the eastern colossi of a century before. The body is carefully observed and feminine – narrow rounded shoulders, soft breast, slim legs and feet, and in full colour any air of sobriety would surely have been dispelled – her chiton shoulder was painted (as if embroidered) with racing chariots.

Finally, [*161*]: the absence of immediately post-Persian offerings on the Acropolis rather than its find place show that this was made no later than 480. Hair, features and type of dress are all familiar, but the rendering of the broad soft folds is already early Classical. Her contemporary, the Kritian boy [*147*], heralded what was to follow in his pose and anatomy – features which had kept the kouros type a live interest for sculptors for a century and a half: in korai their interest lay in dress and its pattern, and it is in this kore's dress that the future is as surely prefigured.

The other major figure type of Archaic sculpture is seated, and we have already seen its development in east Greece [*94–96*] as well as Endoios' Athena [*135*]. The type served in Attica as a grave monument from at least the 560s but it is a moot point whether some examples might represent Dionysos. A figure from his sanctuary at Ikaria must surely be the god but a fine statue from Athens [*162*], seated on a panther skin, which could well be a Dionysos, is from a cemetery area. Seated women may also have been set over graves but the example from Rhamnus [*163*] is presumably votive. A special class is the Acropolis 'scribes', which are Egyptian in subject rather than style or pose [*164*].

Riders too could serve as grave monuments, but are more familiar as votives, like the Rampin figure [*114*]. Its successors on the Acropolis include other naked horsemen [*165, 166*] and one wearing archer's dress. There are other Nikai on the Acropolis too, including a Chian (see below). The most interesting, atop an Ionic column, was dedicated for Kallimachos, the general at Marathon, apparently for a victory in games before the battle in which he died, but

completed after it and commemorating both successes [167].

Unusual and puzzling dedications on the Acropolis are represented by scraps of what seem to be narrative groups in the round which include the heroes Ajax and Achilles playing dice before Athena (cf. *ABFH* figs 100, 227) and Theseus fighting a brigand [168]. There is also an Eros.

More specialized religious sculpture from Athens and Attica is represented by herms and masks. The former are pillars topped by the god Hermes' head and with erect genitals on the shaft. We know that many were dedicated in Athens' streets by Hipparchos, son of Peisistratos, and there are Archaic examples from Athens, even on the Acropolis, but I show the best surviving one of this period, from the island of Siphnos [169]. The 'masks' are of Dionysos [170] and recall the pillars with masks of the god being worshipped on Athenian vases (cf. *ABFH* fig. 178 and the later *ARFH* fig. 311). One from Marathon [171], which appears to have worn horns, has been thought to represent Pan, the rustic deity who was believed to have helped the Athenians at the battle and was subsequently worshipped by them, but other Athenian Pans of these years have goat features while this is Olympian.

Our last Athenian sculptures are Athenas from her Acropolis. Fragments of what seem an Athena [172] ('the foot is unsurpassed in all archaic sculpture' – Payne) are associated with a column bearing the signature of Pythis, who must be an Ionian. Another [173], the work of Euenor, was also set on a column. In common with other statues we have mentioned doubt must linger whether this is in fact a work of before 480 or a rare survivor from the years immediately following – rare because so little by way of private dedication is likely to have survived many centuries to be seen by Pausanias. The Athena is probably earlier than 480 and it shows the new, early Classical stance with relaxed right leg, and the new preference in dress – the heavy broad folds of the peplos, its overfall belted-in in the Attic manner. With the Blond boy and the Kritian she looks forward across rather empty years for major statuary in Athens, to the great new era of the Periclean rebuilding and the refurnishing of the Acropolis with temples and statues worthy of her.

East Greek sculpture and sculptors

An east Greek world bedevilled by Persians does not seem a promising ground for the development of further sculptural achievements, and our evidence is in fact more sparse, but the major sanctuaries still attract offerings and give employment, especially for architectural sculpture, and the studios trained artists whose services were in demand elsewhere, east and west.

The peculiarly east Greek dressed male type continues, with a fine example now in Paris, a statuette offered by Dionysermos [174]. The rotundity of the head is belied somewhat in profile, where we see a more pointed crown, and the figure steps out more realistically than his predecessors. For a naked figure, and

87

late in the series, a tubby kouros from Samos [175] presents the rather loose definition of parts apparent in earlier Ionian anatomical studies yet is on the way to the Kritian boy and the right leg seems slack rather than simply advanced. By contrast, but admittedly earlier, the superb warrior from Samos [176], with elegantly patterned armour and flowing locks, expresses an Ionian sense of pattern on softly rounded surfaces in a subject better served by the more formal and vigorous styles of mainland Greek schools.

For korai we must return to Athens, to Archermos of Chios whom we have met already [103], and his family. A column from the Acropolis carries his signature and a dedication by Iphidike; another has the signature of an unnamed Chian. Scale and material suggest that the columns could have borne two figures, apparently by one artist, a kore [177] and a Nike. The quarter century between these and the Delos Nike [103] make close stylistic comparison difficult, but in terms of contemporary statuary the Athens figures carry all the pattern characteristics of Ionian work, and the rather pointed crown to the head seems a north Ionian, so Chian, feature, to judge from terracottas, and was current, or at least influential even farther north [178]. The sons of Archermos, Boupalos and Athenis, are dated by Pliny to the early 530s and we might have expected their names associated with the Acropolis figures rather than their father's. They were said to have worked at home, in Delos, Lesbos, Iasos and Smyrna (a Tyche with the horn of plenty and three golden Graces) and to have caricatured the poet Hipponax, but they have been better served by ancient authors than by survival of works which can be plausibly attributed to them. An Artemis by them was, says Pliny, set high and her features seemed sad as you approached, joyful as you left, possibly the effect of an Archaic smile viewed close from below and head-on at a distance, respectively (compare [205.2]).

Other areas

The last generation of kouroi is represented on a wide range of sites, including the colonial, but outside Athens and Boeotia it is not distinguished. [179] is an example of some quality from the Ptoon but it lacks the clear grasp of form and features of its Attic contemporary from Keos [144]. Rather later [180] is also from the Ptoon, dedicated by a Boeotian but the style is far closer to Attic and the head invites comparison with the Acropolis korai [152, 153]. A Thebadas, probably Boeotian, signed a kore base in Athens.

The Cyclades had been important in the early history of the kore and there are several dedications on Delos late in the century, as [181], where a certain independently massive treatment of the hanging dress and novel handling of folds might betoken a Cycladic school, also perhaps represented in Athens (Acr. 594) and at Delphi. Some massive seated women, on Paros and Delos, are of the same stock. A drily modelled late kouros in London [182] may be from Anaphe, a small island near Thera.

In the Peloponnese Corinth, Sparta and Arcadia remain better known for minor works in bronze. Ancient authors tell us that the Sicyonian school flourished still, but its home has not proved informative archaeologically for this period. A limestone kore head [*183*] from Sicyon owes too much to Attic ionicizing styles (compare the 'folded' crown hair of [*151*]) to represent any decidedly Peloponnesian type, while the expression is almost Etruscan. The strange little kore from the Athenian Acropolis [*184*] has also been attributed to Sicyon and the Peloponnese. Her proportions are odd and the verticals of her chiton are carefully left undisturbed by the pull at her skirt. Kanachos of Sicyon is recorded as having made bronze, marble, wood and chryselephantine statues; in Sicyon, Thebes and Didyma. His cult statue of Apollo Philesios at Didyma was removed by Darius in 494, returned by Seleucus I two centuries later. The figure was like a kouros holding a bow and a stag, the animal so attached to the hand that a cord could be passed beneath each of its feet in turn, it being supported by the other three – a practical answer to Hephaistos' magic Perseus on the Shield of Herakles, who had no visible means of support at all. Late reliefs, gems and coins give an idea of the Apollo [*185*] which recalls the bronze [*150*] in pose and handling of attributes. If a Roman marble copy of the type is properly identified, it was posed in the new, relaxed Kritian stance.

Texts name Ageladas as an influential master and founder of the Argive school, attributing to him distinguished pupils even of much later date, but his athlete statues and other dedications for Olympia and Delphi are put explicitly in the years between 520 and about 490 and do not survive.

Corinth's role in developing major terracotta sculpture has been remarked already (and see p. 157). Several major works of the fifth century found at Olympia may be Corinthian in origin and the earliest is a clay Athena, three-quarters lifesize [*186*], whose painted features admonish us about the probable original appearance of her marble skin.

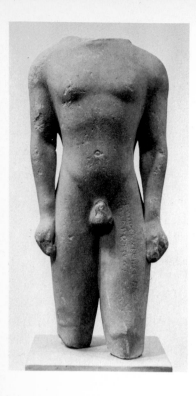

81 Kouros from Samos. The dedication is on the left thigh – 'Leukios dedicated (me) to Apollo'. (Samos 69; H. 1·0) About 560–550

Λευκιος ανεδηκε ΓΕΥΚΙΟΣΑΝΕΘΗΚΕ
τωι Απολωνι ΤΩΙΑΠΟΓΩΝΙ

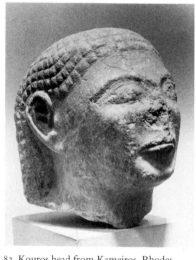

83 Kouros head from Kameiros, Rhodes. (Rhodes; grey marble; H. 0·33) About 550

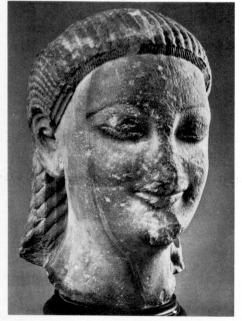

82 Kouros head from Samos, Heraion. The head, in Istanbul, was thought to be from Rhodes but it joins kouros fragments from Samos. The whole figure stood about 3·25 high. (Istanbul 530; H. 0·49) About 550–540

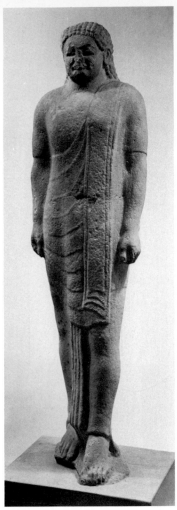

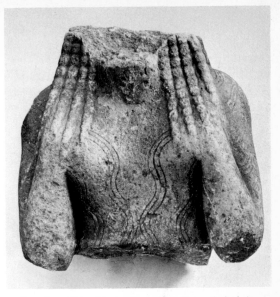

85 Kore from Chios. The hands are placed beneath the hair, over the breasts, in an unusual gesture of prayer (?). The back is similar to the next. (Chios 225; H. 0·55, about 2·25 complete) About 580–570

84 Dressed kouros from Samos, Cape Phoneas. (Samos 68; H. 1·79) About 540

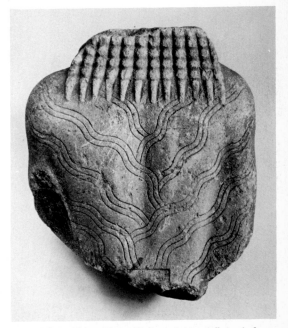

86 Kore from Chios. Cf. 85; this figure held an offering before her breast. (Chios 226; H. 0·62) About 580–570

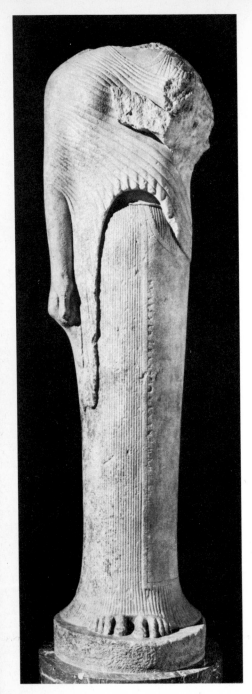

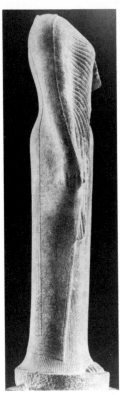

87 Kore ('Cheramyes' Hera') from Samos. She
wears epiblema, mantle and chiton. The dedication
by Cheramyes is written along the front edge of the
epiblema. He dedicated another kore and a kouros
at the same site. Both korai have round plinths and
it has been suggested that they were mounted on
columns with round egg-and-dart capitals. (Louvre
686; H. 1·92) About 560

ΧΗΡΑΜΥΗ≶ΜΑ∧≶⊕ΙΚ≶ΝΤΗΡΗΙΑΓΑΛΜΑ

Χηρομυης μ'ανεδηκεν τηρηι αγαλμα

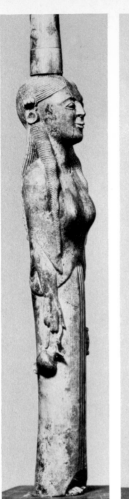
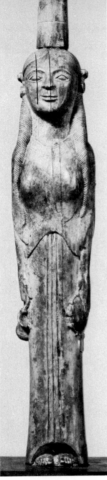
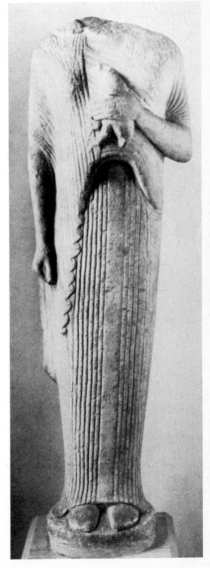

88 Ivory statuette from Ephesus, temple of Artemis. She serves as handle to a wand surmounted by a hawk. She wears a chiton and holds a jug and dish of Lydian type. From below the Kroisos temple. (Istanbul; H. of figure 0·107) About 560

89 Kore from Miletus. She holds a partridge. (Berlin 1791; H. 1·43) About 570–560

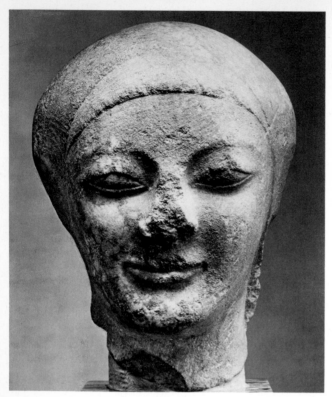

90 Kore head from Miletus, temple of Athena. The epiblema is worn over her hair. (Berlin 1631; H. 0·21) About 550–540

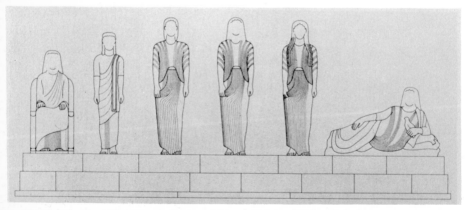

91 'The Geneleos Group' from Samos. The seated figure is Phileia, with the artist's signature – 'Geneleos made us' – on her legs. The next figure is probably a dressed boy, then three girls (unknown name: Philippe: Ornithe 92). The dedicator, -arches, reclines 93. (Samos, except Ornithe; L. of base 6·08) About 560–550

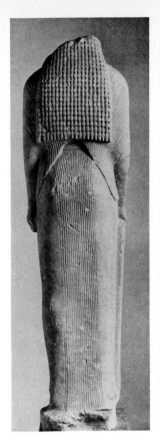
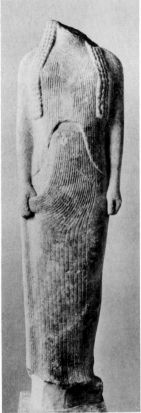

92 (left) Ornithe, see *91*. (Berlin 1739; H. 1·68)

93 (below) -arches, see *91*. He wears chiton and himation, leans on a wineskin, holds a bird. (Samos 768; L. 1·58)

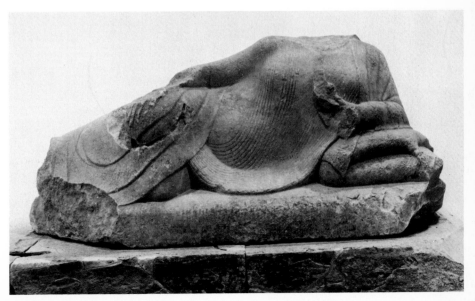

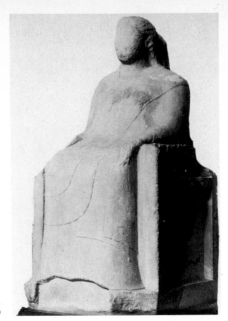

94 Seated figure from near Didyma.
(London B 271; H. 1·55) About 560

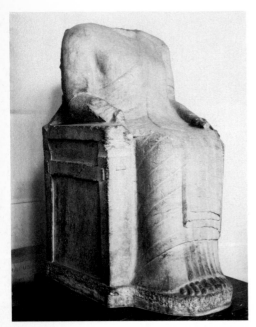

95 Seated figure from near Didyma.
Dedication – 'I am Chares, son of
Kleisis, ruler of Teichioussa. The
statue is for Apollo'.
(London B 278; H. 1·49) About 550

ΧΑΡΗ΢ΕΙΜΙΟΚΓΕ΢ΙΟ΢ΤϜΙΧΙΩ΢ΗΕΑΡΧΟ΢
΢ΟΝ΢ΤΤΟΤΑΟΤΑ·ΛΙΑΙΑ

Χαρης ειμι ο Κλεσιος Τειχιοσης αρχος
αγαλμα το Απολλωνος

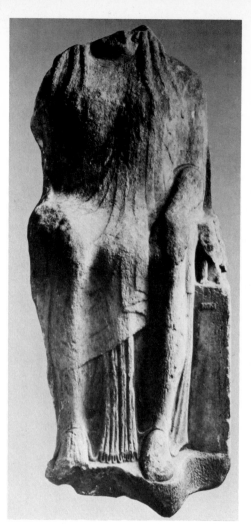

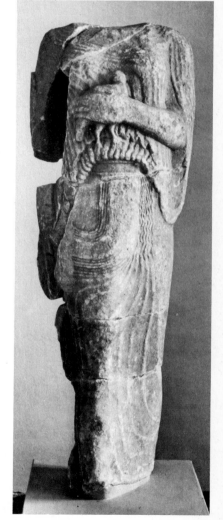

96 Aiakes from Samos town. Seated lions support the throne arms. The dedication, on the side of the seat, reads – 'Aiakes, son of Brychon, dedicated (me). He secured the booty for Hera during his stewardship' – a civic pirate! (Samos, Tigani Museum 285; H. 1·48) About 540

ΑΕΑΚΗΣΑΝΕΟΗΚΕΝ
ΟΒΡ ν < Ω Ν Ο Ξ : Ο Ξ Τ Η Ι
Η Ρ Η Ι : Τ Η Ν Ξ ν Λ Η Ν : Ε
Γ Ρ Η Ξ Ε Ν : Κ Α Τ Α Τ Η Ν
Ε Π Ι ξ Τ Α Ξ Ι Ν

Αεακης ανεθηκεν
ο βρυφωνος : ος τηι
Ηρηι : την συλην : ε-
-πρησεν : κατα την
επιστασιν

97 Kore from Samos. She holds a partridge. (Samos I. 217; H. 1·15) About 540–530

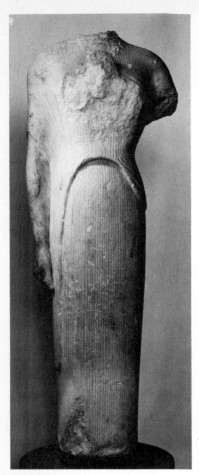

98 Kore from the Acropolis.
(Acr. 619; H. 1·43) About 560–550

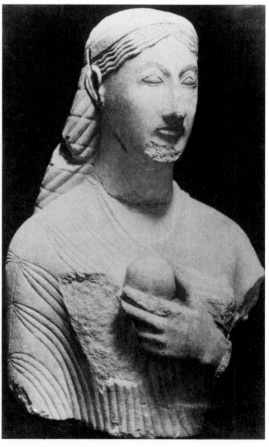

99 Kore from the Acropolis.
(Acr. 677; H. 0·545) About 560–550

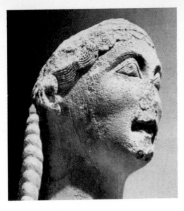

100 Sphinx from Delphi. It stands on one of the earliest extant Ionic columns, about 10 m high. A later dedication on its base honours the Naxians with *promanteia* (priority with the oracle). (Delphi; H. 2·32) About 560

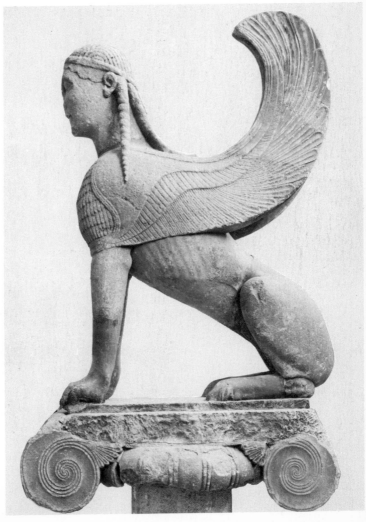

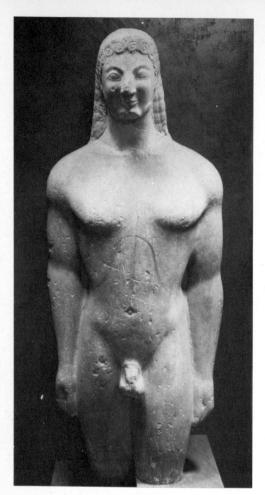

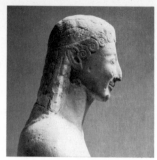

101 Kouros from Thera, cemetery. (Athens 8; H. 1·24) About 570–560

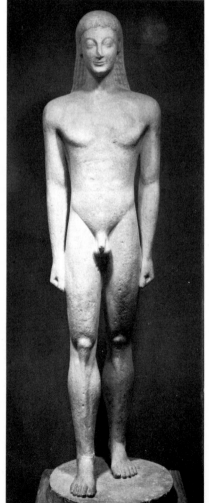

102 Kouros from Melos. (Athens 1558; H. 2·14) About 550

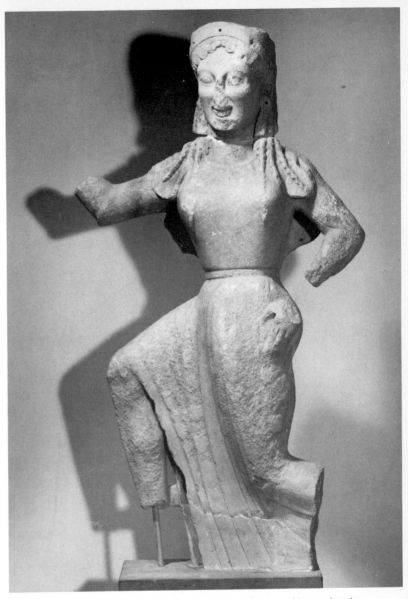

103 Nike from Delos. She has wings at back and heels and wears a chiton and peplos
fastened by disc brooches at the shoulders. The inscription on the base reads – 'Farshooter
[Apollo, receive this] fine figure [. . ., worked by] the skills of Archermos, from the Chian
Mikkiades, . . . the paternal city of Melas'. (Athens 21; H. 0·90) About 550

Μικκια[δηι τωδ' αγα]λμα καλον Ν[ικην πτερωεσσαν?]
Αρχερμω σο[φ]ιειϲιν ηκηβω[λε δεχϲαι Απωλλων]
[τ]οι Χιοι, Μελαγος πατροιων αϲ[τυ νεμωντι?]

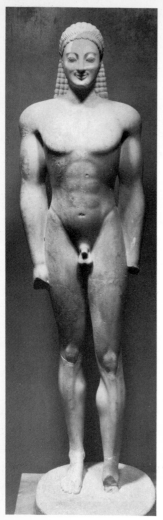
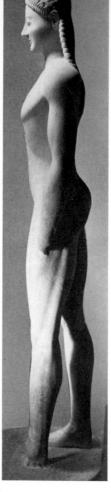
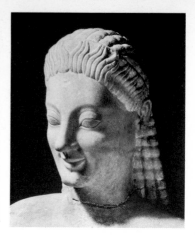

104 Kouros from Volomandra (Attica).
(Athens 1906; H. 1·79) About 570–560

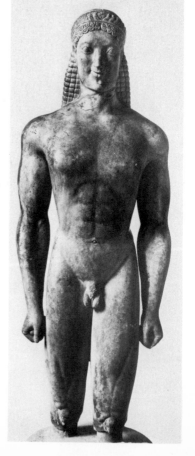

105 Kouros from Greece, probably Attic.
(Florence; completed H. about 1·90)
About 560

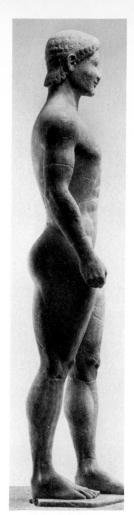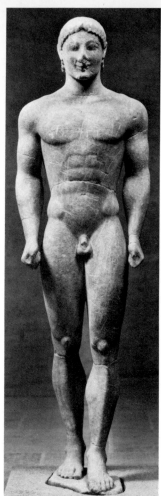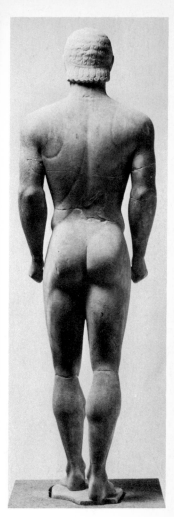

106 Kouros from Attica. (Munich 169; H. 2·08) About 540–530

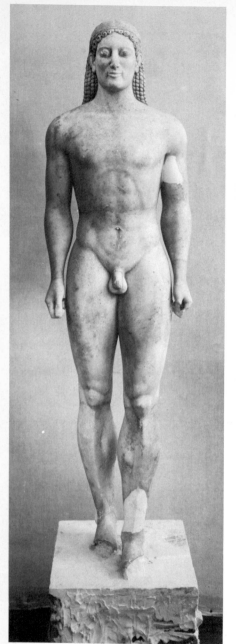

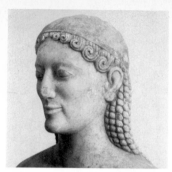

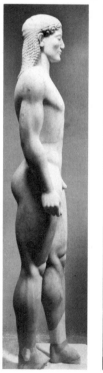

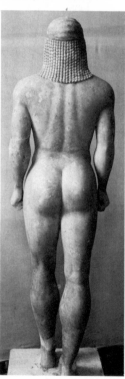

107 Kouros from Anavysos (Attica). This stood on a stepped base inscribed – 'Stay and mourn at the monument for dead Kroisos whom violent Ares destroyed, fighting in the front rank'. He bore the name of the Lydian king, deposed in 546. The statue had been sawn in half and smuggled to Paris in 1937 before being returned to Greece. (Athens 3851; H. 1·94) About 530

στέθι : και οικτιρον : Κροισο
παρα σέμα θανοντος : hον
ποτ' ενι προμαχοις : ὄλεσε
Ϛϲρος : Αρές

ϚΤΕΘΙ:ΚΑΙΟΙΚΤΙΡΟΝΚΡΟΙϚΟ
ΓΑΡΑϚΕΜΑΘΑΝΟΝΤΟϚΗΟΝ
ΓΟΤΕΝΙΓΡΟΜΑ+ΟΙϚ:ΟΛΕϚΕ
ΘΟΡΟϚ:ΑΡΕϚ

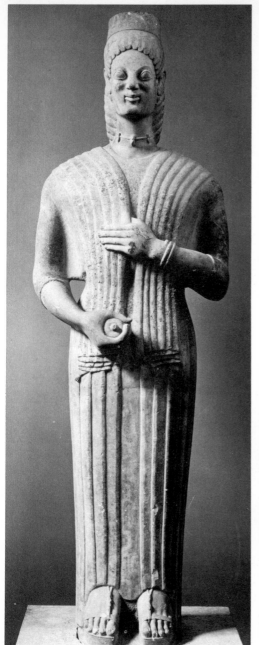

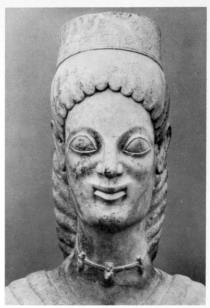

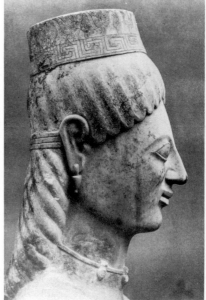

108 Kore (the 'Berlin kore', formerly '..goddess') from Keratea (Attica). Found wrapped in
protective lead, probably buried in antiquity at a time of threat, either of invasion (Persian?)
or through the unpopularity of the family in whose burial plot she stood. The crown is
painted with lotus-and-bud and maeander. She wears mantle and chiton, holds a
pomegranate; battlement pattern painted at neckline and skirt centre. (Berlin 1800; H. 1·93)
About 570–560

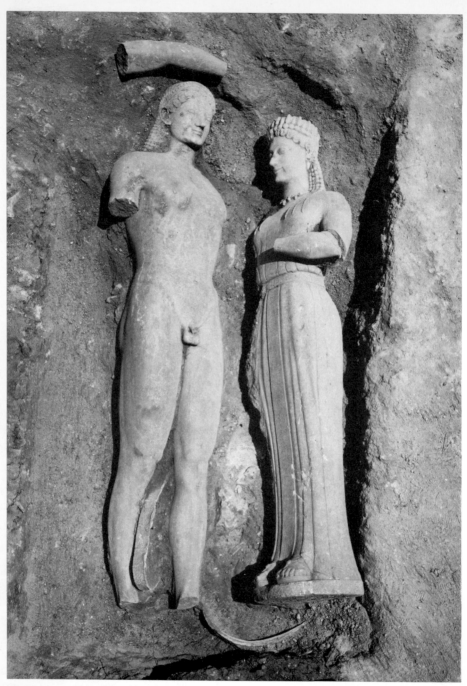

108a Kouros and kore (Phrasikleia, by Aristion of Paros) on discovery (1972) in a pit at
Merenda (Myrrhinous) in Attica, where they had been buried in antiquity. For Phrasikleia's
base see p. 73. About 550

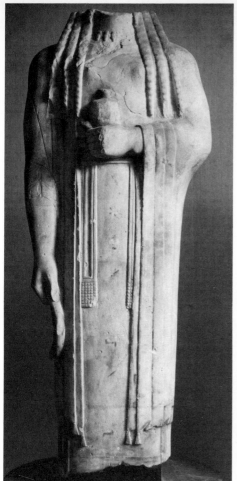

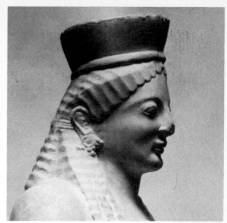

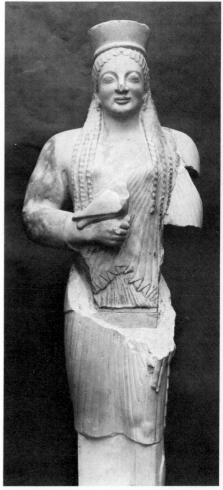

109 Kore from the Acropolis. She wears mantle, peplos and chiton, holds a wreath and pomegranate. The weighted belt ends hang at the front. This is one of the earliest sculptures to show use of the claw chisel. (Acr. 593; H. 0·995) About 560–550

110 Kore (the 'Lyons kore') from the Acropolis. The upper part reached France by 1719. The join with the lower part was observed by Payne only after some scholars had contrasted the 'Ionian' and 'Attic' character of each half. The crown is painted with lotus and palmette and her earrings are the eastern triple 'mulberry' type worn by Hera in *Iliad* 14, 182f. The upper part of the chiton is not rendered in folds but unrealistically shown as if with tailored sleeves. (Acr. 269+ and Lyons; H. 1·13) About 540. See also

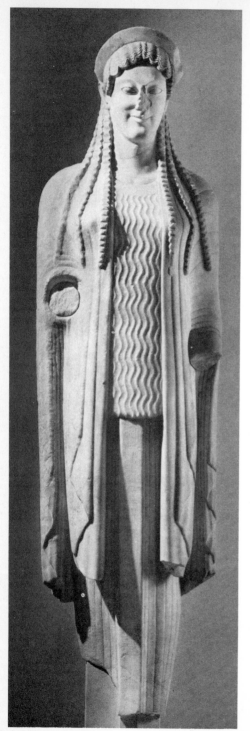

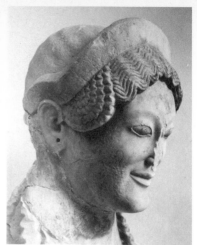

111 Kore from the Acropolis. She wears mantle and chiton. (Acr. 671; H. 1·67) About 530

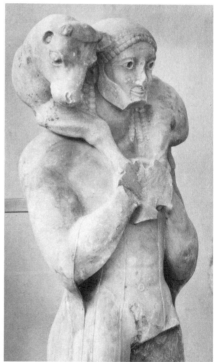

112 Calf-bearer (Moschophoros) from the Acropolis. He wears a light cloak, its folds ignored. Dedicated by Rh]ombos. By Phaidimos (?), and see on 193. (Acr. 624; restored H. about 1·65) About 560. See also frontispiece

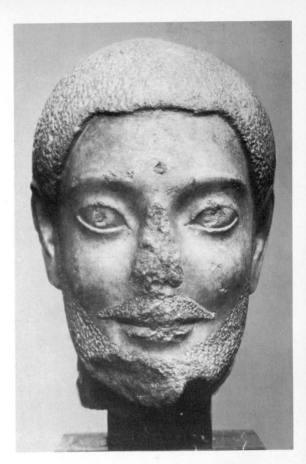

113 Head of a man ('Sabouroff head')
from Athens or Aegina.
(Berlin 608; H. 0·23) About 550–540.
See also *133*

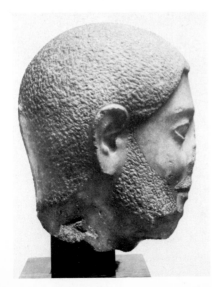

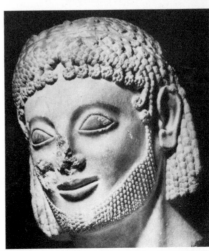

114 See next page

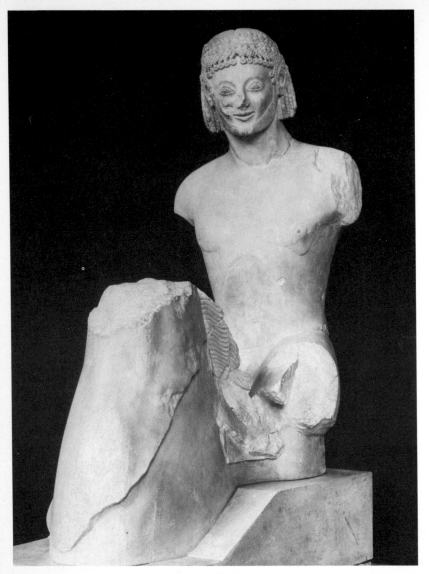

114 Horseman from the Acropolis. The 'Rampin head' is in Paris (see previous page), the rest in Athens. He wears a wreath of wild celery (the prize in the Isthmian and Nemean Games). Other fragments suggest that there was a pair of horsemen set side by side, the horses' heads inclined in, the riders' heads out. The suggestion that they are a dedication of the two 'horsy' (by name and nature) sons of Peisistratos would only be credible if the work is later than 546 (not quite impossible) when the tyrant returned to power. (Would they have survived the fall of the tyranny in 510?) They are too early to be a compliment to anti-tyrant Sparta, as the Dioskouroi, which is another suggestion. (Louvre 3104 and Acr. 590; H. of head 0·29) About 550

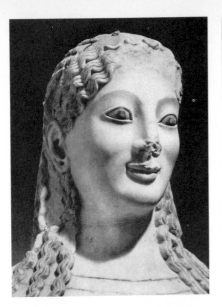

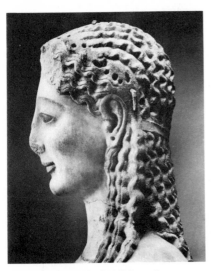

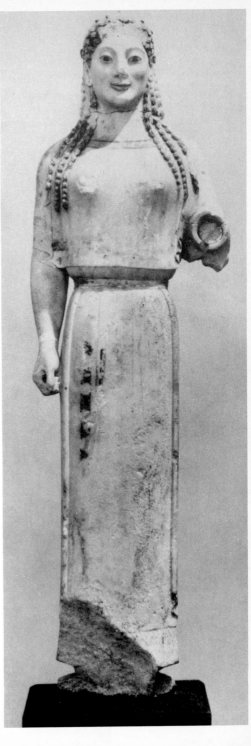

115 Kore (the 'Peplos kore') from the
Acropolis. She wears a peplos over chiton
(we see the sleeves and the bottom of the
skirt). The left forearm was made
separately; a wreath and shoulder brooches
were attached. Richly painted. By the Rampin
Master (?). (Acr. 679; H. 1·17) About 530.
See also *129*

116 Kore head from the Acropolis. By the Rampin Master (?).
(Acr. 654; H. 0·117) About 560–550

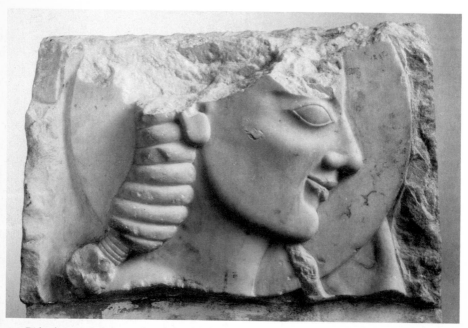

117 Diskophoros stele fragment from Athens. By the Rampin Master (?).
(Athens 38; H. 0·34) About 550

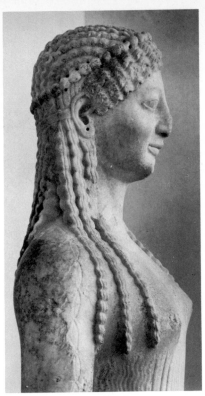

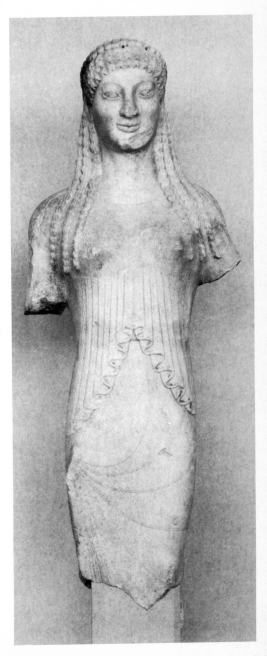

118 Kore from the Acropolis. A mantle hangs
symmetrically over the chiton and is not divided
at the flanks. (Acr. 678; H. 0·97) About 540–530

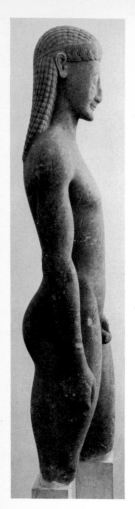
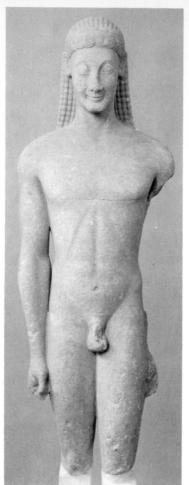
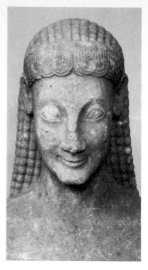

119 Kouros from the Ptoon
(Boeotia). (Thebes 3: H. 1·37)
About 550

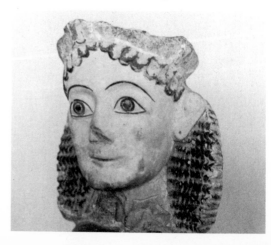

120 Clay head of a sphinx
from a temple at Kalydon.
(Athens; H. of head 0·23)
About 580–570

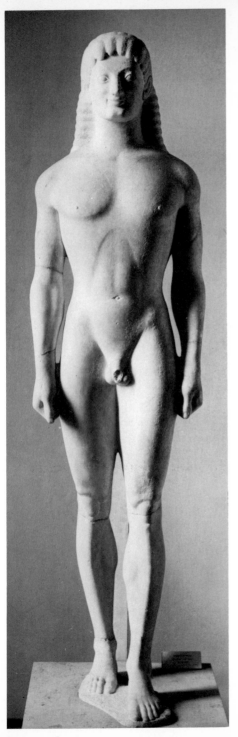
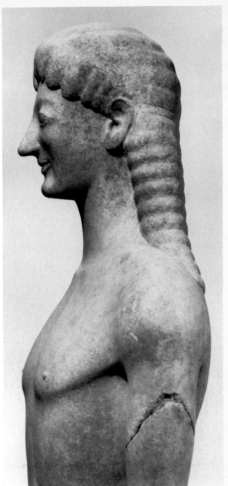

121 Kouros from Tenea. Found lying over part of a tomb, its head protected by a clay jar. (Munich 168; H. 1·35) About 550

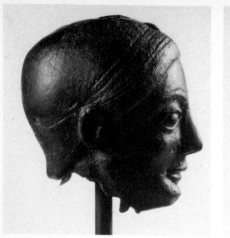
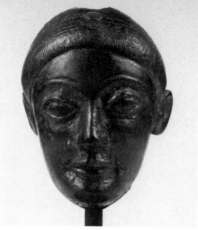

122 Bronze head of a youth from Sparta (?). Hollow cast. (Boston 95.74; H. 0·69) About 540

123 Basis from Sparta. A – a man and a woman, his arm round her neck; she holds a wreath. B – as A but no wreath and he threatens her with a sword. On each narrow side a snake. Menelaos with Helen (?), wooing on A and threatening after Troy on B. The snakes suggest a votive for a hero rather than a grave relief; perhaps then from the Menelaion. (Sparta; H. 0·67) Second quarter of the 6th c.

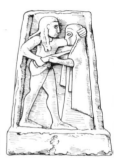

A

B

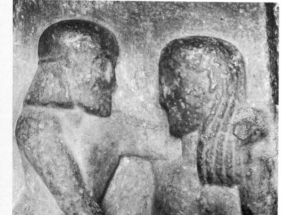

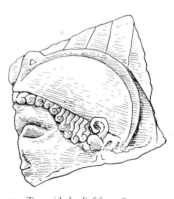

124 Two-sided relief from Sparta, Acropolis. Apparently the blazoned shield of a warrior (there is another fragment with a head blazon), once associated with the later 'Leonidas' marble. The helmet type is east Greek. (Sparta) Late 6th c.

125 Bronze coin of the Emperor
Gallienus showing the Athena of
Gitiadas. (London)

126 Silver 'New Style' Athenian
tetradrachm showing the Apollo of Tektaios
and Angelion on Delos. (London)

127 Ivory head and foot
fragments from Delphi. From
chryselephantine figures. There
are also fragments of seven other
heads of various sizes and from
sandalled feet and hands, as well
as decorated gold plaques from
the dress. (Delphi; two-thirds
lifesize) About 550–540

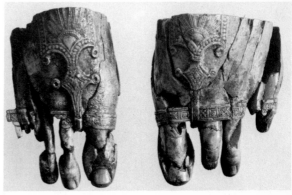

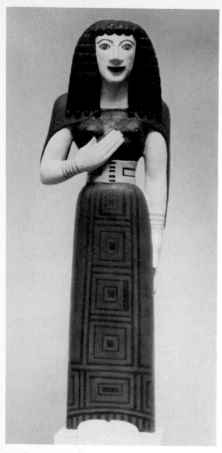

128 Painted cast of *28*, the Auxerre goddess.
(Cambridge, Museum of Classical Archaeology)

129 Painted cast of *115*, the Peplos kore
(Cambridge, Museum of Classical Archaeology)

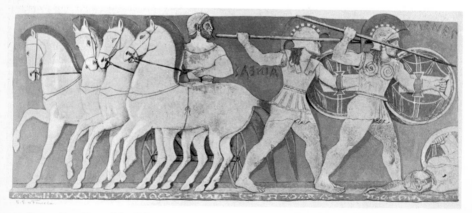

130 Restoration of part of the Siphnian treasury frieze; cf. *212.2* (after *FDelphes*)

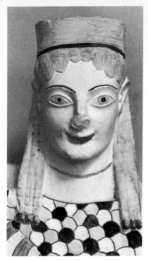
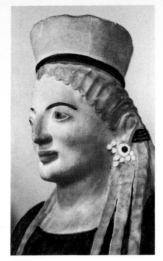
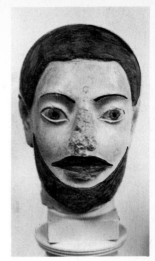

131–3 Painted photographs of casts of *227, 110, 113*

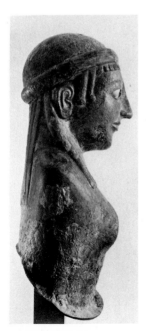
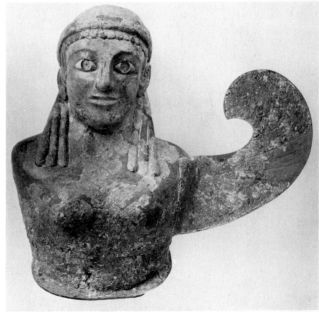

134 Bronze (sphyrelaton) bust of a winged goddess from Olympia. Hammered over a wooden core. (Olympia; nearly lifesize) About 580

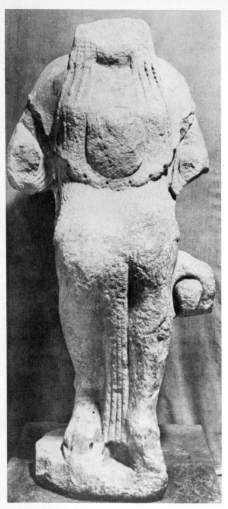

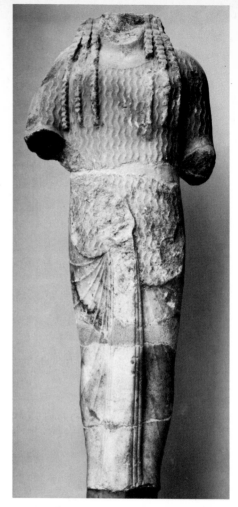

135 Seated Athena from the Acropolis. Her aegis bore a gorgoneion, totally effaced, and bronze snakes were fitted at its edge. By Endoios, dedicated by Kallias (?). (Acr. 625; H. 1·47) About 530–520

136 Kore from the Acropolis. Associated with a column bearing the signatures of Endoios and Philergos, dedicated by Ops[iades. (Acr. 602; H. 0·66) About 530–520

137 Votive relief of a potter from the Acropolis. Beazley suggested for the dedicator's name Pampha]ios, a known potter of about 520–500. The sculptor's signature may be restored with the name En[doios. (Acr. 1332; H. 1·22) About 510–500

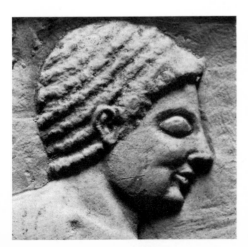

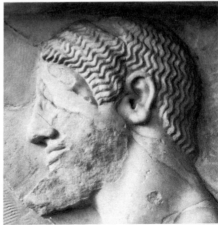

138 Detail of *242*

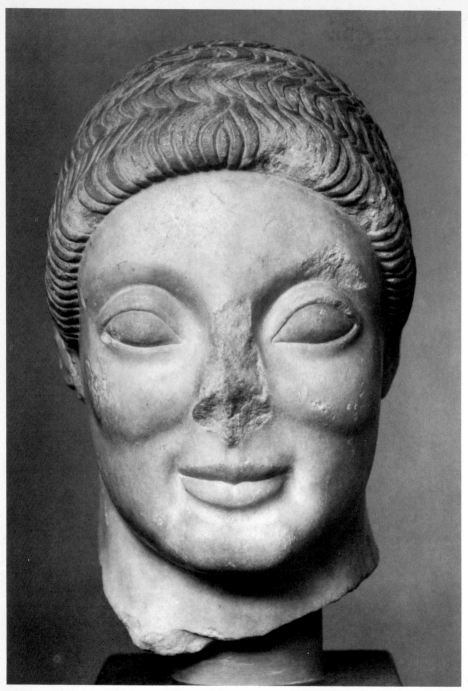

139 Kouros head (the 'Rayet head') from Athens. Associated with fragments of a kouros
from the Piraeus Gate and perhaps belonging to one of the bases bearing signatures of
Endoios and Philergos found near by. (Copenhagen, Ny Carlsberg 418; H. 0·315) About 520

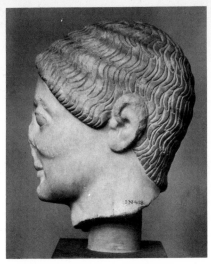

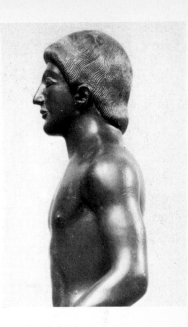

139 See opposite page

140 Bronze youth from the Acropolis. He probably held jumping weights (*halteres*), cf. *ARFH* fig. 85.2. (Athens 6445; H. 0·27) About 520–510

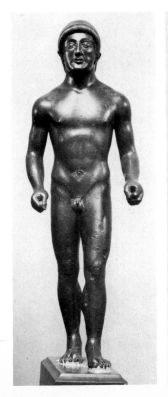

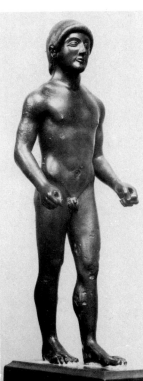

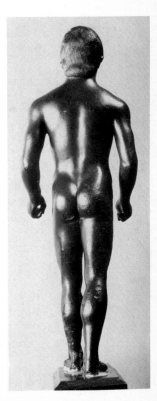

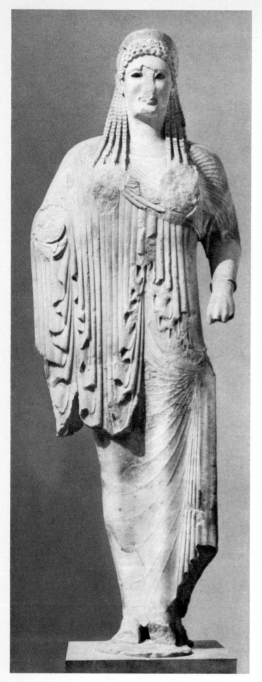

141 Kore ('Antenor's kore') from the Acropolis. Dedicated by the potter Nearchos (a Nearchos signs vases about 570–555 and his sons work to about 540) and signed by Antenor son of Eumares. The eyes are rock crystal set in lead. (Acr. 681; H. 2·155) About 530–520

ΝΕΑΡ+ΟΣΑΝ·ΘΕΚΕ
ΥΣΕΡΛΟΝΑΠΑΥ+ΕΙΡ ΙΑΘ

ΑΝΤΕΝΟΡΕΓ
ΟΕΥΜΑΡΟΣΤ

Νεαρχος ανεϟεκε[ν ho κεραμε]
υς εργον απαρχεν ταϟ[εναιαι]
Αντενορ επ[οιεσεν h]
ο Ευμαρος τ[ο αγαλμα]

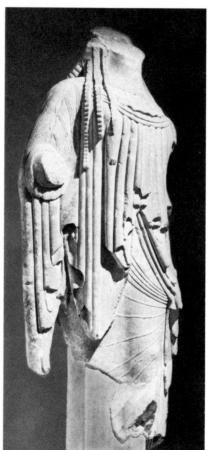

142 Woman from the east pediment, temple of Apollo, Delphi. See also 203.1 (Delphi; H. 1·16) About 520–510

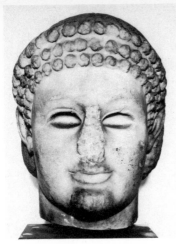
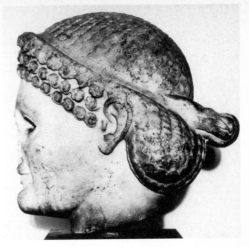

143 Head of a youth (the 'Webb head'). This has been thought a copy of the head of Antenor's Harmodios in the tyrant-slayer group. (London 2728; H. 0·29) Roman copy of an original of about 500

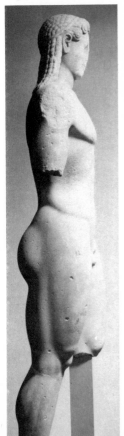
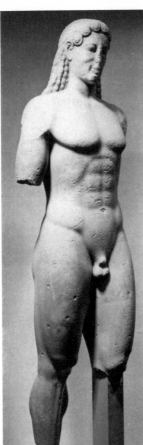
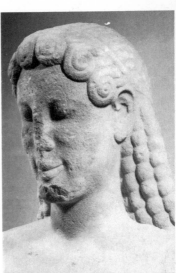

144 Kouros from Keos. Found in the cemetery area near a pile of ash and bone. (Athens 3686; H. 2·07) About 530

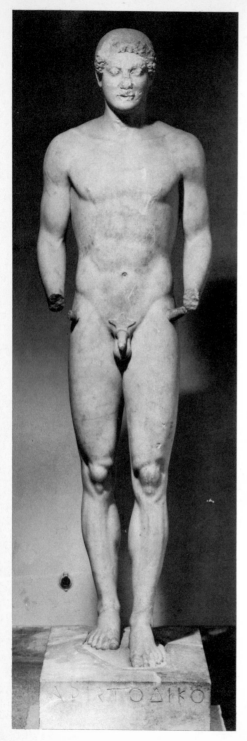

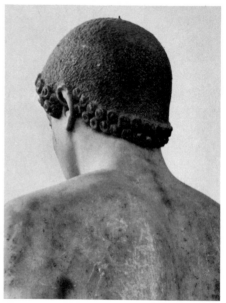

145 Kouros from near Mt Olympus (Attica).
The base is inscribed 'of Aristodikos'.
(Athens 3938; H. 1·95) About 510–500

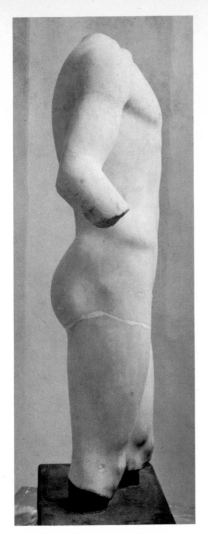
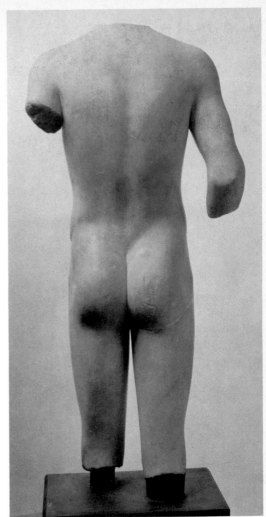

146 Kouros from the Acropolis. (Acr. 692; H. 0·87) About 490

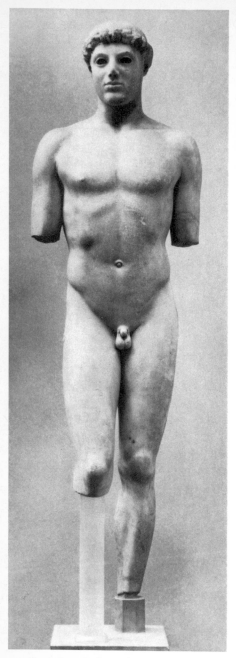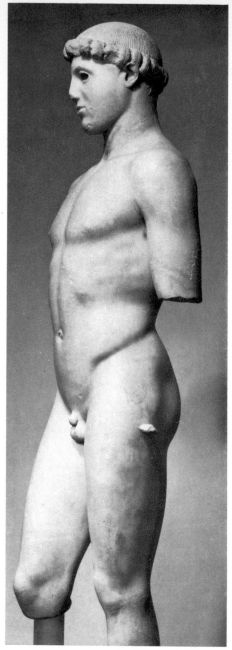

147 Youth from the Acropolis ('Kritian boy'). The sobriquet is given because of the
similarity of the head to the head of Harmodios in the tyrant-slayer group by Kritios and
Nesiotes, set up after 479 and known from copies. (Acr. 689; H. 0·86, about half lifesize)
About 490–480

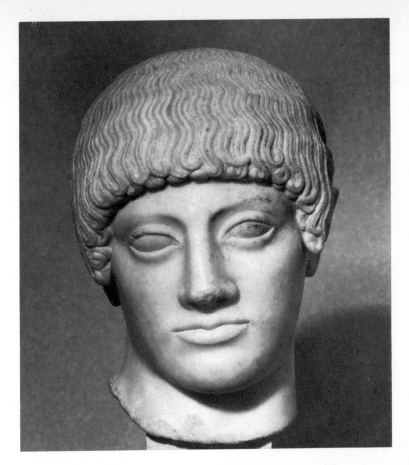

148 Youth from the Acropolis ('Blond boy'). Head
and part of loins. Traces of yellow-brown on the hair;
ringlets and side whiskers were also painted on.
(Acr. 689+; H. of head 0·25, loins 0·34; about three-
quarters lifesize) About 490–480

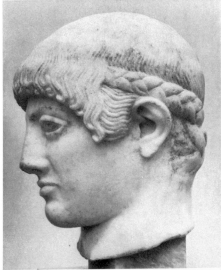

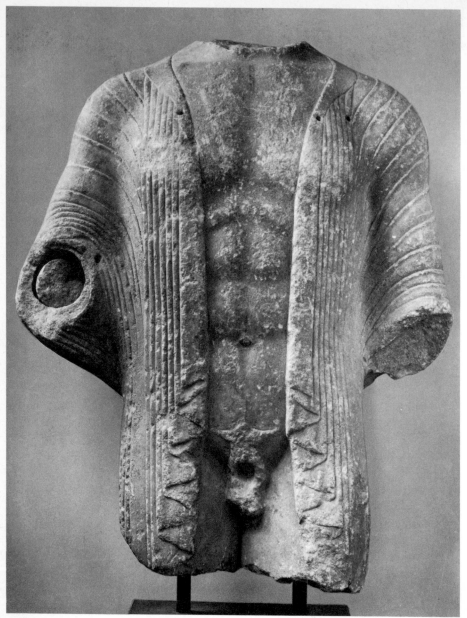

149 Worshipper from near the Ilissos. For the dress compare *112*. Possibly a Hermes. (Athens 3687; H. 0·65) About 500

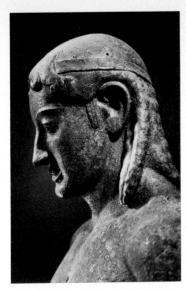

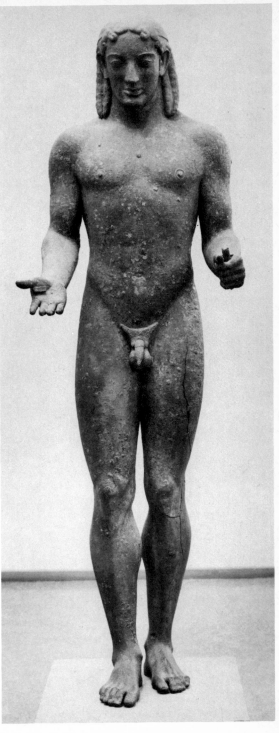

150 Bronze Apollo from the Piraeus. Excavated in 1959 with a cache of later, Classical bronzes and marbles, possibly overtaken by Sulla's sack in 86 BC. He held a bow in the left hand, a phiale in the right. (Athens; H. 1·92) About 530–520

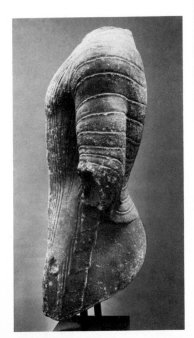

149 See opposite page

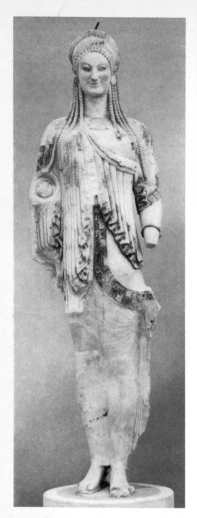

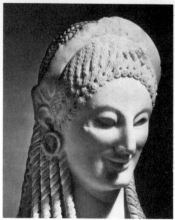

151 Kore from the Acropolis.
(Acr. 682; H. 1·82) About 530–520

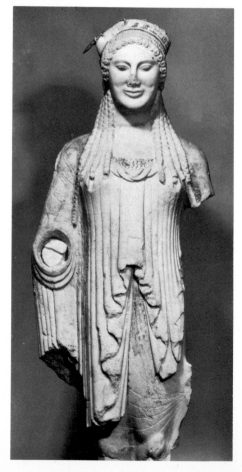

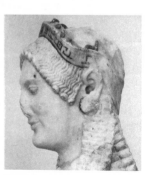

152 Kore from the Acropolis. By the same hand
as 153. It has been thought (Karouzos) an
early work by the artist of Aristodikos 145.
(Acr. 673; H. 0·93) About 520–510

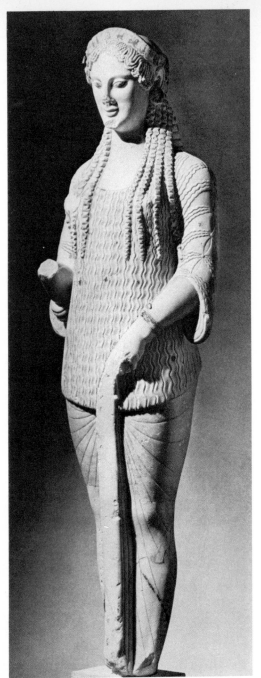

153 Kore from the Acropolis. By the same hand as *152* and cf. *180*. (Acr. 670; H. 1·15) About 520–510

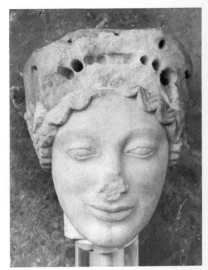

154 Kore head from the Acropolis. The upper part was made separately, probably a repair. '. . . one of the great works of Attic sculpture' (Payne). (Acr. 643; H. 0·145) About 520–510

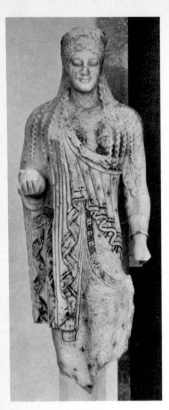

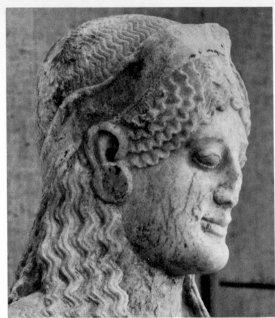

155 Kore from the Acropolis.
(Acr. 680; H. 1·15) About 520–510

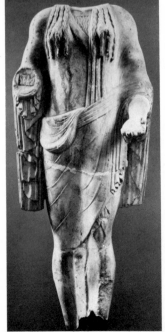

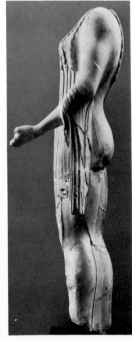

156 Kore from the Acropolis
(Acr. 615; H. 0·92)
About 510–500

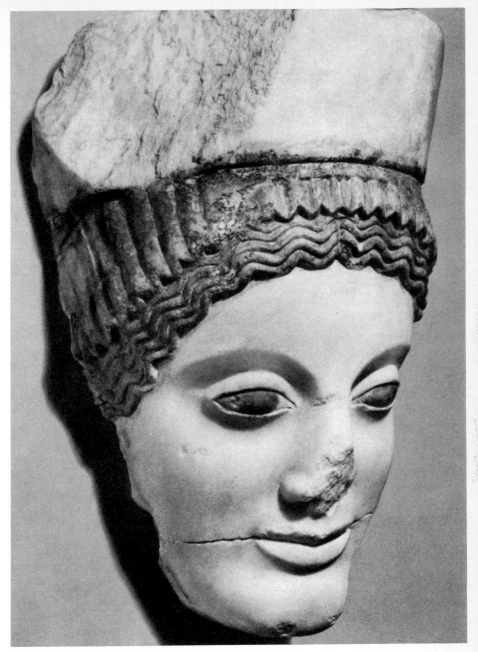

157 Kore from the Acropolis. Fragments of the body found also.
(Acr. 696+; H. of head 0·275) About 510–500

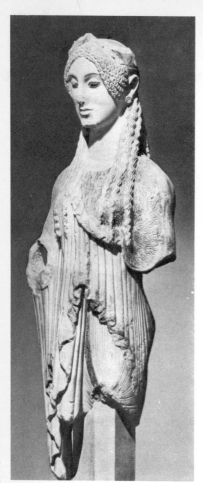

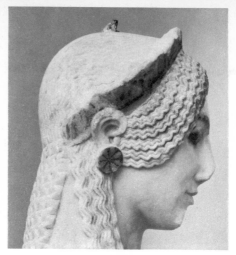

158 Kore from the Acropolis.
(Acr. 674; H. 0·92) About 500

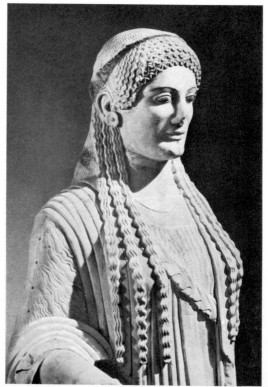

159 Kore from the Acropolis.
(Acr. 684; lifesize) About 500–490

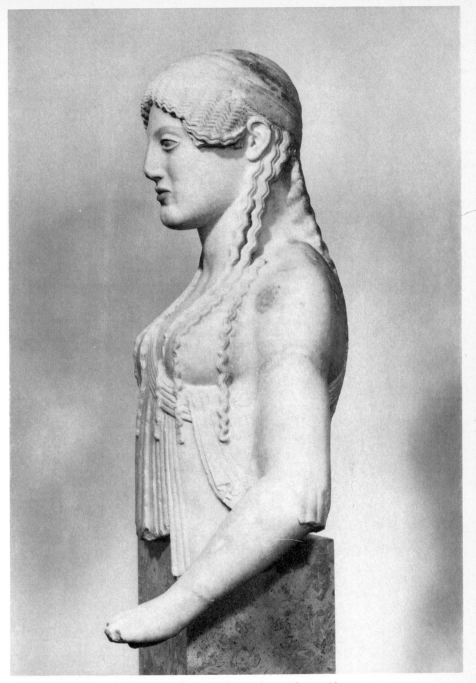

160 Kore ('Euthydikos' kore') from the Acropolis. Mounted on a column with a
hemispherical capital inscribed 'Euthydikos, son of Thaliarchos, dedicated (me)'. Euthydikos
dedicated another statue after 479 (pillar base found). The Blond boy *148* is probably by the
same artist. (Acr. 686, 609; H. 0·58, 0·42) About 490. See also next page

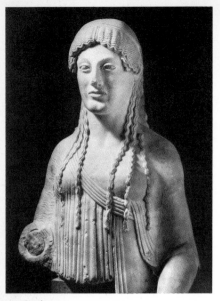

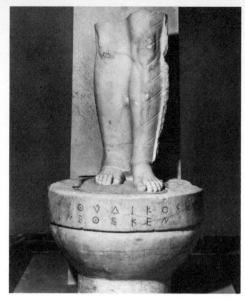

160 See last page

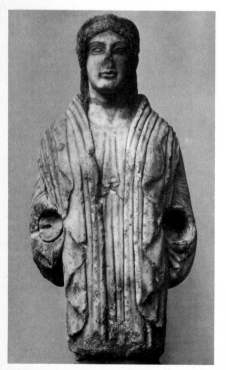

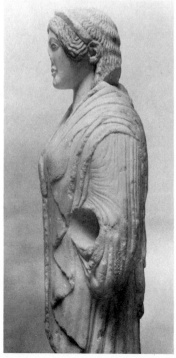

161 Kore from the Acropolis. (Acr. 688; H. 0·51) About 480

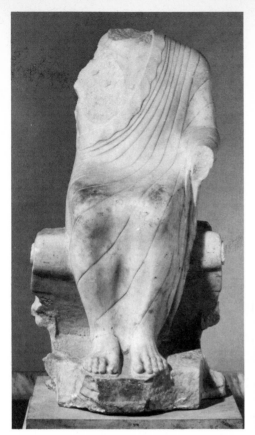

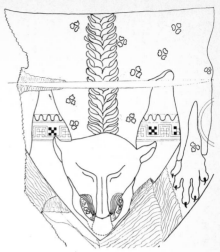

162 Seated Dionysos from Athens. The dress, sandals, stool cloth and panther skin are elaborately painted (see drawing). (Athens 3711; H. 1·07) About 520

163 Seated woman from Rhamnus. (Athens 2569; H. 0·44) About 530–510

164 Scribe from the Acropolis. Seated on a stool, wearing himation only and with an open writing tablet on his lap. The dedication of a bureaucrat of the new 'democracy' or a Treasurer of Athena (?). (Acr. 144; H. 0·45) About 500

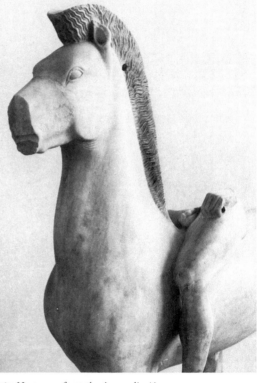

165 Horseman from the Acropolis. (Acr. 700; H. of whole horse 1·12) About 510

166 Horseman from the Acropolis. For the pose of head and body cf. *114*. This, however, is a miniature. (Acr. 623; H. 0·20) About 510

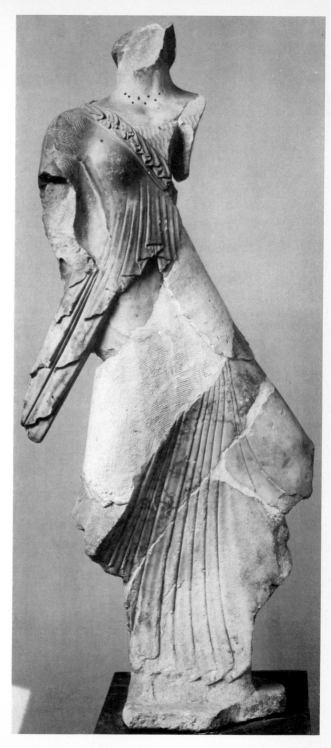

167 Nike from the Acropolis.
Set on a column bearing the
dedication of Kallimachos, the
general who commanded and
was killed at Marathon, set up
after his death. (Acr. 690; H. 1·4)
About 490–480

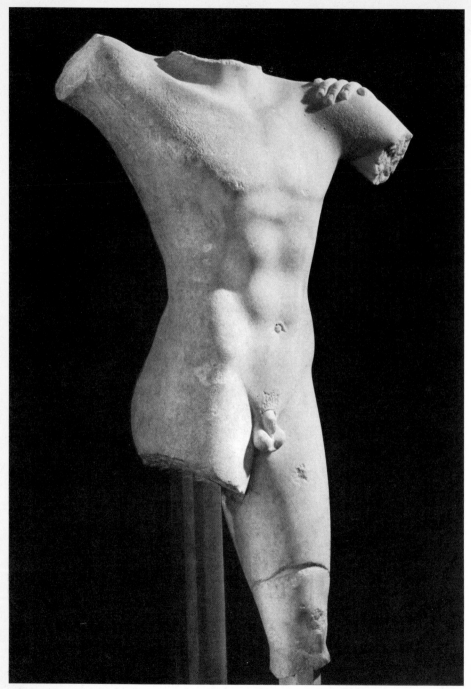

168 Theseus from the Acropolis. An action group in the round. His opponent's hand grasps his left shoulder from behind. A fragment with Theseus' hand seizing the throat of a bearded man must belong. Skiron or Prokrustes? (cf. *ARFH* figs. 90, 233.2). (Acr. 145; H. 0·63) About 510–500

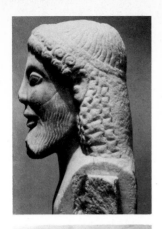

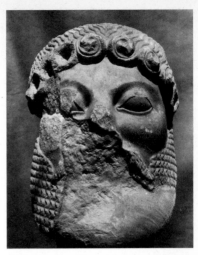

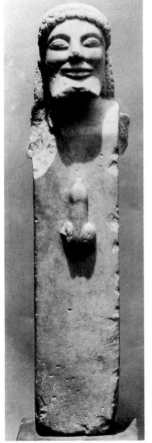

170 Mask of Dionysos from Ikaria (Attica) where there was a shrine of the god. The richly plastic treatment of hair curls and features transcends its battered state. (Athens 3072; H. 0·41) About 520

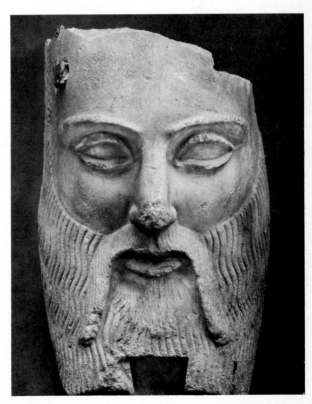

169 Herm from Siphnos. (Athens 3728; H. 0·66) About 520

171 Mask of a god from Marathon. Horns were attached at the forehead. The style has been compared with that of the Euthydikos kore *160* and Blond boy *148*. (Berlin 100; H. 0·32) About 500–480

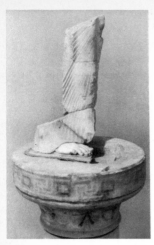

172 Fragments of an Athena from the Acropolis. The left foot was made separately. There is a cutting for a spear held upright, so an Athena. By Pythis, dedicated by Epiteles (the same combination on an Acropolis base). The capital of its column survives. (Acr. 136; H. of capital 0·25) About 510

Γ Υ Θ Ι Σ Ε Π Ο Ι Ε Σ Ε Ν
Ε Π Ι Τ Ε Ι Ε Σ Α Ν Ε Θ Ε Κ Ε Ν Α
Α Θ Ε Ν Α Ι Ρ Ι

Πυϲιϲ εποιεϲεν
Επιτελεϲ ανεϲεκεν απαρχεν
Αϲεναιαι

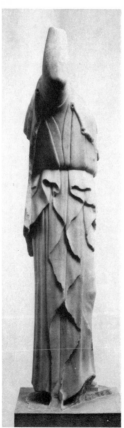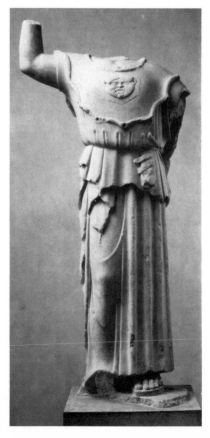

173 Athena from the Acropolis. She wears an aegis and once held spear and shield. Set on a column dedicated by Angelitos and signed by Euenor. (Acr. 140; H. 0·77) About 480

Ι Ν Λ Ξ Ι Τ Ο Σ Μ Α Ν Ε Θ Ι
Α Θ Ε Ν Λ Ι Α Ι Ι
Ι ν Ε Ν Ο Ρ Ε Ι Ο Ι Ι

Αυγελιτοϲ ꞉ μ'ανεϲε[κεν....]
[Ποτνι'] Αϲεναια ꞉ χεχ[αριϲϲο ϲοι τοδε δϲρον ?]
Ευενϲρ εποιεϲεν.

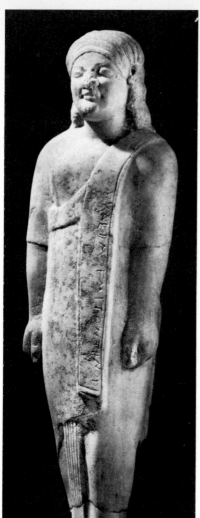

174 Youth. Dedicatory inscription on the broad vertical strip of the himation, worn over a chiton – 'I am Dionysermos, of the (genos?) of Tenor'. (Louvre MA 3600; H. 0·69) About 520

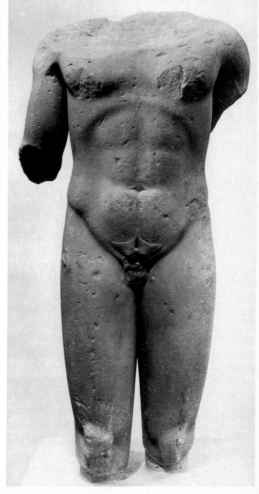

175 Kouros from Samos, the Heraion. (Samos 77; H. 1·07, lifesize) About 490–480

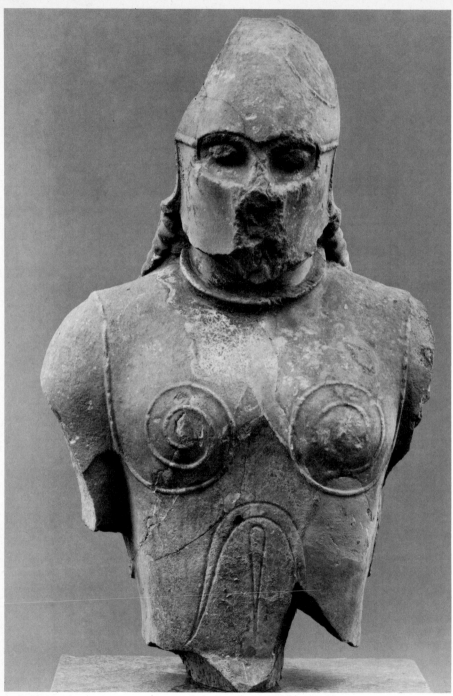

176 Warrior from Samos, the Heraion. The grey marble is as that for 75 but unlike the other
Heraion statues. Fragments of his buttock and a greaved shin also found. (Berlin 1752; H.
0·86) About 520

177 Kore from the Acropolis. Associated with the column bearing a signature of Archermos of Chios. The colour is well preserved – blue chiton with blue and red patterns. The back is finished but without detail of dress. The marble has been thought Chian. (Acr. 675; H. 0·55) About 520–510

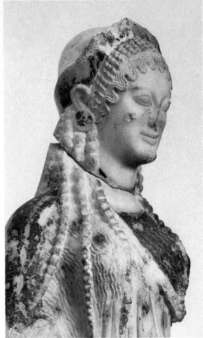

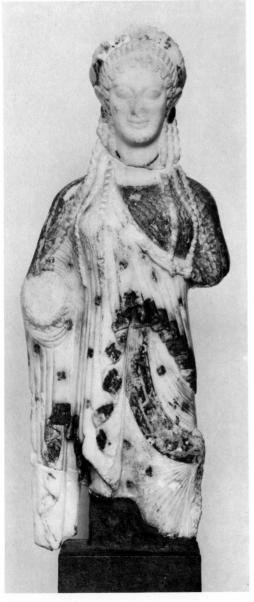

178 Kore head from Kyzikos (Troad). (Berlin 1851; H. 0·25) About 520

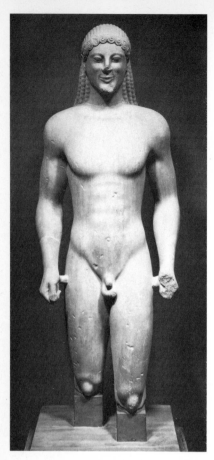

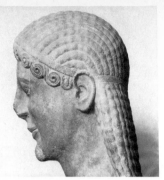

179 Kouros from the Ptoon. (Athens 12; H. 1·6=about 2·16 complete) About 530–520

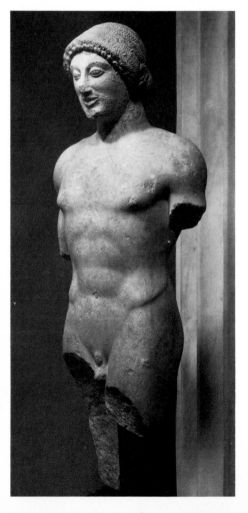

180 Kouros from the Ptoon. Dedicated by Pythias of Akraiphia and Aischrion (inscribed on thighs). See on *152, 153*. (Athens 20; H. 1·03=about 1·47 complete) About 510–500

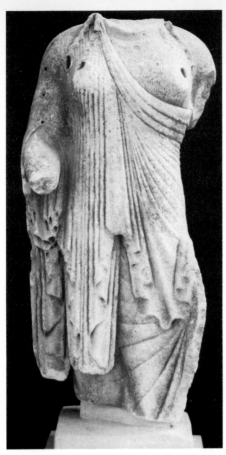

181 Kore from Delos. (Delos A 4064; H. 0·94)
About 520–510

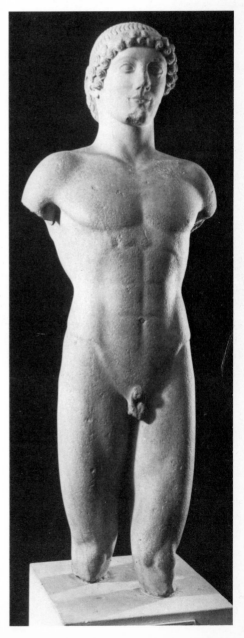

182 Kouros from Anaphe (?).
(London B 475; H. 1·01)
About 510–500

183 Limestone kore head from Sicyon.
(Boston 04.10; H. 0·175) About 530

185 Bronze coin of Miletus, 1st c. BC,
showing the Apollo Philesios of
Kanachos. (London)

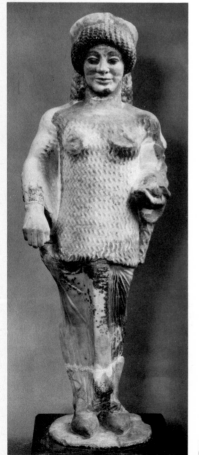

186 Clay Athena head from Olympia. She was helmeted
and carried shield and aegis. Apparently from a votive group
including a fight, perhaps a Herakles adventure, of which
some scraps survive. (Olympia T 6; H. 0·22) About 490

184 Kore from the Acropolis.
(Acr. 683; H. 0·805) About 510

Chapter Seven

ARCHITECTURAL SCULPTURE

Placing and character

The architectural sculpture of seventh-century Crete was applied to simple one-roomed temples and disposed in an eastern manner, with dado friezes. In mainland Greece the second half of the century saw the inception of the stone Doric order of architecture for temples and at the end of the century the beginnings in east Greece, at Smyrna, of what was to become the Ionic order. These orders defined buildings which had colonnades around a central room for the cult image (*cella*) and low-pitched tiled roofs, leaving shallow gable ends. In Doric the entablature over the outer columns and sometimes over the inner porches was articulated by a frieze of triglyphs and metopes. This frieze is a translation of timbering into stone, presenting a series of plain rectangles (the metopes) with thinner vertically ridged dividers (the triglyphs). A frieze composed of separate panels like this was familiar in the east and in Greek Daedalic art [*31, 35*]. On some early Doric buildings the metopes have painted figures, as at Thermon in Aetolia. On developed Doric buildings relief sculpture could appear on the metopes, with relief or eventually free-standing sculpture in the gable pediments, and free-standing figures at the roof corners and apices (*acroteria*) as well as human or animal heads in clay or stone along the gutters. Minor friezes may be admitted in porches. The rendering of the order in stone was probably inspired by Egypt but the shape of the buildings was Greek and so was the disposition of the sculpture.

Ionic temples are confined to the east Greek world in this period, though elements of the style may appear on the mainland for votive monuments and for treasuries at Delphi. On Ionic buildings the placing of sculpture is rather less predictable than in Doric. There is normally nothing in the pediment ([*211*] is an exception, on an exceptional building) but there are acroteria. The continuous frieze is an Ionic feature but not invariable and in fact rare on Archaic exteriors and not unknown even on Doric buildings. But the gutter (*sima*) may carry a frieze, there can be a frieze dado in porches and on the lower and perhaps upper drums of columns [*217–20*]. The continuous frieze devoted to a single developing theme, rather than with repeated identical or similar figures without dividers as on many seventh-century vases or at Prinias [*32*], is a foreign concept, already met in the strongly orientalizing Chania relief [*15*]. On vases

such narrative friezes appear rarely in the seventh century, more often in the sixth. There is eastern precedent too for the 'Caryatid' korai replacing porch columns in treasuries [209, 210] and oddities like capitals with animal foreparts (Pegasi in Thasos and Chios) or the Chian anta bases in the shape of lions' paws, like massive furniture. (The Chian sculptor Boupalos was also an architect.)

Archaic architectural sculpture, then, appears on temples, on the temple-like treasuries, on Ionic altars, but rarely in other contexts until civic architecture rivals the religious in its use of the ornate orders.

The Doric pediment was called *aetos*, 'eagle', a Corinthian invention according to Pindar. It does resemble outspread wings and calls to mind the winged and tailed sun disc which crowns Egyptian and eastern stelai. The earliest pedimental decoration known to us is of large clay gorgon heads from temples at Selinus and Gela in Sicily. These rather heighten the resemblance to the sun disc, but gorgons, facing monsters and monster fights, are recurrent themes on Archaic temples – demonstrations of power not without an element of magical, apotropaic defence. The myth scenes that may accompany and which eventually replace them must relate to the cult or local myth although the connection is not always readily explained, and the symbolism or relevance of the subsidiary sculpture in friezes is often even more obscure. The pediment is an unhappy shape into which to force figure sculpture. Once more than a single gorgon was attempted for it the scheme begins to resemble that of some Greek vase friezes, with abrupt transitions between apparently unrelated subjects, but also with no unity of scale, though the shape naturally requires a roughly symmetrical composition. The scheme lasts even until the Apollo temple at Delphi [203], here to accommodate two of the last of the major pedimental animal-fight groups. Where there is a single theme unity of scale is at first ignored [187, 192], then realized with the help of falling or fallen figures to fit the narrowing wings [206], a constraint favouring battle subjects.

As in most other classes of stone carving the Greek treatment of relief soon displays an originality of execution and intention which far removes it from the shallow pictorial treatment of relief in the east and Egypt, where it covers wall areas rather than helps articulate architecture. At its simplest it is hardly more than drawing, lightly rendered in relief, though this can be infinitely subtle even in the shallowest field, and is naturally best suited to small monuments and not to architecture. Pedimental and eventually metopal figures become executed in the round and attached to, sometimes carved with, or set before the pediment wall or metope ground. An intermediate manner, best suited to friezes and smaller monuments, foreshortens the figures front to back, thus suggesting the whole figure and usually leaving just the head in high half-relief, not slicing through the fully rounded figures as happens in much later relief sculpture. As much detail as possible is carved on the forward plane (where it was drawn) and overlapping is suggested successfully by the slight recession of planes. There are virtuoso examples of this in the Archaic period [208.2, 212.1–2]: later frieze

figures tend to be more discreet. Shadow, heightened by a dark painted background, helped to project and distinguish the figures to the viewer, who was normally far more distant from the carving than the modern museum-goer.

The beginnings: Corfu

The earliest sculptural decoration on temples of the canonic orders was in clay – roof and gutter antefixes in the form of mould-made heads or figures. They appear in the Corinthian sphere in the second half of the seventh century, and it was at Corinth that the Sicyonian Boutades was said to have invented the practice. The island of Corfu (Kerkyra) lay within the area of Corinthian artistic influence, and it is there that we find the first major stone pediment in homeland Greece, on the temple of Artemis [187]. Unity of scale and theme have yet to be sought but the great central Gorgon and her two leopards make a brave trio. At this date there is inevitably still much linear detail to be defined in colour, with incised and compass-drawn outlines or low relief in the maeander-patterned dress. Much is conceived still in flat planes, but the smaller figures are almost in the round or only partly foreshortened front to back in what is to be the normal manner later. Chrysaor [187.2] is a notable figure, his features and body too advanced to allow the very early date once proposed for the pediment. His grotesque face suits his family background but the hooded lids and grimace are pleasanter when viewed from below. Sculptors are quick to make allowances for the unnaturally oblique viewpoints required for most architectural sculpture.

Athens

Most of the architectural sculpture found on the Acropolis is of limestone (*poros*), stuccoed and painted. It is generally now assumed to have been discarded after the Persian sack of 480/479, but since it all antedates the end of the Peisistratid tyranny in 510, since it was found in a fairly compact area immediately south and east of the later Parthenon, since there is a strong suspicion that there are originals and replacements for single buildings, and since only one major foundation is preserved (immediately south of the Classical Erechtheion, and still visible), and the idea that there was a second where the Parthenon now stands remains purely hypothetical, the older theory of the demolition of the tyrants' buildings after 510 and depositing of debris (*Tyrannenschutt*) thirty years before the Persian sack (producing the *Perserschutt*) should not be too readily abandoned. Peisistratos had promoted himself to live beside the gods on the Acropolis – the safest place for a tyrant – for at least some of his years in power, and so had his sons. It is understandable that his buildings, even perhaps sacred ones, might have been thought an affront to Athens and Athena, and it is always possible that some of the smaller pediments are not

from sacred buildings at all. It would be unparalleled, so far as we know, in this period for a house or palace to be so decorated, but Peisistratos had posed virtually as a second Herakles, protégé of Athena, and Herakles is the dominant theme of the architectural sculpture of the dismembered buildings on the Acropolis. The only building that must have survived 510 was the temple of Athena with her sacred image, though the building had been newly furnished with marble pediments.

The earliest pieces are marble, the first use of the material on Greek buildings, if they are in fact architectural: a gorgon which may be an acroterion [188], possibly a Perseus and appliqué relief leopards [189]. The gorgon's hair, ears and eyes show some advance on the Dipylon head [62], the panthers some advance on the Corfu pediment [187]. The Athens pieces cannot be much later than 580–570, probably still too early for any temple constructed for the reorganized Panathenaia in 566. None of the limestone sculpture is near them in date though scholars have preferred to distribute the surviving pieces through the century and not subject them to the same general process of scaling down dates rightly applied to major works in marble. The tendency for some elements of the limestone sculpture to look primitive may be inherent in the treatment of the softer material, or the sculptor's different handling of figures to be viewed only at a distance. The reconstruction of pediments from the shattered fragments has provoked considerable speculation. Of the larger animals there is, at least, a lioness tearing a bull [190], a recumbent lion, and a lioness with a lion together tearing a bull [191]. The first may be somewhat the earlier but all are virtually in the round, not relief, of comparable though not uniform scale, and with no greater stylistic differences than are observed in the figures of other Acropolis groups. It is not altogether impossible that all except the first are from one building, which must be the Athena temple whose foundations we see. The animal threesome was certainly assembled with other figure groups beside it and the consensus seems in favour of the animals central, with a Herakles and Triton at the left, the three-bodied 'Bluebeard' [193] at the right [192.1]. A recent controversial suggestion for the other pediment [192.2] places a gorgon (of which there are possible scraps) between lion and lioness (compare Corfu), the snakes which are also available at the corners, promotes an Introduction of Herakles to Olympus [194] (hitherto taken as a small separate pediment), and restores a Birth of Athena (including [195]) to match the myth figures at the other end. The felines are far more developed than the Corfu or marble Acropolis leopards, the mass of their soft bellies realistically spreading on to the bodies of their victims, a treatment well in advance of, for instance, the Calf-bearer [112], let alone the architectural pieces named. The other figures too, in style and iconography, can hardly be earlier than about 550, despite some primitive-seeming features: additions, it may be, to the temple with the 'gorgon acroterion' in marble and perhaps replacing the limestone lioness and bull, and conceivably no earlier than Peisistratos' return to rule in 546. This

view is supported by the assembly of the pediments indicated in [192] but does not depend on it.

Of the smaller pediments the exceptionally shallow relief of the Herakles and Hydra [196] may indicate an earlier date, unless it is a secondary, back pediment. A small Herakles and Triton [197] is more nearly in the round and the mysterious Olive Tree pediment [198] where the narrative is presented more as in a puppet theatre than with figures filling the pediment field, need hardly be earlier than the large limestone pediments, to judge from the developed treatment of dress folds.

In about 520 the Athena temple was provided with new pediments, of marble now. One end included lions with a bull, very close in style and composition to its limestone predecessor: another reason for not dating the latter too distantly. The other has a gigantomachy [199] where the fighting and falling figures can fit the gable without offending unity of scale. This is the work of a great sculptor, an artist who for the first time grapples with the problems posed by figures in the round (though for a single viewpoint) in twisting, violent action or collapse, but still far from success, still bound to the rigid axes on which figures and their parts are composed: 'in force of movement they are the only archaic statues really comparable with the west pediment of Olympia' (Payne). Fragments of a large frieze [200] must also have had an architectural setting but they are later than the temple, post-Peisistratid, and unlikely to have anything to do with it.

In the lower town of Athens there were large and small limestone pediments with lions, one with satyrs and women for the temple of Dionysos [201], and in marble a Herakles with the lion and another with two lions and a bull. To judge from vase paintings some of the new fountain houses built under Peisistratos carried acroteria and pedimental sculpture (animals, a satyr). At Eleusis the famous running girl [202] and a female winged figure are thought to be from the pedimental group of a small building overthrown by the Persians. The distinctive flat, flaring pleats and the treatment of features and eyes found on other works from the site suggest the existence of a local studio or influential local stylist in statuary.

Central and south Greece

The early Archaic temple of Apollo at Delphi was destroyed by fire. A subscription list for a new one was opened and the exiled Athenian family, the Alkmaionids, undertook the contract, themselves paying for marble to be used instead of limestone on the east façade. Herodotus says this was done after their abortive attack in Attica in 514 but some scholars have found difficulty in believing the temple sculptures to be so late. The building was in some respects a rival to the Peisistratid temple of Athena in Athens and borrowed from it the gigantomachy theme for the west pediment, of which very little survives. The

east pediment [203] retains the old, disjointed composition of the older Athens pediments and Corfu, with animal fights at either side and a frontal centre piece with attendants and a chariot bearing the deity. The frontal chariot was repeated at the west for Zeus. The challenging frontality of the early gorgon pediments is divided now between the displays of power in the animal fights and a calm presentation or epiphany. In style and detail the kore attendants [142] in the east pediment and the Nike acroteria [204] so much resemble Antenor's kore in Athens [141] that it is most likely that Antenor designed the Delphi pediments.

The temple of Apollo at Eretria in Euboea was destroyed by the Persians on their way to defeat at Marathon in 490. The city had been closely associated with Athens, both under and after the tyrants, and despite the temple's occupant it is Athena [205.3] who stands at the pediment's centre (this seems to be the back pediment, however), another early example of the frontal-central-deity theme. The fight around her is of Greeks against Amazons with Theseus, new darling of the Athenian state, carrying off their queen [205.2]. Style and subject might suggest Athenian interest and perhaps patronage in post-tyrant years. The figures were carved in the round and fastened to the background by large square pegs. The cutting is sparkling and sharp, the postures well in advance of the experiments in the Athens temple but the figures comfortably rounded in a non-Athenian manner. One of the Amazons appears to have been salvaged in antiquity and carried off to Rome [205.1].

For the fullest expression of the fight motif as a pediment filler we turn to the island of Aegina. At the end of the sixth century a large Doric temple was built for a local goddess, Aphaia. Both pediments house fights, with a central Athena, probably as patroness of the Greeks at Troy where the action seems to be set, being chosen because of the involvement there of Aeginetan heroes Telamon and Ajax. The sculptures were excavated in 1811, bought by King Ludwig I of Bavaria and restored and improved by the neo-Classical sculptor Thorwaldsen. The restorations have been removed from the new display in Munich. The east pediment seems marginally later in style and more advanced in composition than the west. The earlier pediment [206.1], in the latest reconstruction proposed, presents duels beside Athena and symmetrical groups with the action moving towards the corners. The later, east pediment [206.2], has a more active Athena, the action moves rather towards the centre and the figures are more ambitiously posed with some falling, others poised to support. In some ways the contrast between the two is the contrast between the Archaic and the imminent Classical, yet little more than ten years may separate them. It seems that an east pediment had been designed and at least in part completed in the earlier phase of construction, but never installed and the figures were displayed on a base near the east end of the temple together with an acroterion (two korai and an anthemion; there were sphinxes at the roof corners). The subject and style are as for the west, and scraps have suggested that there might have been yet a third

group prepared (possibly not for a pediment) involving women – perhaps Zeus pursuing Aegina. The twisting and falling figures of the east pediment are figures more familiar to us in vase painting, or in the high relief of the Megarian treasury [215], but here they are executed in the round, severely testing the sculptor's understanding of the anatomy of torsion. He had still, it seems, a little to learn, but these figures only suffer in comparison with the Athenian treasury at Delphi [213] through their scale and the artist's decision to attempt figures in action but off balance. Onatas of Aegina, whose attested works are slightly later, is a name often associated with the east pediment. An Aeginetan sculptor's signature appears on the Acropolis at Athens and his name, Kallon, was known to ancient writers who record many more from the island in the fifth century and remark their skills in bronze work. How far the sharp detail of the marble figures and their many metallic embellishments reflect this tradition it is hard to say, but a bronze head from Athens [207] in the style of the pediments conveys the quality of Aeginetan work in the metal, and its essential identity with styles in marble carving.

There are other important pediments of homeland Greece in the Archaic period, but smaller or less well preserved. I mention only a fine marble fragment of a small pediment with a fallen Amazon in the corner from Kopai in Boeotia; scraps of a terracotta Amazonomachy from Corinth, which reminds us of the city's earlier reputation in architectural sculpture in this material; and a recent find on Corfu, apparently from a temple of Dionysos, with an excellent limestone study of Dionysos and a lad at a symposium, with a dog and lion and, it seems, attended by satyrs. The style here is still broadly Corinthian [207a].

Treasuries

Treasuries are small, one-room, temple-like structures usually with columned porches, dedicated by states at the national sanctuaries both as rich tokens of thanksgiving and of ostentatious piety, and as repositories for rich offerings. The most elaborate are at Delphi and Olympia, and the majority date from the Archaic period. At Delphi they flanked the Sacred Way to the temple: at Olympia they overlooked the altars and the end of the stadium.

The earliest with sculptured decoration is the Sicyonian at Delphi, presumably dedicated by the tyrant Kleisthenes near the end of his rule, about 560. Its remains, with those of a strange round building, were found in the foundations of the later Sicyonian treasury. The earlier buildings, also Sicyonian, we assume (their stone seems to come from the area of Sicyon), may have been destroyed in the earthquake of 373. The treasury is unusual in having an all-round Doric colonnade of 5 × 4 columns, providing fourteen unusually broad metopes for relief sculpture [208], four of which are almost wholly preserved, with some scraps. Inscriptions painted on the background named the figures and an interesting design feature is the apparent continuation of a single

object, the ship Argo, on two adjacent metopes, and the action carried across an intervening triglyph, if one with a boar shows the Calydonian creature and it is being attacked. The compositions are ambitious with the frontal horsemen severely foreshortened [*208.1*] and the brilliant impression of receding planes achieved in the cattle rustling [*208.2*]. Within the shallow field the sculptor finds room for considerable subtlety in modelling of anatomy and of dress, notably in the Europa relief [*208.3*].

Possibly more than one treasury at Delphi had Caryatid korai for porch columns. To the Cnidian parts of bodies only have been attributed. Of another there is a head [*209*] resembling the most ionicizing of the Athenian Acropolis. And there is the Siphnian, the most important of the Delphi treasuries. Siphnos had struck it rich in her gold and silver mines and the treasury was a tithe from her new wealth, built before the island was sacked by the Samians in 525 and the mines flooded; but only little before, we might judge, and there are signs of haste and incompletion. One beautiful Caryatid head is preserved [*210*] and enough of the bodies to show affinities with Cycladic korai. The relief decorated drum on her head is an architectural feature, to make an easy transition to the carved capital, not a formal polos head-dress, as sometimes described. The building is articulated by exquisitely carved Ionic mouldings and apart from the maidens in the porch had sculptured acroteria (Nikai), a frieze all round over the architrave, and two pedimental groups of which that on the back is preserved. The pediment [*211*] is unusual in having the lower parts of the figures engaged with the back wall, their upper parts in the round with the background deeply recessed. The scale of the centre group is uniform, with a slightly taller Zeus, reducing for the figures and horses at either side. The long friezes [*212*] are continuous compositions but the south has much missing. Of the short friezes that at the back (east) is bisected and each half, interrelated in theme – Olympus: Troy – symmetrically composed; that at the front is trisected to match the triple division of the porch. Painted inscriptions named the figures and were probably several times repainted, but few have survived. On a shield in the north frieze a signature has been severely recut but is just intelligible. The artist's name has been variously restored as Endoios or Aristion of Paros, but he claims to have carved 'these and those behind', i.e., the north and east friezes, which are the only ones on which painted inscriptions also survive. This is clearly true and we can add perhaps the surviving pediment and attribute to a second master the south and west friezes, with the Caryatids. The former artist cuts stockier, bigger-headed figures which look like early Athenian red figure vase painting rendered in the round, and he displays notable skill in cutting the roundness of figure and limb despite the shallow relief, and real virtuosity with overlapping figures which avoid becoming merely confused. Thus, the chariots in the Troy scene are shown in three-quarter view, not profile, the receding parts being painted on to the background [*130*]. His companion works on detailed forward planes cut abruptly back at the edges, and his high-crowned

heads have seemed to some north Ionian beside his colleague's Cycladic. The building faced away from the visitor mounting the Sacred Way, who thus saw the east and north friezes first. If the 'islander' created the façade for the island treasury it was the more gifted eastern guest artist who secured the more conspicuous fields to decorate.

The Siphnian treasury is the high point of Archaic decorative sculpture, almost overwhelming in the elaboration of all surfaces and members which were by then deemed suitable to receive it. With colour and the many metal additions of weapons and jewellery it must have resembled more a large and glittering casket, less than nine metres long, than monumental architecture. Moreover, in the composition of the friezes it demonstrates Archaic narrative at its best, and the ingenuity with which Greek artists could face the problem of presenting complicated action in shallow relief. The gigantomachy theme, the Olympian defeat of the powers of primaeval earth, recurs often in Greek sacred sculpture and secular art. At Delphi it reflects as truly the quality of its age as it does over three centuries later, on the altar of Zeus at Pergamum.

Little later and of comparable quality is the sculpture from the Massilian (Marseilles) treasury at Delphi. The scraps that survive show that the style owed much to the north Ionian taste and origins of the settlers from Phocaea.

The Athenian treasury at Delphi, now rebuilt on the site, is the best known of these monuments, one of the latest of the Archaic series and, like the earliest, of the Doric order. Pausanias says it was dedicated after Marathon (490) but style and architecture point to a somewhat earlier date, and it is likely that he was misled by the immediately adjacent base, which *was* Athenian and for Marathon. The subject matter of its metopes, dividing the honours between Herakles and Theseus, makes it a good propaganda document of the new democracy, especially since Theseus is given the more conspicuous position, but does not chime with what we know of Athenian symbolism for Marathon. There are scraps of pediments including a fight at one end, chariots and perhaps a frontal Athena at the other, which would then be a direct further reference to the dedicating state. The acroteria were mounted Amazons, adversaries of both the heroes celebrated. The metope figures are wholly in the round or only tangentially attached to the background with which they are carved [213]. The figures are comparatively neat and small, not crowding the field, and the artist, dealing mainly with stock themes, occasionally creates for his subjects new compositions. Style and theme invite comparison with Athenian vases and suggest a date hardly much after 500. Athens itself offers no architectural sculpture of these years, so close sculptural comparisons are lacking since the shallow grave reliefs and major Acropolis dedications in the round, not all from Athenian hands, are different genres. But the treasury metopes own no other obvious home and we would expect an Athenian artist. The hard detail of hair, features, anatomy, is brilliant and the sharp pattern in no way hinders the effective vigour of the compositions. Limbs and torsos posed in triangles or

oblique lines in the field present more thoughtful compositions than the horizontals and verticals of earlier metopal schemes, but are not yet as carefully balanced as they will be on, for instance, the temple of Zeus at Olympia. The sad state of preservation is tantalizing, yet wherever any major part of a figure survives it satisfies the eye as well as any late Archaic sculpture from anywhere in Greece. With the Aegina pediments, where composition is determined more by field than subject, they are the ultimate expression of Archaic narrative in sculpture. Single metopes can be securely placed architecturally on both the north and south sides and they suggest that the nine north metopes carried separate Herakles scenes, the south (more conspicuous) Theseus. At the back (west) one fallen metope suggests that the six showing the narrative of Herakles and Geryon go here, the action crossing the intervening triglyphs; leaving metopes with an Amazonomachy at the front, and of this we do not know whether it involved Herakles, or Theseus, or both, or neither.

The treasuries at Olympia are all Doric, more than half of them the gift of Greek colonies. From the pediment of the treasury of Cyrene is a fragment showing the eponymous nymph wrestling a tiny lion. Cocks and hens from this treasury and another, perhaps of Byzantium, suggest that the cock fight was a relevant symbol for a sanctuary devoted to sport, and this symbolism for courage in competition is met elsewhere in Greek art (cf. *ABFH* 167). A superb fragmentary relief [*214*] comes from another treasury but the only substantial sculpture surviving is from the pediment of the treasury of Megara (just possibly the Megara of Sicily, not Greece) with its gigantomachy in a high relief approaching that of the Athenian treasury at Delphi, but poorer in execution. It is composed in duels [*215*].

East Greece

We start with the least characteristic of all east Greek assemblages, the sculpture of the temple of Athena at Assos in the Troad [*216*]. Athens had dealings in this area in the sixth century and this may be the reason for it being the only Doric building on this coast and for the Herakles scenes upon it. It carries carved metopes, at least at the front, but the architrave below bears a frieze at front, back and sides (or for most of their length) in the Ionic manner and there is no pediment sculpture, another Ionic trait. The material is the local hard, brittle andesite. This partly accounts for the primitive appearance of the shallow relief which may be regarded as truly provincial and dates well into the second half of the sixth century.

The first massive Ionic temples of the rulers and tyrants of Ionia were built in the second quarter of the century, with important rebuilding or continuing work of decoration through the Archaic period. From buildings at the Heraion on Samos there are tantalizing scraps of high quality relief friezes including some over lifesize. The temple of Artemis at Ephesus is more rewarding. We are

told by Herodotus that King Kroisos of Lydia paid for many of the columns and since he was deposed in 546 we have a terminus ante quem for the earliest sculptures, some of which were applied to the columns – to the lowest drums at the façade or, just possibly, the topmost drums. But none of the fragments of the dedicatory inscriptions naming the king are attached to the sculptured drums, the temple was long a-building and the surviving pieces are few. It is with a touch of optimism, then, that we regard the reliefs as an indication of the point reached in the rendering of dress in relief sculpture before 546. The figures on the columns are almost in the round [217]. The shape of heads and their soft, fleshy features are those of central and south Ionian sculpture, already discussed. There was no frieze on or over the architrave but there was a shallow one all round the gutter (0·88 high), apparently not begun before about 525 and being added to still in the fifth century.

At the temple of Apollo at Didyma we find the entablature frieze again but not a narrative one, as at Assos or on the Siphnian treasury. At the corners are flying gorgons and beside them massive reclining lions [218]. The lower column drums were decorated, however, not with a frieze of profile figures as at Ephesus, but with women facing outwards. Two heads are well preserved, wearing an epiblema veil held by a fillet. Their features are warm and velvety, a quiet enigma behind closed lids and lips, servants of a famous oracle [219]. The same scheme of out-facing women but with quite different intent appears on a smaller drum from Kyzikos, in the north, where they perform a ring dance [220].

The relief drum was one of the few recurrent features in the diverse record of architectural sculpture in east Greece. Another is the use of the relief frieze, not continuous, as at Assos, but in repeating slabs, a scheme inspired by the relief clay revetments widely used in both Greek and native regions of Anatolia and clearly related to a comparable Etruscan practice. Fine series of examples in stone relief, with the popular racing chariot motif, are found at Kyzikos [221] and earlier at Myus [222] and Iasos. A relief with Europa from Pergamum may also be architectural, and others from Kyzikos with a Herakles and a heraldic group of lions over foreparts of bulls.

The Cyclades have virtually nothing to offer by way of architectural sculpture but on Thasos, the Parian colony in the north Aegean, we find a new genre, the relief decoration of city wall gateways with figures of deities in a robust late Archaic style [223], something much more in the manner of Hittite Anatolian architecture.

Chapter Eight

RELIEFS

The use of relief or painted slabs as grave markers or as votives was not peculiar to Archaic and Classical Greece but their manner of decoration there was novel. Comparable grave markers are not commonly found in the east or Egypt, but the royal tombs of Mycenae show the practice already established in Greece and the discovery of such monuments might have contributed to the ultimate choice of the relief grave stele. The barbarian knew votive reliefs and those which show an act of adoration find some parallel in Greece: what is new is the Greek monumentalizing in relief of more trivial symbols or of representations of the dedicator or deity. We deal here with relief work far shallower than that for contemporary architectural sculpture. At times it is hardly more than emphasized drawing, yet at times its subtlety of expression is exquisite. We have to remember that painted stone and wood may have been in common use for these purposes too, and occasionally painted clay.

In this chapter we look first at the grave markers – their shapes then their decoration, noting regional developments or taste where appropriate; then the votive reliefs. Athens dominates the first class more than the second. Some decorative reliefs from larger monuments will also be mentioned.

Grave reliefs

Plain and sometimes very rough hewn slabs served as grave markers in Geometric and seventh-century Greece. There is no unequivocal evidence that any bore figure decoration, although some are inscribed, and it seems likely that kouroi were serving as grave monuments before figure-decorated stelai appear.

In the sixth century Attica presents the fullest series [224] and must serve as our yardstick for practices elsewhere in Greece. The tall rectangular stelai are topped by splaying cavetto capitals [224.1, 2] – an Egyptian member which was also used in the Doric order. These capitals are decorated with incised and painted tongues, a variety of florals or, rarely, figures on front and sides [229]. About 550 this is replaced by a double-volute scroll [224.3], like a lyre, a type which is abandoned by about 530. All these capitals carried sphinxes, some perhaps a gorgon, in the round, the sphinxes' heads turned to the viewer. One early sphinx sits with haunches low and is carved in one piece with the capital [224.1]; later they raise their haunches and so require a smaller plinth set in to the

stele top [*224.2, 3; 226–8*]. The shaft usually carries a single male figure in relief [*230*], but there may be a panel below [*231*], or above and below [*224.3*], decorated in relief or paint only, and stelai with the main figure only incised and painted, not cut in relief, are not uncommon.

The grave stelai of Ionia, best known on Samos, are not usually figure-decorated, but are plain shafts topped by elaborately carved palmette anthemia, some of the earlier being supported on lyre volutes. It is likely that these inspired the change from the cavetto in Athens and almost certain that, in common with so much else in Attic art, they inspired the stele type which follows those with sphinx crowns [*224.4, 5*]. These later Attic stelai have palmette crowns only, or double or single pairs of volutes, still with reliefs on the shaft but the whole monument is shorter and less elaborate. The type disappears at the end of the sixth century, presumably the result of legislation, hinted at by later authors.

The early stelai of Attica are not readily matched elsewhere but comparable monuments were certainly known. In Boeotia the Dermys and Kittylos stele [*66*] had a crown of some sort and later there is a lyre volute capital, very like the Attic, and some marble relief shafts. There are also stele crowns resembling the Attic from Aegina and, in clay, from Corinth, and a marble sphinx from Corinth, possibly from a grave stele. However, in the last decade of the sixth century and later, when the Attic series ceases, several slim stelai with palmette crowns are found throughout the Greek homeland and colonial world: far more than can be attributed to any diaspora of disappointed Athenian sculptors. The shape and decoration for stelai in these areas are retained into the early Classical period. The only important innovations are a more deliberately architectural setting for some reliefs [*244*], where on the Attic there was no frame, or only a simple narrow border which has the relief background rising gently to the forward plane and with a narrow 'shelf' as ground line; and some examples of two-sided stelai in north Greece, a feature of a famous earlier stele from the borders of the east Greek world (Dorylaion).

All the stelai so far discussed have been tall and slim. A broader variety appears in the late Archaic period [*236–8*], in Athens and elsewhere, its shape determined by the seated figure or multi-figure group upon it. With some of these we approach problems of identifying function, funerary or votive.

In the last years of the Archaic Attic stele we find also in Athens rectangular bases with relief decoration on front and sides [*241–3*] which served to support grave stelai or statues, but the type goes back to near mid century with one example, carved on the front only [*240*]. A metope-like slab with a horseman (of which there is also an example on Chios) and the enigmatic 'Marathon runner' [*239*] may be from grave monuments of other types.

The commonest subject on the Attic stelai is a standing naked youth – a kouros [*230–2*]. He usually holds a staff or javelin but may be further characterized as an athlete by holding an oil flask (*aryballos*) or raised discus [*117*] and an older man raises the bound fist of a boxer [*233*] – a fine characterization

with broken nose and battered ears where other heads convey the impersonal calm of the monumental kouroi, but more intimate, in a way, for the relief setting and the attributes held. Some later stelai carry a more mature bearded figure, fully armed [234, 235]. Occasionally there are pairs of figures – two youths, brother and sister [224.3], man and youth (this from Thebes), two warriors (one crouching) on a broader stone [236]. If we include painted stelai we can detect a tendency to dress on the later ones, both for men and youths, and an important theme continued on later, non-Attic stelai, is the older man leaning on his stick, with his dog [244]. The Attic stelai seem to present archetypes for the three ages of Archaic man – young naked athlete: warrior: man and dog – with javelin, discus or aryballos: with spear and armour: with a crutch. If the man-and-dog type originates, as has been suggested, in east Greece, it may be that all these variants identifying different ages and occupations were encouraged by east Greek artists, as much else in Attica of these years.

Seated figures such as appear also as grave markers are the subjects for a few broader stelai. The touching mother and child [237] was probably one but there are pieces of a male figure too, from Velanideza in Attica. The famous relief [238] may then very well be a grave monument, in which case we are brought very close to the subjects of Classical stelai, and a slightly later stele from Aegina shows the *dexiosis* handclasp between a standing man and a seated woman, a common motif later.

In subsidiary panels on stelai we have a minatory gorgon [231], but otherwise only horsemen or chariot scenes [229], which probably reflect upon the status of the dead, not without some hint of heroization. The stele or kouros bases likewise offer horsemen and chariot [240, 241] but also athletes [241, 242.1], a leisure scene [242.3] and once the animal confrontation [243] which recalls older fighting groups and displays of power.

Many of the stelai and bases from Athens were recovered from the 'Themistoclean wall', thrown up hurriedly after the departure of the Persians, in which, as Thucydides notes, grave monuments were incorporated. Inscriptions appear on the shafts or bases of stelai, or both, to name the dead, sometimes the artist, and we have noticed some stelai and bases already in discussing Attic sculptors. Stele and base are not often found together but on a famous exception [235] Aristokles signs on the stele ground line, with the dead Aristion's name appearing alone on the base. His name is found also on one, perhaps two other bases for broad stelai and on a kouros base for a Carian, Tymnes, which is inscribed in Carian script too. He was an artist of quality, not far short of his contemporary Endoios, so far as we can judge, but forgotten by ancient commentators on Greek art. (There is record of a Sicyonian sculptor of this name and date.)

The very wide use of stelai outside Attica at the end of the Archaic period has been remarked. The subjects are frequently like the Attic, often youths but

more often clothed now [245], and the man-and-dog stele becomes especially popular. A notable example which demonstrates the continuing role of Naxos and mobility of artists is that made by the Naxian Alxenor for a grave at Orchomenos in Boeotia [244]. New motifs are the standing girl, alone on a stele [246] (Crete) and a child holding a cock and oil flask [247] (Kos). Broader stelai with unusual subjects include one from Kalchedon on the Bosporos perhaps commemorating death in childbirth [248], and one with an erotic subject from Kos [249] where the funerary connection is more questionable.

Votive and other reliefs

Seated figures on grave stelai we have found acceptable in Attica. Elsewhere they begin to pose the question whether they are not better regarded as votive for a goddess or, if a man or couple are involved, votives for a hero cult. We have then to ask whether the hero might be the recent dead and the stele serving as a grave marker also. Where figures of worshippers or attendants are added, often on a reduced scale in the Egyptian manner, the purpose clearly becomes votive whatever the association with a grave, recent or old. A seated figure of a woman appears as early as the mid-seventh century on Paros [250], and there are sixth-century examples from Paros, her colony Thasos [251] and in Boeotia at Thespiae. The seventh-century incised stelai from Prinias in Crete [252] show a standing woman spinning or holding a bird; or a warrior, once accompanied by a tiny attendant; or, once, a seated figure. These are often taken for gravestones and must then have been embedded in standing masonry, but they might all be votive or even decorative like the other Cretan dado reliefs. This would explain why they seem all of roughly the same period, the slight differences of style not being of obvious chronological importance: in a cemetery we would expect a greater range. A seated man on a stele from Lebadea in Boeotia holds a kantharos cup and on one from Rhodes a drinking horn: these associations can be either Dionysiac or funerary. The kantharos appears also in the hands of the seated man on an important series of Laconian reliefs which begin about 550 and continue into the Hellenistic period. Here the man is seated beside a woman, a snake rears behind or under their thrones, and small worshippers approach [253]. These are clearly the heroized dead, and that the stele might serve for the recent dead in exceptional circumstances is suggested by one inscribed for Ch]ilon, the name of a sixth-century lawgiver, one of the Seven Wise Men of antiquity, who is known to have been worshipped as a hero. Most of the reliefs are in a dull, angular style of little merit but a late Archaic fragment is quite competent [254] and shows the relief with a pediment top, such as becomes the norm for broad reliefs from now on. Other Laconian votive reliefs show worshipper and snake or the Dioskouroi.

In the Classical period and later the hero at feast (*Totenmahl*) becomes a common votive subject. In the Archaic period it has an immediate funerary

context only on the periphery of the Greek world, in Asia Minor and Etruria, and examples in Greece – from Tegea and a frieze slab on Paros [255] – are more probably votive or from *heroa*.

We turn to other relief work, votive or decorative. On the Acropolis at Athens an early marble relief carries a bold frontal chariot [256]. The goddess, alone or in action, is one theme for broad stelai, like metopes, but we find also relief-decorated bases, as in the cemetery (one with a chariot scene), and a two-sided stele. Illustrated are a fussily detailed scene of a family worshipping Athena [258], and a pleasing celebration of a festival [257] which demonstrates the use of the pediment over a broad stele to give an architectural setting. The girls engage us in their dance by looking out at us, like those on the east Greek columns [218–20]. The way such reliefs could be displayed is well shown by a contemporary vase painting where the votive tablet is mounted on a column and its façade is provided with doors [259]. As on the buildings of Athens Herakles was a subject for votive and decorative sculpture: a relief of him with the boar [260], and a base at Lamptrai in the countryside [261].

The islands have been cited for examples of early grave or votive reliefs. Paros offers others – slabs with the three Graces (one facing us), a gorgon [262], Artemis with Hermes, the last two in the flat foldless style of the seated woman stelai; and in her colony Thasos, where we saw the city gate reliefs, appears the seated goddess Kybele in a doorway, approached by korai [263]. The scheme is repeated in an Early Classical relief for the island, but Kybele alone in a niche or temple door is a type with a prolific later history in east Greece. An early example carved in the native rock on Chios has won spurious acclaim as 'Homer's seat'. Finally, an enigma from Samothrace [264]: a relief with a mythological scene, the figures named, closed at one side by a griffin head and neck, perhaps from a monumental throne or altar. As with the architectural sculpture, the myth and iconography of minor relief sculpture take us far beyond the range of more familiar and prolific classes of minor antiquities, such as bronzes and vases, and fragments like this are a sharp reminder of our ignorance.

Chapter Nine

ANIMALS AND MONSTERS

Greek artists were hardly less observant of the animal kingdom than they were of man, and the sculpture of the Archaic period includes several sympathetic and accurate studies of animals at rest or in action. In earlier years their presence in Greek art had been determined by their involvement in myth or cult; or, in the case of the horse, for its function as a status or heroizing symbol, whether ridden or harnessed to a chariot; or as symptoms of the orientalizing movement which introduced or re-introduced monsters like the sphinx and near-monsters like the lion, and which made of the 'animal frieze' a commonplace vase ornament.

Horses and horse-monsters, the centaurs, we have observed aplenty. The horses in chariot teams (e.g. [203, 212]) are strictly subordinate to the main theme, although a chariot group alone [234, 241.2] may sometimes, perhaps, be used symbolically. The Acropolis horsemen dedications [114, 165, 166] show the artist as involved in his concern for the rendering of the beast as of the man, as excited by the pattern of muzzle and mane as, in a different way or with different effect, the Geometric bronze-worker had been [8].

Sphinxes have the heads of korai, the bodies of lions; and we have seen them as votive monuments [100] and on grave stelai [224–8], generally facing front and side respectively. The lion and its feline kin appears occasionally in a myth context, as with Herakles, or in major groups of architectural sculpture as a deity's familiar (the leopards at Corfu [187]) or with its prey [190, 191, 203, 243]; but it is also the one animal often presented alone, as grave marker or dedication, and since most Greeks knew it by report or representation rather than by sight, it left the artist more free to let his imagination run over pattern of limb, mane and muzzle, more susceptible also to the influence of foreign models.

Seventh-century vase painting demonstrates a progression in Greek approval from the round- or square-headed Hittite lion to the pointed-nose and shaggy Assyrian. The former, in its tamer aspect, we saw on the perirrhanteria [74, 75, 77, 78]. The latter is more ferocious, with gaping jaws and lolling tongue, and both painter and sculptor make great play with patterns of crinkled muzzle, mane and paws [265], and compare the rounder-headed [266].

In the sixth century the artist lightens the creature's limbs and body, taking as model the dog rather than any feline. One result is the crouching position,

bottom in air, which is purely canine, and other mistakes are the placing of a lioness' dugs along the belly [*190, 191*], and giving her a heavy mane. In the sixth century regional types also become differentiated. The Peloponnese gives the head a heavy ruff of mane [*267, 268*], sometimes, as in Sparta, like a stiff round collar. The Cyclades offer a sleeker transition from small head to neck and long wiry body [*269*]. In east Greece, at Miletus and Didyma, we meet sleepy egyptianizing lions, set in pairs along the Sacred Way or as a grave marker. In the best preserved example [*270*] the artist has excelled in rendering the rough loose pelt, delighted in the languorous sweep of the spine, the pattern of mane, as consummate a compromise of pattern and observation as in any kouros. This differentiation of regional types diminishes with the end of the Archaic period. The head alone long continues to serve architectural sculpture as a water spout.

For other animal statuary the Athenian Acropolis offers the greatest variety: an owl for Athena, a fine dog of the breed met on several grave stelai [*271*], and one of the rarer monsters, a cock-horse ridden by a boy; nor should we forget the calf [*112*]. The horsemen have been introduced already with the Rampin rider [*114*] and there are pieces of others, being ridden [*114, 165, 166*] or led, including a rider in eastern dress and the early frontal chariot group [*256*]. An east Greek marble siren may be a grave monument.

Chapter Ten

CONCLUSION

The pictures and text of this book offer a view of the development of Greek sculpture over nearly three hundred years, from miniaturist works in the formal conceptual style of Geometric Greece, through periods in which the east, then Egypt, suggested new techniques and possibilities, to the sixth century in which the sculptor's own search for improved expression of canonic forms led him to the point at which he wished consciously to take life as his model. The overall development is clear and so is its chronology. In detail it is less clear, and in many respects the dates assigned are conventional. Often they depend on parallels with other, better dated arts, as that of the vase painter where the relative chronology is evident, the absolute chronology fairly well established (for the sixth and early fifth centuries see, on this, *ABFH* 193–5, *ARFH* 210f.). Sometimes vase and 'sculpture' are combined [*41*] or there is a stratigraphic association in a grave [*40*] or votive deposit (Samos and much minor sculpture). There are fewer dangers in comparing, say, a drawn head with a sculpture which was once itself based on a sketch, than in comparing works in fundamentally different techniques, but the difference in scale can be misleading. Absolute dates for the sculptures themselves are few enough. The building of the Siphnian treasury [*210–12*] and the sack of the Athenian Acropolis (p. 62f.) are historically attested and the relevant sculpture can be identified. So too with stelai built into the Themistoclean wall (p. 164). For the temple at Ephesus [*217*] the evidence is more circumstantial, and in dates suggested by the supposed occasions for the overthrow of temples or grave monuments we are in serious danger of seeing associations wilfully (e.g. [*232*]). For a few other individual monuments political circumstances suggest dates – the Apollo temple at Delphi [*203–4*], the Aiakes of Samos [*96*], Kallimachos' Nike [*167*]. But any stylistic sequence, local or general, deduced from such 'pegs' can never give us the confidence to date individual pieces to within, say, ten years, or to allow detailed historical conclusions such as are permissible, often, from the study of pottery.

Almost all the major works of Archaic sculpture were created to serve the religious and spiritual life of the Greeks, from state-financed temple sculpture to the more personal commemorative monuments which immortalized the dead. But the secular constantly intrudes – an artist's signature; the epitaph which names the sponsor of the monument as well as the dead; the extravagant

displays of personal or state wealth in sanctuaries, bribes for gods designed, no less, to provoke mortal envy or respect.

Of the sculptors themselves we know too little. They worked material which was difficult to come by rather than precious, and may have been rewarded for their time rather than their skills. Euthykartidas both made and dedicated a statue on Delos [56], but of the dedications on the Acropolis at Athens we can identify nearly thirty by painters or potters, none by sculptors except for Pollias, and his offering is a clay plaque painted for him by his son Euthymides! In early days the makers of magic images, the Telchines or a Daedalus, were themselves regarded as near-divine. Later in the Archaic period it is their creations alone which acquire sanctity. We know something of Archaic sculptors' careers because the signatures on their works survived to be recorded in later years when such artists enjoyed a higher social status, in an age of the artist not the artisan. In the sixth century, it seems, it was the potters who made money, the architects who won esteem and wrote books (some, like Theodoros of Samos, being sculptors also), while sculptors were less courted than poets, their works, once damaged, prized neither for their sanctity nor their merit (p. 64). Yet of all artists' signatures it is the sculptors' which speak most clearly of their pride in achievement, and in our eyes it is their work which expresses the zenith of artistic endeavour in any material in this age.

Whatever their status in the eyes of their contemporaries, their achievement in terms of the history of western art brooks no criticism. In Greece, as in the rest of the ancient world, before the end of the sixth century, figures and groups rendered in the round, in relief or indeed by other arts as that of the vase painter, were composed as one might compose a sentence: a succession or structure of separate members or clauses which can be reassembled in different ways for different purposes. For drawing and for writing the word in Greek is the same – *graphein* – and we 'read' an Archaic kouros or a narrative scene in the way we read a poem or epic, gathering the parts in succession until, finally, we learn the whole. In drawing and sculpture, and perhaps first in drawing, the artist comes to realize that the elements of his composition become the more effective symbols of his statement, of a figure or of narrative, the more closely they resemble life. So he looks at life, observes the interrelation of anatomy patterns on figures in repose or action, observes the interaction of figures, comes to understand that he can do what the writer cannot – present the whole in a single image: a single realistic image of a man or woman, now more than a sum of parts or dress, or a realistic expression of action which can abandon the 'literary' composition of 'A watched B fight C watched by D' for figure groups which 'freeze' the figures as on film, petrify them as with Medusa's head, and yet lose nothing of the advantages bestowed by older conventions of narrative, in gesture, pose or attributes, and abate nothing of the overriding demands of pattern, composition and proportion which long continue to inform Greek art. This is followed by us more easily, perhaps, in two dimensions than in three, on

vases or in the composition of relief pediments. It led naturally enough to a better understanding of the field or space in which the figure or action is thought to operate, and this ambience too becomes part of the whole and not an embarrassment to be filled or trimmed away. For a single figure in the round it means that the rigid axes on which frontal images of parts are assembled are dismissed, and that for the satisfactory presentation of a unified study of a man life, perforce, becomes the model. What is achieved now in pose is improved later in exploration of expression and personality, and much of the remaining history of Greek sculpture is a study of the shifting dominance of interest in proportion and pattern or in expression and realism. The revolution effected by Greek artists at the end of the Archaic period was neither sought nor achieved by any other ancient people and it determined the future development of all European art.

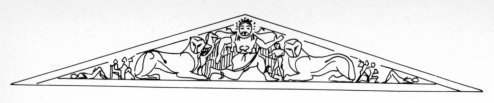

187 Limestone pediment (west) from Corfu, temple of Artemis. At the centre is the Gorgon Medusa flanked by Pegasus and Chrysaor (rather than Perseus) who were supposed to have been born when she was decapitated by Perseus. Both Gorgon and Artemis are Mistresses of Animals, whence the leopards at either side. The small group at the right is Zeus striking down a Titan or giant with a thunderbolt. At the left a seated figure is threatened by a spearman: the scheme resembles that for the death of Priam at an altar, but this subject has no relevance here and it is more likely another display of divine power or retribution, and the seated figure may be female (Rhea, if the other victim is Kronos or a Titan). Stricken or dead Titans or giants in the corners. There are scraps of a similar Gorgon group from the east (main) pediment and of a metope (?) frieze from the porch, with a fight. (Corfu; pediment 3·15 × 22·16) About 580

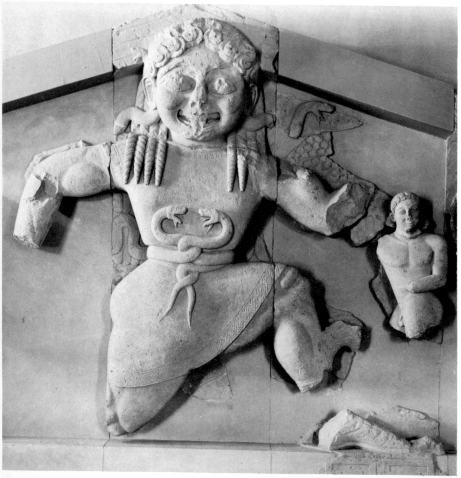

187.1

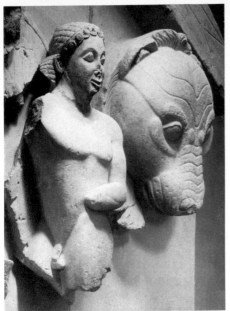

187.2

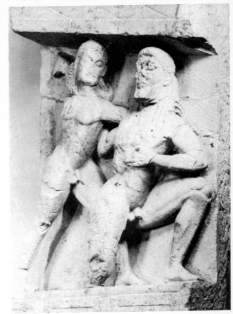

187.3

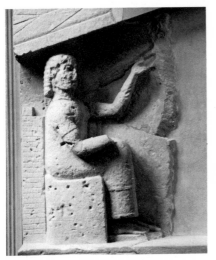

187.4

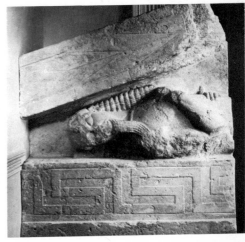

187.5

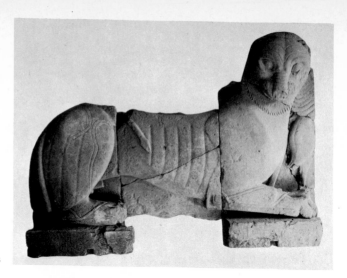

187.6 See previous pages

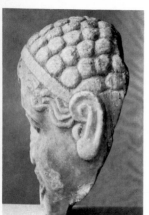
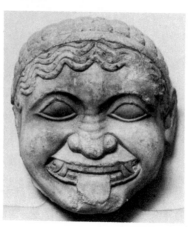

188 Gorgon head from the Acropolis, a temple acroterion. The figure's hands and snake belt also survive. (Acr. 701; H. 0·25) About 580–570

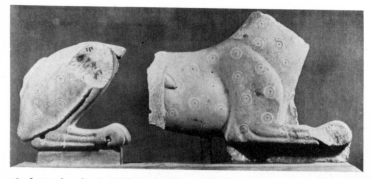

189 Leopard appliqué relief from the Acropolis. Probably from a frieze. Parts of two survive. (Acr. 552 + 554; H. 0·50) About 580–570

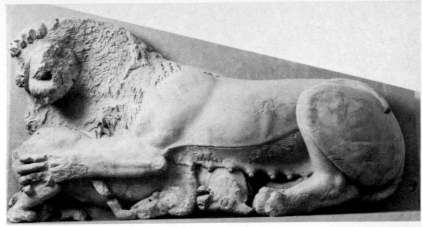

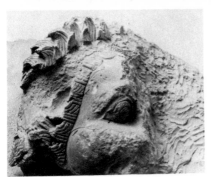

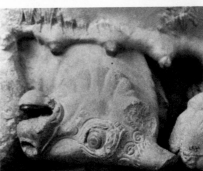

190 Limestone lioness (much restored) and bull from the Acropolis. From a pediment, probably answered by a lion and bull in the other half. (Acr. 4; H. 1·60) About 570–560

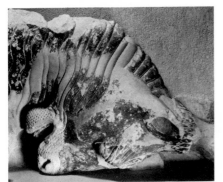

191 Limestone lion and lioness attacking a bull. From a pediment, see 192. (Acr. 3; H. 0·97) About 550–540

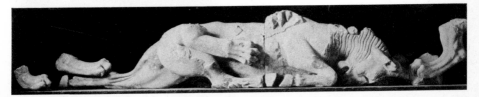

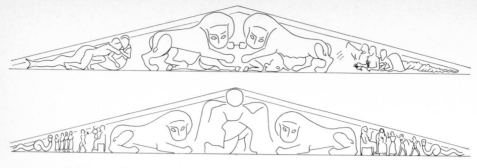

192 Pediments of the Athena temple on the Acropolis as restored by Immo Beyer (the drawings simplified). W. of gable floor 15·40. 1 – Herakles fights Triton; the bodies of the lion and lioness *191* are largely missing, as is the man before the three-bodied monster *193*. 2 – the snakes, part of the lions and scraps of the wings of the Gorgon survive; also parts of few figures from the supposed Birth of Athena group *195* at the left; and more from the Introduction of Herakles to Olympus *194* at the right

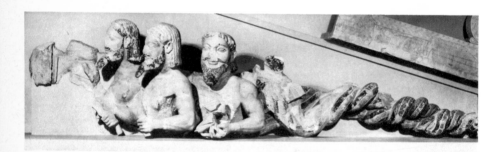

193 Limestone triple-bodied monster (see *192*) from the Acropolis, with wings, snake tails, holding water-symbol, corn, a bird. A symbolic rather than myth figure, of uncertain significance. Hair and beards are blue (the central head's hair is white), the flesh reddy, the scales blue, green and plain. Small snakes were attached to the figures' shoulders and arms. This has been attributed to the master of the Calf-bearer *112*. (Acr. 35; H. 0·90) About 550–540

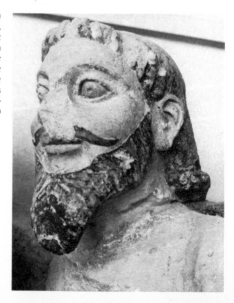

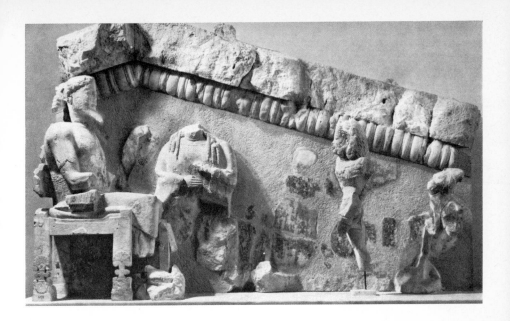

194 Limestone pedimental group from the Acropolis. Introduction of Herakles to Olympus (see 192). Zeus and Hera (frontal) seated, Athena missing, Herakles, Hermes. Here with the possibly incorrect crowning moulding. (Acr. 9; H. 0·94) About 550–540

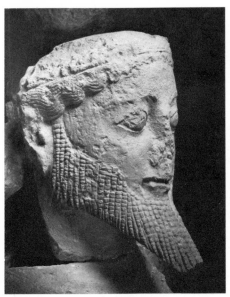

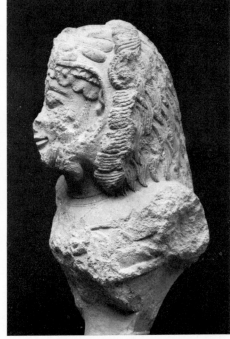

195 Limestone man from the Acropolis, perhaps from the Birth of Athena group (see *192*). (Acr. 55; H. 0·46) About 550–540

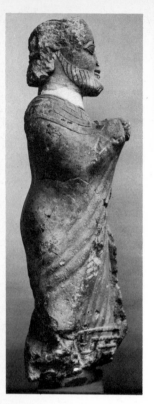

196 Limestone pediment from the Acropolis. Herakles and the Hydra. The crab at the left was sent by Hera to attack Herakles. Iolaos waits with the chariot. Very shallow (0·03) relief. (Acr. 1; H. 0·79) About 560–550

197 Limestone pediment from the Acropolis. Herakles fights Triton; cf. *192*, which is later. The figures are painted a dark brick-red. (Acr. 2; H. 0·63; H. of relief 0·18) About 560–550

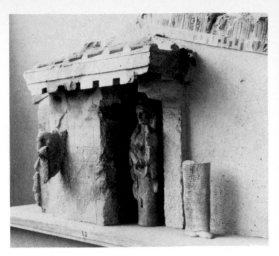

198 Limestone 'Olive Tree' pediment from the Acropolis. A central building with a free-standing girl carrying something on her head. Parts of another two women, and a man at the left before the wall, behind which is an olive, incised and painted on the background. Perhaps the myth-aition of a cult. The Ambush of Troilos has been suggested but the subject is implausible here, the required Achilles and horses are wholly lacking, and the building does not resemble a fountain house. (Acr. 52; H. 0·80) About 550–540

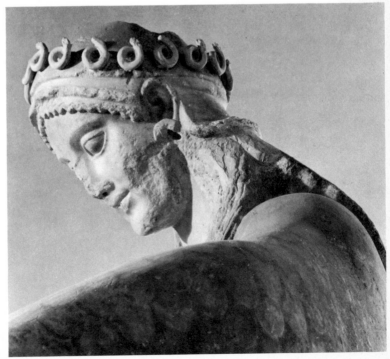

199.1 Athena from the Gigantomachy pediment on the Acropolis. The figures are all slightly over lifesize. (Acr. 631) About 520

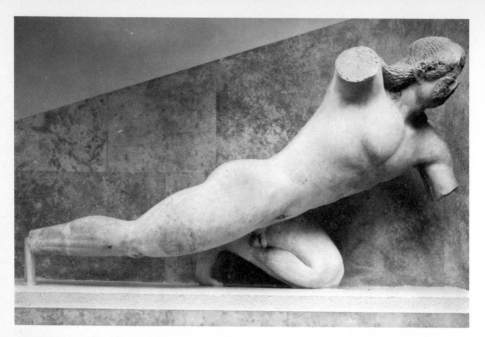

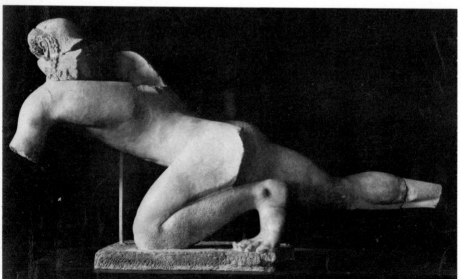

199.2 Giant

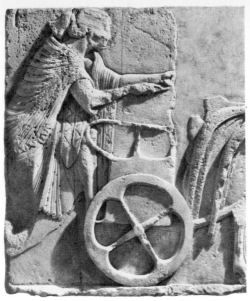

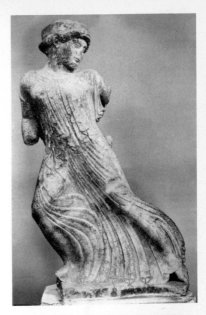

200 Frieze from the Acropolis. A charioteer mounting.
Other fragments include a 'Hermes' and a seated figure;
perhaps an assembly of gods. (Acr. 1342; H. 1·2) About
510–500

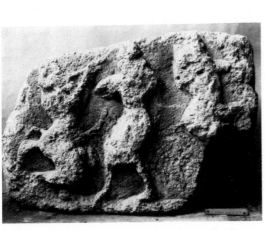

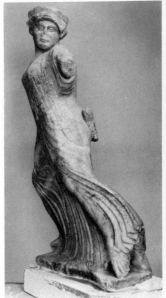

201 Limestone pediment, probably from the temple of
Dionysos, Athens. Satyrs and women. (Athens 3131; H. 0·54)
About 540–530

202 Running girl from Eleusis.
Possibly from a pediment.
(Eleusis; H. 0·65) About 490

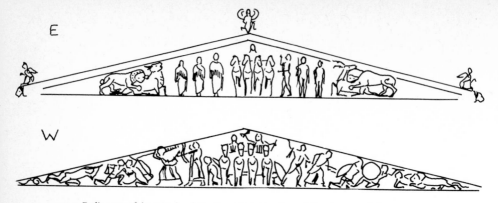

E

W

203.1 Pediments of the temple of Apollo at Delphi, restored. E – the central chariot carries Apollo. Few fragments survive *142, 203.2*. The figures are carved in the round. W – gigantomachy with Zeus in the central chariot (this is far more hazardously restored). (H. of pediment 2·30; E – marble, W – limestone) About 520–510

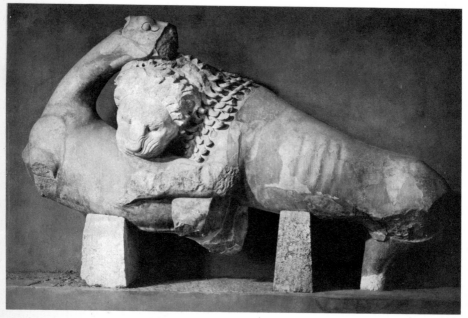

203.2 Lion fighting a hind, from the temple of Apollo, Delphi. (Delphi; H. 1·1)

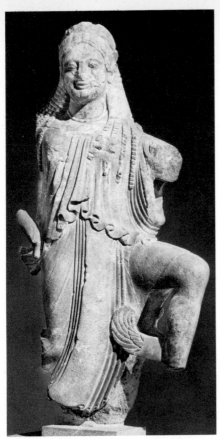

204 Nike acroterion from
the temple of Apollo, Delphi.
(Delphi; H. 1·13)

205.1 Temple of Apollo at Eretria.
Amazon archer. Found in the Villa
Ludovisi, Rome. The figure was angled
out from the pediment wall.
(Rome, Conservatori Mus. 12; H. 0·69)
About 510

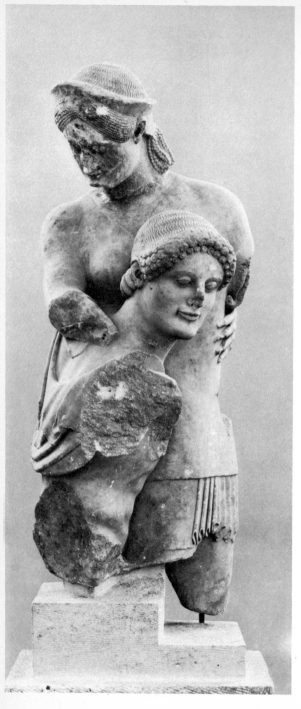

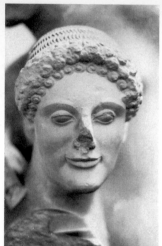

205.2 Temple of Apollo at Eretria.
Theseus lifts the Amazon Antiope on
to his chariot. A low viewpoint
notably improves Theseus' features.
(Chalcis 4; H. 1·10) About 510

205.3 Temple of Apollo at Eretria. Athena; the gorgoneion on her aegis is exceptionally prominent (recall the earlier role of gorgons at pediment centres). (Chalcis 5; H. 0·74) About 510

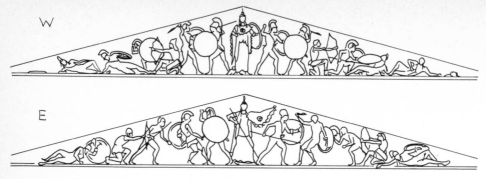

206 Temple of Aphaia on Aegina. Restored pediments (W. 15·0; H. 4·2). West: Probably fighting at Troy involving Ajax of Salamis (but of Aeginetan family). About 500–490. East: Probably fighting in the earlier attack on Troy, since a Herakles is identified *206.6* and he was accompanied by the Aeginetan Telamon (father of Ajax). About 490–480

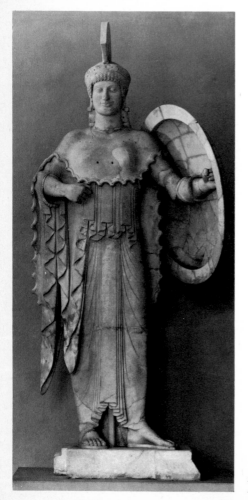

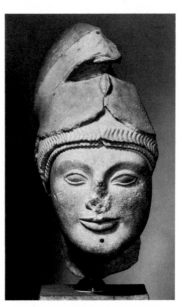

206.2 Warrior's head from the earlier east pediment, Aegina. The hole in the chin is for the attachment of a beard. (Athens 1933; H. 0·28)

206.1 Athena from the west pediment, Aegina. (Munich 74; H. 1·68)

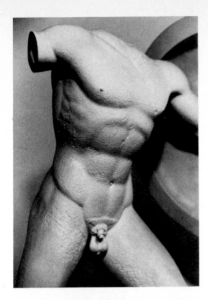

206.3 Torso of a warrior from the west pediment, Aegina. (Munich; cast in Oxford)

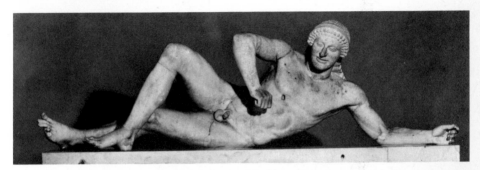

206.4 Fallen warrior from the west pediment, Aegina. (Munich 79; H. 0·47)

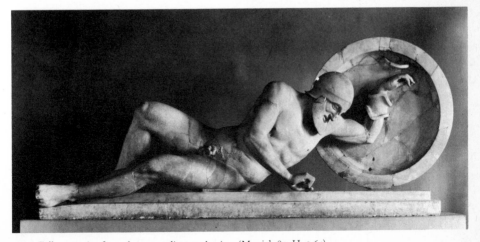

206.5 Fallen warrior from the east pediment, Aegina. (Munich 85; H. 0·64)

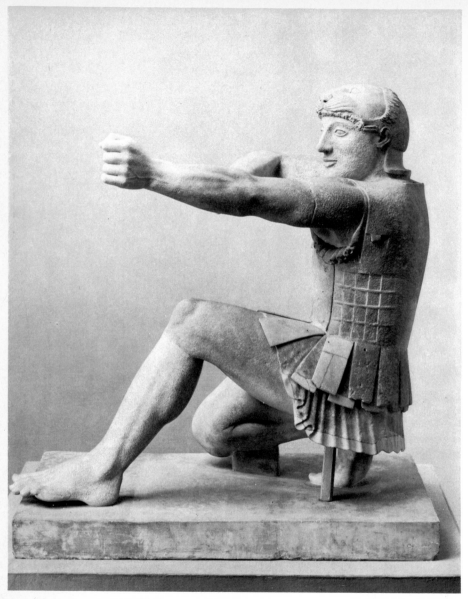

206.6 Herakles from the east pediment, Aegina. He wears a helmet fashioned as a lion mask (see also *213.8*; usually he never wears a conventional helmet in art). (Munich 84; H. 0·79)

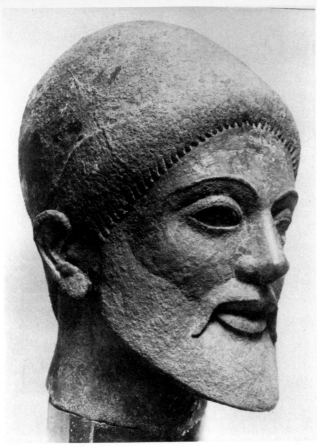

207 Bronze head from the
Acropolis, Athens. Its helmet
is missing. (Athens 6446;
H. 0·25) About 490

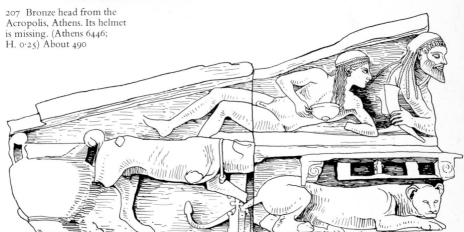

207a Limestone pediment from Corfu, temple of Dionysos (?). Discovered by A. Choremis
in 1973. It shows a feast, with Dionysos and a boy on a couch below which is a lion, the
god's familiar. To the left a mastiff and a wine crater. (Corfu; 2·73 × 1·3) Late 6th c.

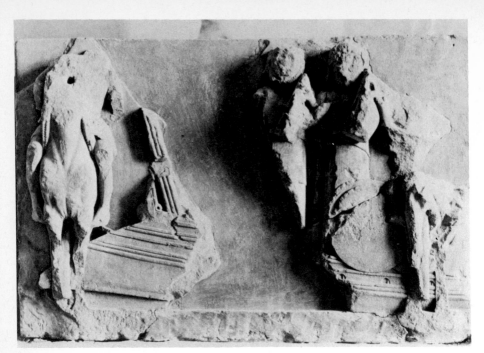

208.1

208 Sicyonian treasury at Delphi. Limestone metopes. 1. The ship Argo (a fragment shows that it was completed on a second metope) with the mounted Dioskouroi at either side and on the ship two cithara players (Orpheus named, the left) and a third figure (...el..). 2. Lynkeus (missing) and Idas, Kastor and Polydeukes (these three named) steal cattle. They each hold two spears in the left hand, a spear or goad in the right. 3. Europa on the Zeus bull. Other fragments show: a boar, perhaps the Calydonian but not obviously attacked though the missing object below is a small hunting dog; Phrixos on the ram: another frontal horseman; a large animal, etc. The Dioskouroi are common to 1 and 2 and perhaps the boar hunt; they were worshipped at Sicyon. (Delphi; metopes 0·84–0·87 × 0·62–0·63) About 560

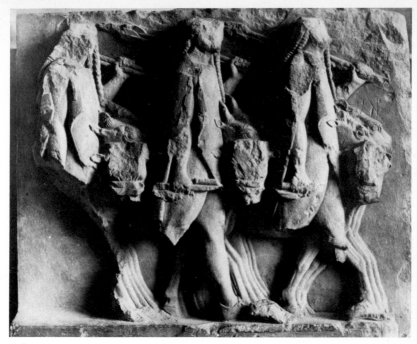

208.2

208.3

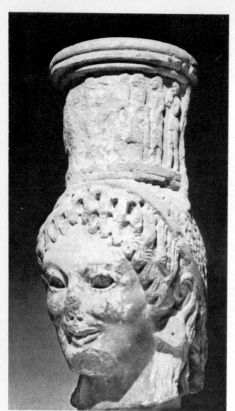

209 Head of a caryatid from an unknown treasury at Delphi. The 'drum' is carved with a group of women, a lyre-player and a syrinx-player. (Delphi; H. 0·66) About 530

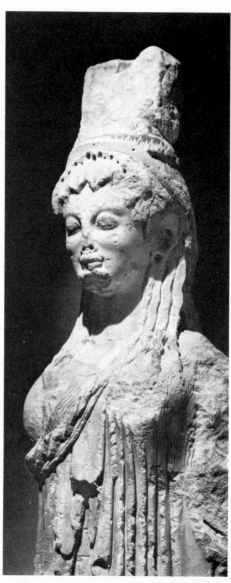

210 Caryatid from the Siphnian treasury at Delphi. The 'drum' is carved with satyrs and nymphs (front missing; detail above from cast), the capital with lions attacking a stag. (Delphi). About 525

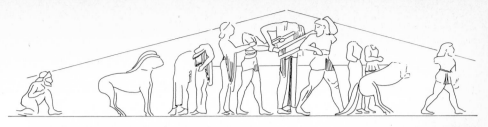

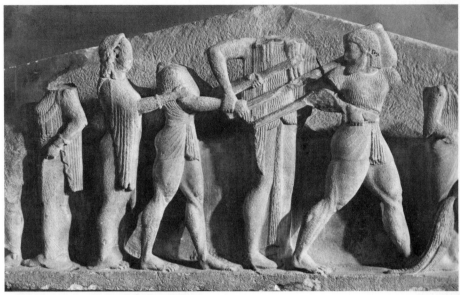

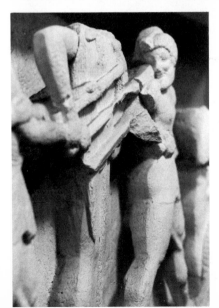

211 East pediment of the Siphnian treasury. Herakles makes to carry off the tripod; Apollo, supported by Artemis, to retain it. Zeus stands between restraining them. The other figures, chariots and horses seem not related to this theme, which may have been used to symbolize the First Sacred War at Delphi early in the century. (Delphi; H. at centre 0·74) About 525

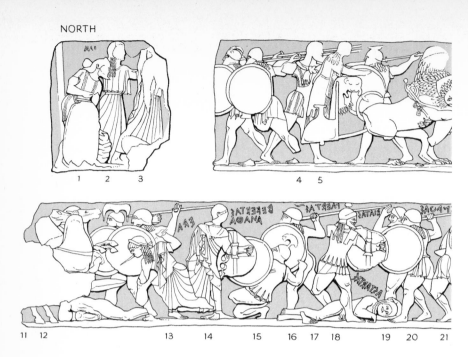

NORTH

212.1 North frieze of the Siphnian treasury. (Figures named by inscriptions are italicized.) Gigantomachy. 1 – *Hephaistos* with bellows to heat coals. 2, 3 – Demeter and Kore, or the Moirai (?). 4 – Dionysos. 5 – Kybele in lion chariot. 6, 7 – Apollo, Artemis. 8, 9, 10 – giants *Kantharos* (note crest holder), *Ephialtas*, *Hypertas*. 11, 12 – Zeus with his chariot (and Herakles?) missing. 13 – *Hera*. 14 – *Athena*. 15, 16, 17 – giants *Berektas*, *Laertas*, *Astartas*. 18 – Ares. 19, 20 – giants *Biatas*, *Enaphas*. 21 – Hermes. 22 – Poseidon (?). 23 – a god. (Delphi; H. of frieze 0·64) About 525

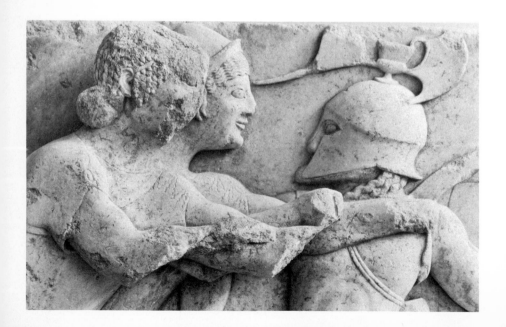

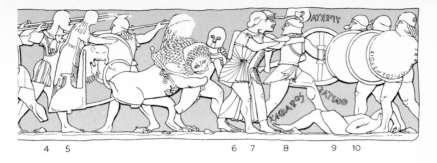

4 5 6 7 8 9 10

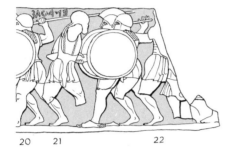

20 21 22

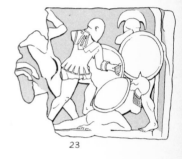

23

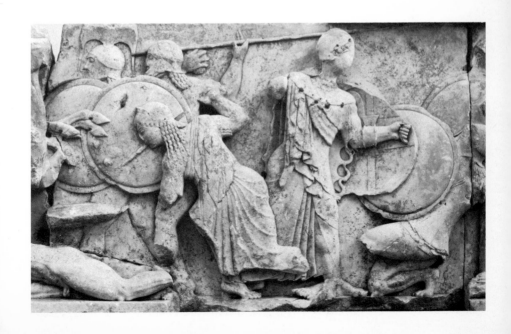

212.2 East frieze of the Siphnian treasury. Gods in Council: *Ares, Aphrodite, Artemis, Apollo* (these pro-Troy); *Zeus* (suppliant *Thetis?); (Poseidon?); Athena, Hera, Demeter* (these pro-Greek). Fight at Troy: *Glaukos, Aineas, Hektor*, dead *Sarpedon* (a son of *Zeus; Iliad* 16); *Menelaos, Patroklos, Automedon, Nestor.* (Delphi) About 525. See also *130*

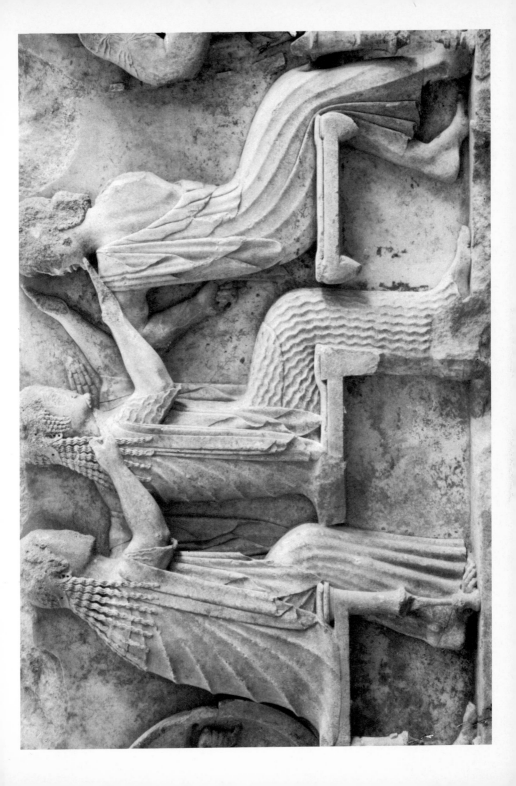

212.3 South frieze of the Siphnian treasury. A woman carried on to a chariot (the Dioskouroi with the Leukippidai?), chariots, a horseman, an altar

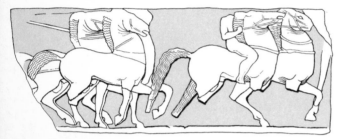

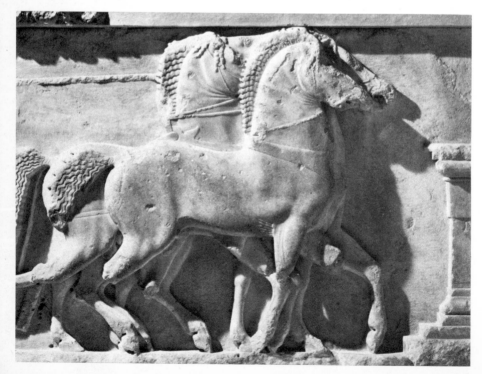

WEST

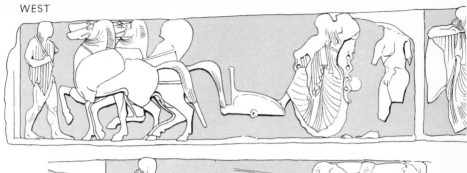

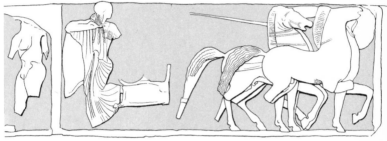

212.4 West frieze of the Siphnian treasury. Hermes before a chariot of winged horses being mounted by a winged Athena (an Ionian conception) with a companion. A woman (Aphrodite) dismounting from a chariot adjusting her necklace; at the right part of a palm tree. Chariot wheels, as elsewhere on the building, were added as separate pieces. The missing third slab must have shown Hera's chariot and Paris, on the occasion of the Judgement

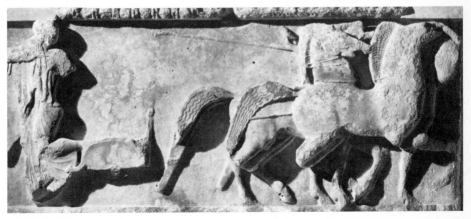

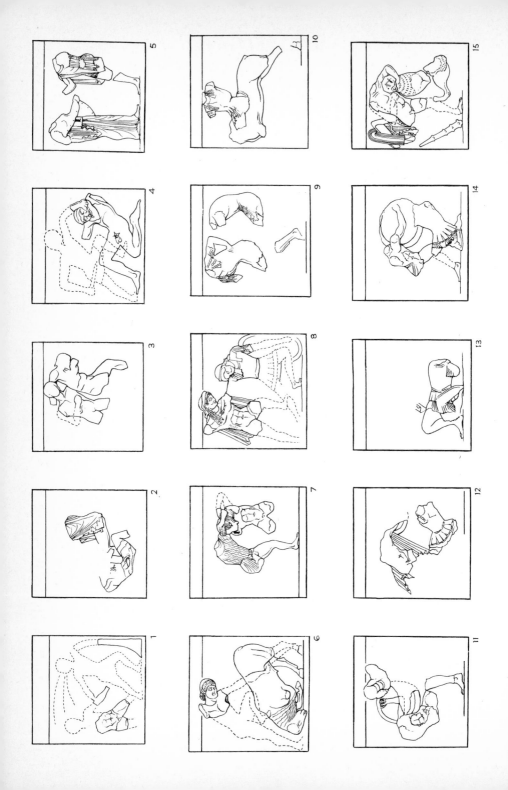

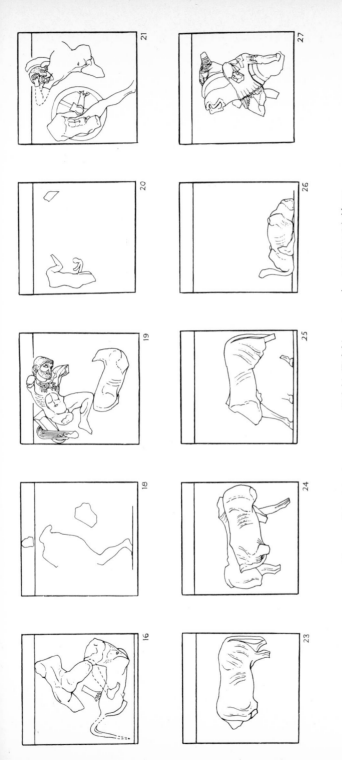

213 Metopes of the Athenian treasury at Delphi. (Delphi; metopes about 0·67 × 0·63) About 500–490. The numbering here follows *FDelphes* iv. 4. THESEUS (1–8): 1 – T. binds the robber Sinis to his pine tree (cf. *ARFH* figs. 115, 287); 2 – T. and a brigand wearing an animal skin; 3 – T. wrestles Kerkyon; 4 – T. fights Skiron, seizing his neck (cf. *ARFH* fig. 90); 5 – T. and Athena; 6 – T. binds the bull of Marathon (cf. *ARFH* fig. 201); 7 – T. and the Minotaur (cf. *ARFH* fig. 118); 8 – T. and Amazon Antiope. AMAZONOMACHY (9–14): 9 – an Amazon draws an arrow, another shoots; 10 – A. on horseback; 11–14 – Amazons v. Greeks. HERAKLES (15–22): 15 – H. v. lion, his useless weapons hang behind him; 16 – H. v. centaur; (17 – H. v. horses of Diomedes?); 18 – pursuit (H. and Apollo with tripod?); 19 – H. v. stag, probably breaking the antlers; 20 – Atlas and H. (?); 21 – H. v. Kyknos, H. wearing a lion-head helmet, cf *206.7*; (22 – H. v. Amazon). HERAKLES and GERYON (23–27); 23–25 – Geryon's cattle; 26 – H. (foot) and the dead dog Orthros; 27 – Geryon, the triple warrior; one body raises a spear, one draws a bow, one collapses. Other unassigned metope fragments have parts of fights

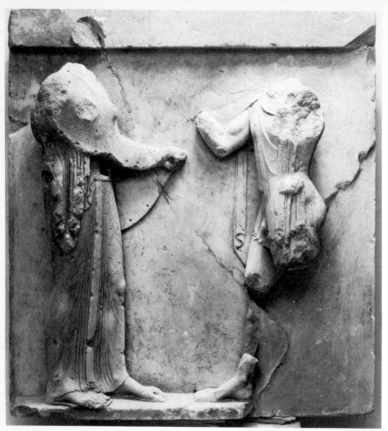

213.1 Metope 5. Theseus and Athena

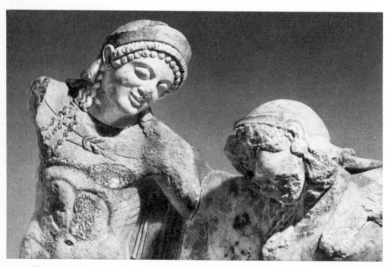

213.2 Metope 8. Theseus and Antiope

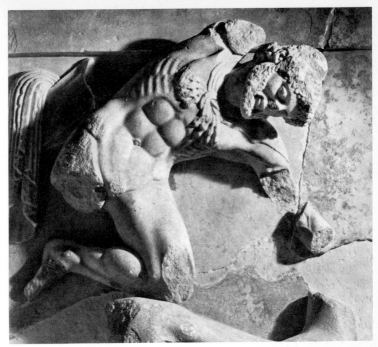

213.3 Metope 19. Herakles and stag

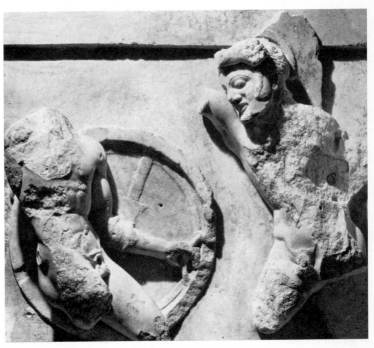

213.4 Metope 21. Herakles and Kyknos

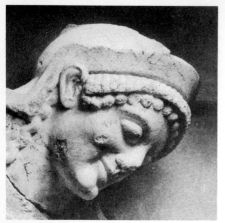

213.5

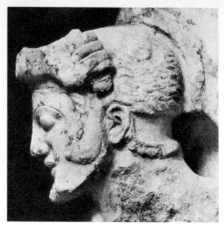

213.8

213.5–8 From metopes 8, 19 (cast), 4, 21

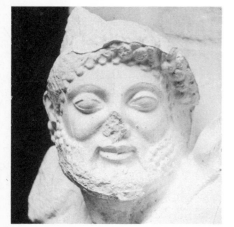

213.6

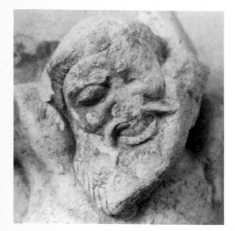

213.7

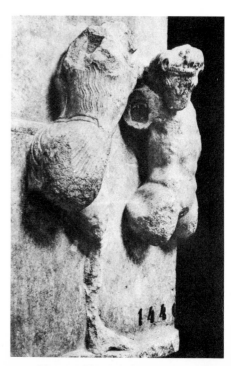

213.9 Metope 7. Theseus and Minotaur

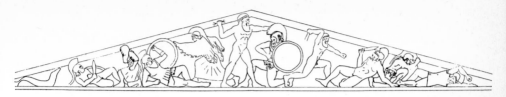

215.1 Pediment of the Megarian treasury at Olympia. Gigantomachy (after Bol and Herrmann). At the centre Zeus, to the left Athena and Poseidon (crushing a giant with a rock, the island Nisyros); to the right Herakles and Ares (?); each deity with a giant foe and with serpentine familiars of the giants in the corners (or, at the left, Poseidon's sea monster). (Olympia; W. 5·95, H. 0·84) About 510–500

214 Relief from an unknown treasury at Olympia. A chariot horse. The locks of the mane were alternately blue and red, the body yellow, the harness red, background blue. (Olympia; H. 0·47) About 540–520

215.2 Giant. Megarian treasury at Olympia, pediment

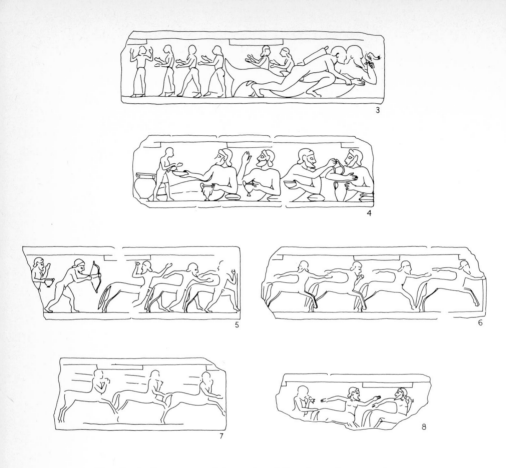

216 Temple of Athena at Assos. (The numbers follow those of Bacon *et al.*, *Assos* 151.)
Frieze slabs 3–8: 3 – Herakles fights Triton while Nereids flee; 4 – feast, probably for
Herakles; 5 – Pholos, with cup, watches Herakles shoot at the centaurs who flee or run with
branches on 6–8

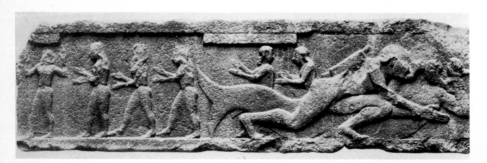

216.1 Frieze slab 3

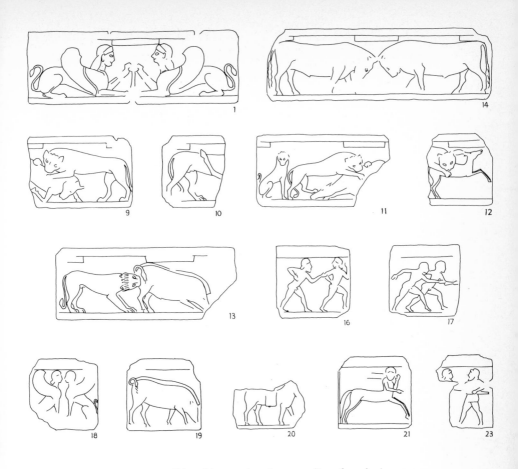

216 Temple of Athena at Assos. Frieze slabs 1–15 (2 and 15 are replicas of 1 and 14).
Metopes 16–23 (22 is a replica of 21): 20 – Europa on the Zeus bull; 23 – fight or struggle for
the tripod? (Istanbul, Boston and Paris) About 540–520

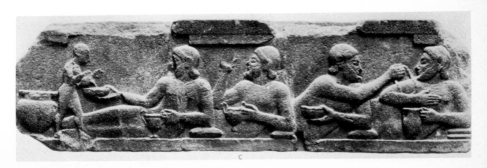

216.2 Frieze slab 4

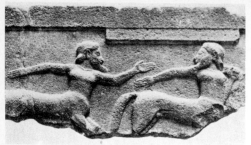

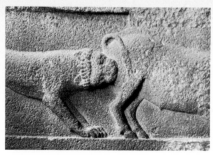

216.3 Frieze slab 8

216.4 Frieze slab 13

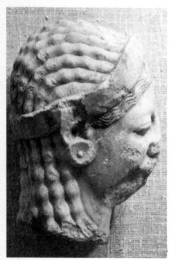

217.1

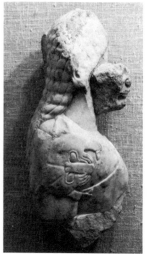

217.2

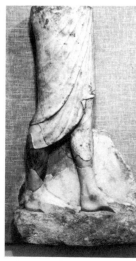

217.3

217.4

217.5

217.1–5 Reliefs from the column drums of the temple of Artemis at Ephesus. 1 – woman's head (London B 91; H. 0·30); 2 – man wearing a panther skin (B 90; H. 0·59); 3 – man's legs (B 121; H. 1·0); 4 – dressed woman (B 119; H. 0·36); 5 – woman's hand and dress (B 118; H. 0·26) About 550–540

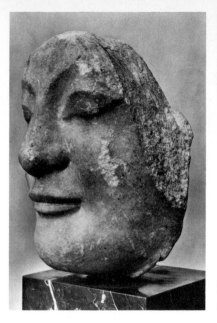

217.7 Relief from the parapet, Ephesus. Woman's head. (London B 215; H. 0·10) About 500

217.6 Relief from a column drum, Ephesus. Woman's head. (London B 89; H. 0·19) About 550–540

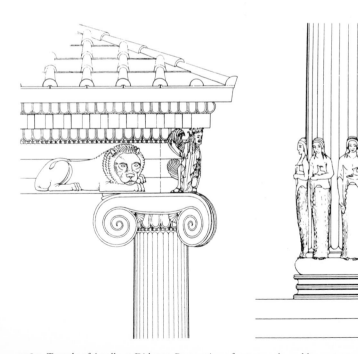

218.1 Temple of Apollo at Didyma. Restoration of upperworks and lower parts of columns to show relief sculpture (after Gruben). About 540–520

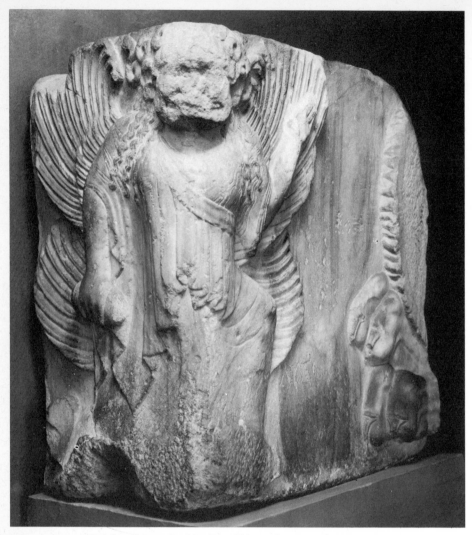

218.2 Architrave reliefs from the temple of Apollo at Didyma. Gorgons at the corners; recumbent lions. (Istanbul 239; H. 0·91) About 540–520

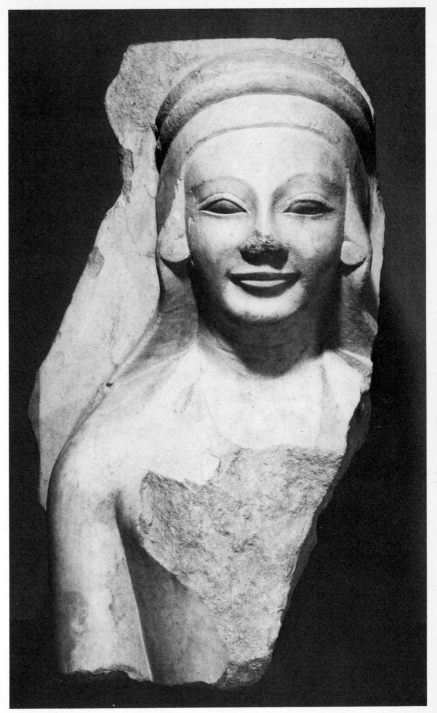

219 Column drum relief from the temple of Apollo at Didyma. (Berlin; H. 0·27)

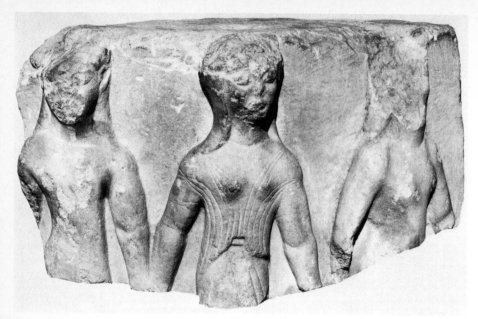

220 Relief drum from Kyzikos. (Istanbul; H. 0·30) About 540

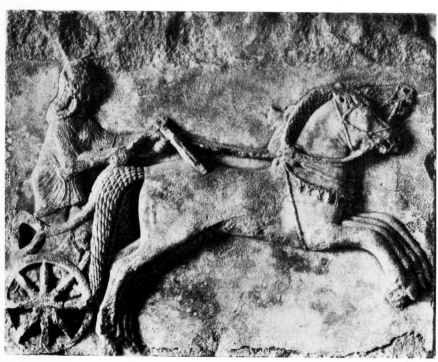

221 Relief slab from Kyzikos. (Istanbul 525; H. 0·55) About 520

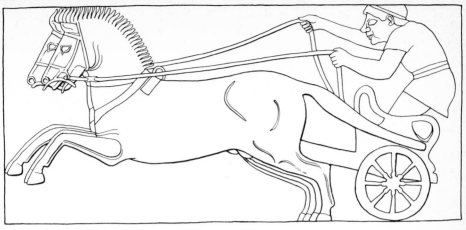

222 Relief slab from Myus. (Berlin; H. 0·70) About 540

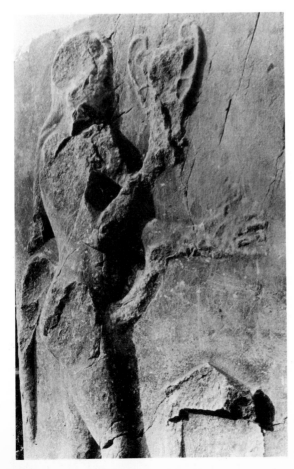

223 Gateway relief on Thasos, in the city wall. An alert satyr, booted, holding a kantharos. The niche is for votive offerings. (H. 2·54) About 500

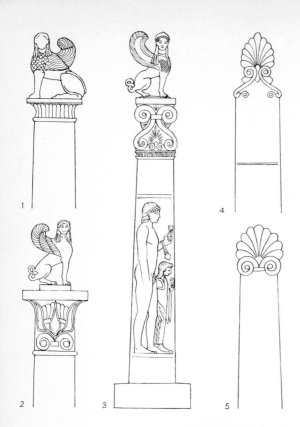

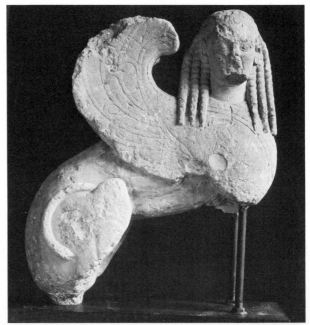

224 The sequence of Attic stelai (after Richter): 1 – New York; 2 – sphinx in Athens *226* and capital in New York, combined; 3 – New York *232*; 4, 5 – painted examples, Athens and New York

225 Limestone sphinx from Spata (Attica). A stele crown. The head is little more developed than that of the early Attic kouroi. (Copenhagen, Ny Carlsberg I.N. 1203; H. 0·84) About 580

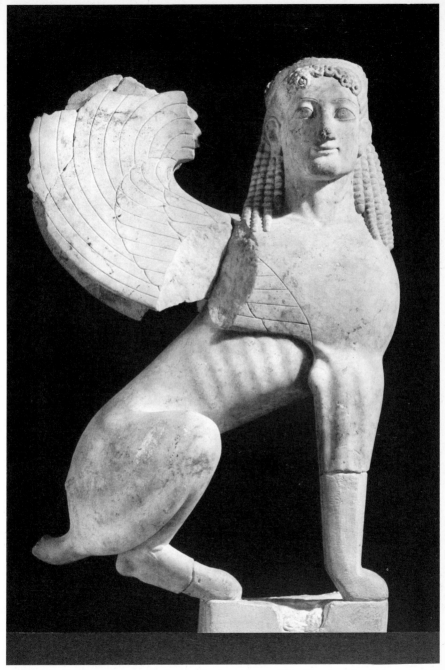

226.1 Sphinx from Athens, Themistoclean wall. The cavetto capital, with painted floral, also survives. She wears a fillet with upstanding leaves (?). (Athens, Kerameikos Museum; H. of sphinx 0·63) About 560. See also next page

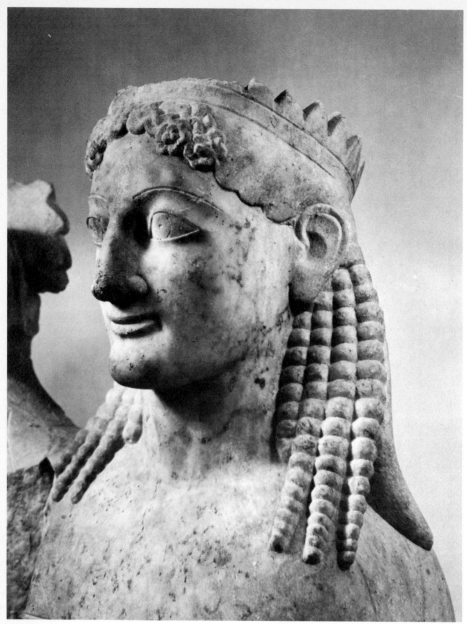

226.2 See last page

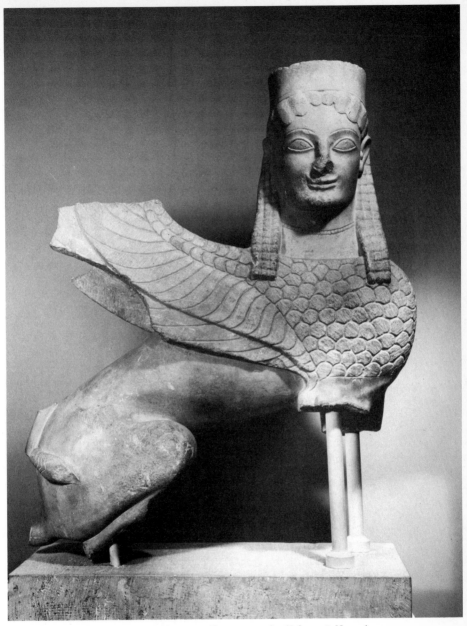

227 Sphinx from Spata (Attica). A stele crown. She wears a *polos*. (Athens 28; H. 0·45)
About 550. See also *131*

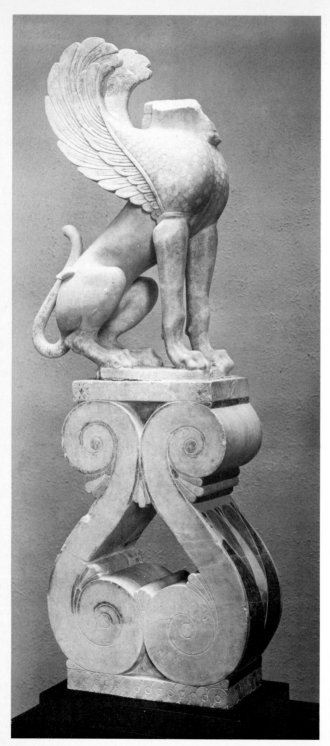

228 Sphinx and capital from
Attica. The hair was black,
feathers green, black, red, blue;
breast scales red and blue; red
and black on the capital. This
has been associated with *234*.
(Boston 40.576; H. 1·42) About
540–530

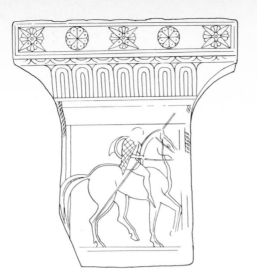

229 Stele capital from Lamptrai (Attica). A man and two women mourners at the sides. On the front a mounted squire leads his master's horse. (Athens 41; H. 0·73) About 550

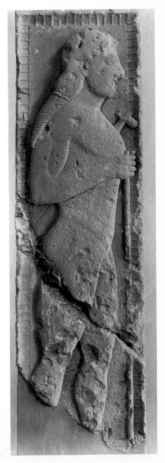

230 Limestone stele from Athens, Kerameikos. Man with sword and spear. All later stele warriors wear armour. The patterned border is unusual. (Athens, Kerameikos Museum; H. 1·81) About 560

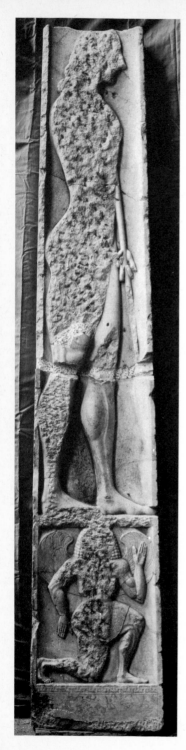

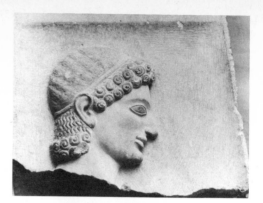

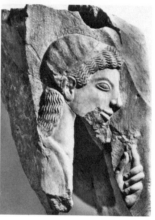

232 Stele from Attica. Details, and see *224.3*. The boy
carries a pomegranate and oil flask, the girl a flower. The
panels above and below were once painted. The base
inscription is in verse: 'To dear dead Me.... his father and
dear mother raised this monument . . .'. Scholars wish to
restore the name Megakles, of Alkmaionid family, and
believe the monument was overthrown by the
Peisistratids in 514. (New York 11.185; H. restored 4·23;
the fragment with the girl's head is Berlin 1531) About
540

```
┌─────────────────────────────────────┐
│ ΜΝΕΜΑΦΙΛΟΙ:ΛΛΓ                        │
│ ΓΑΤΕΡΕΓΕΘΕΚΕΘΑΝΟΝ :                    │
│   Λ   ΛΕΦΙ   ΜΕΤΕΡ·                    │
└─────────────────────────────────────┘
```

μνἑμο φίλοι : Με[γακλἐι με ?]
πατἐρ επεϲἐκε ϧανοντ[ι]
χϲυν δε φιλἐ μἐτἐρ : [...

231 Stele from Athens, Themistoclean wall. Youth
with staff; a gorgon below. The block was cut
back for re-use. This has been associated with
Phaidimos and with the Rampin Master.
(Athens 2687; H. 2·39) About 560–550

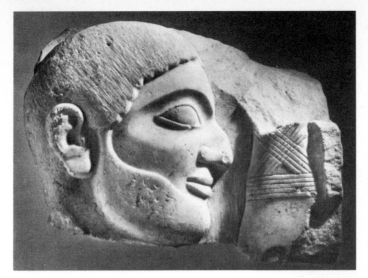

233 Stele fragment from Athens,
Themistoclean wall. The head and
raised bound fist of a boxer.
(Athens, Kerameikos Museum; H. 0·23)
About 540

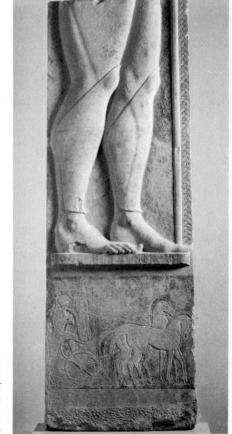

234 Stele fragment from Attica.
Greaved legs and spear of a
warrior. A warrior mounts a
chariot in the shallow relief
panel below. Red, blue, green in
the cable border. Red background.
(New York 36.11.13; H. 1·42)
About 530

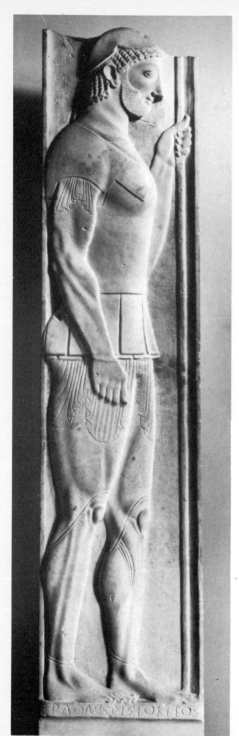

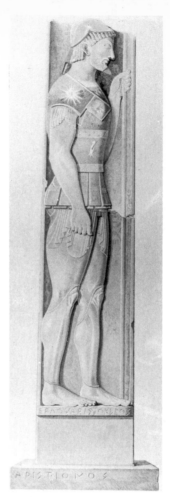

235 Stele of Aristion (name on base) from Velanideza
(Attica). Also restoration showing colour, and detail.
'The work of Aristokles' inscribed on the base line.
The upper part of the helmet and the beard tip were
made of separate pieces, missing. Red on hair and
background. Blue on helmet and corselet leaving
'ghosts' of patterns in other colours. (Athens 29; H. of
shaft 2·4) About 510

236 Stele fragment from near
Athens. A standing and a kneeling
warrior. Possibly not a gravestone.
(Copenhagen, Ny Carlsberg
I.N. 2787; H. 0·57) About 500

237 Stele fragment from Anavysos
(Attica). A woman, probably seated,
holds a child in her arms. The child's
eyes are not closed, despite
appearances. From a broad stele. The
upper edge, top left, is finished and
makes the outline of a painted volute
finial. (Athens 4472; H. 0·38) About
530

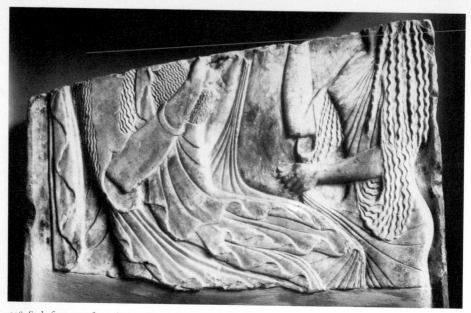

238 Stele fragment from Attica. A seated woman and a girl. Both wear chiton, the woman a himation. Possibly a gravestone. By the artist of *258*. (Athens 36; H. 0·43) About 490

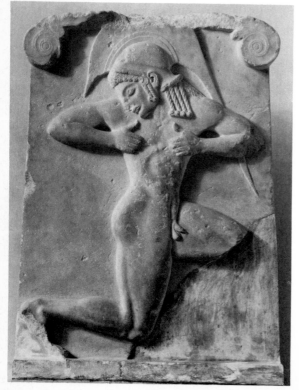

239 Stele from Athens. The palmette top is missing. The position of legs and arms indicates running, and the pose of the head has suggested to some that he is collapsing, dancing – both unlikely – or turning. It may have decorated one end of a brick grave monument. (Athens 1959; H. 1·02) About 510

240 Stele base from Athens. Four horsemen. (Athens, Kerameikos Museum P 1001; H. 0·32) About 550–540

241 Base for a seated figure (?) from Athens, Themistoclean wall. Front – 'hockey' players. Sides – warriors and chariot. (Athens 3477; H. 0·27) About 500

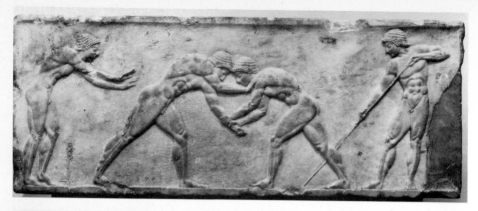

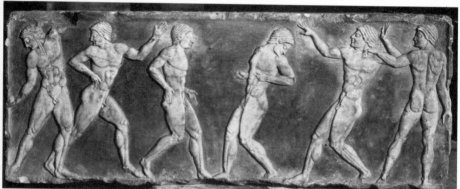

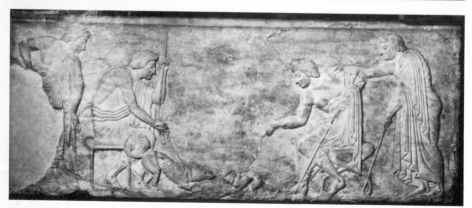

242 Kouros base from Athens, Themistoclean wall. 1 – front – a jumper, wrestlers, boy with javelin. 2 – side A – a ball game. 3 – side B – youths with cat and dog. Associated with the work of Endoios *138*, this and a base signed by Endoios bearing a painted seated figure were found close together near the Piraeus Gate (see on *139*). (Athens 3476; H. 0·32) About 510

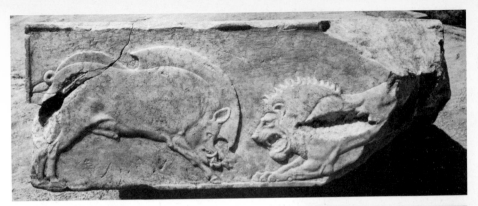

243 Kouros base from Athens, Themistoclean wall.
Lion and boar from one side. The other side has
two horsemen and the front a ball game, as
on 242.2. The base seems to have been set on a
narrower pillar or block. (Athens, Kerameikos
Museum P 1002; H. 0·29) About 510

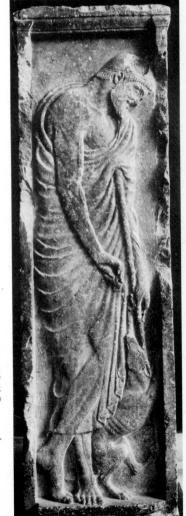

244 Stele from Orchomenos (Boeotia).
The man offers a locust to a dog.
Inscribed 'Alxenor of Naxos made
this; just look!' (Athens 39;
H. 1·97) About 490

ΑΡΧSΗΝΔΡ·ΓΓ·C·ΗSΕΝΗΟΝΔΧΙϽSΑΠΕSΙΔL

Ἀλχσηνδρ ἐποιησεν ho Ναχσιος· αλλ' ἐσιδε[ῦσε]

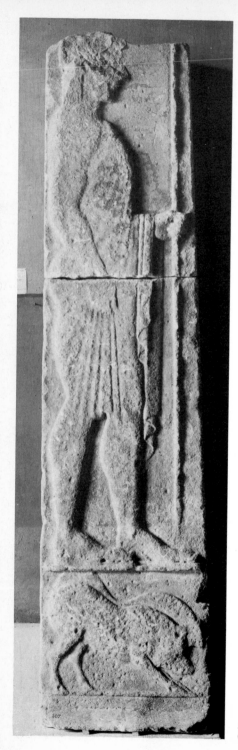

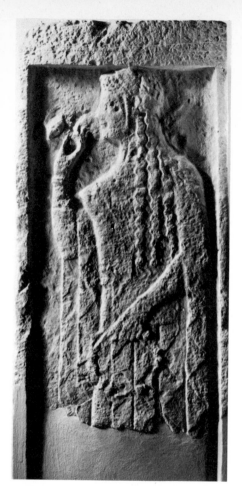

246 Limestone stele from Eltyna (Crete). The girl holds a flower and wreath. (Heraklion 473; H. 1·85) About 490

245 Stele from Syme, near Rhodes. (Istanbul 14; H. 2·32) About 500

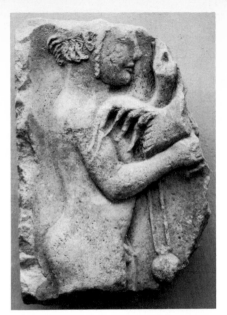

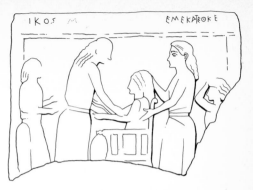

248 Stele from Kalchedon, on the Bosporos. The seated woman resembles figures on island stelai. The attendant figures recall assistants at childbirth (as for Zeus bearing Athena! cf. *ABFH* figs. 62, 175) with a mourner at the right. Inscribed: '[Gravestone of]....ikos: . . . had me put up'. (Istanbul 524; 0·38 × 0·57) About 550

247 Stele from Kos. (Kos; H. 0·42) About 490

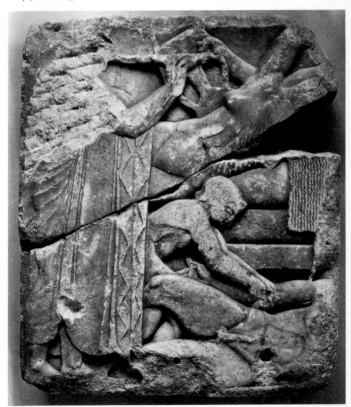

249 Stele from Kos. On a couch a man holding a lyre with a naked girl in his lap (both heads gone, to the right); a child helps up a fallen man; at the left a piper. Not certainly a gravestone. (Kos; H. 0·72) About 500

250 Stele with a seated woman from Paros. The stippled area is only lightly recessed. The drawing is approximate only. (Paros; H. 1·19) About 650–625

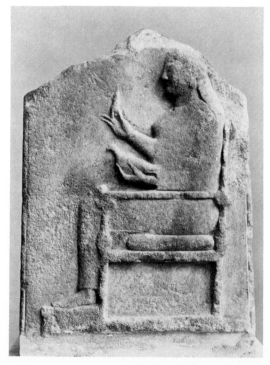

251 Relief with a seated woman from Thasos. The block is too small and deep to be a grave marker. (Louvre 3103; H. 0·24) About 550

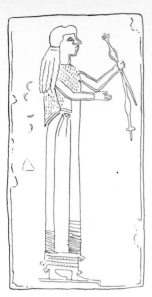
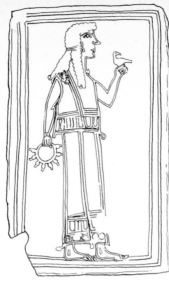

252 Incised limestone stelai from Prinias (Crete). 1 – a spinner, with traces of an inscription. 2 – kore with bird and wreath. 3 – warrior. 4 – seated man (?), a dog beneath the throne. 5 – detail of a warrior. The style resembles contemporary incised bronzes. (Heraklion 234, 396, 399, 397, 402; H. 0·725, 0·485, 1·06–1·09, 0·67) About 650–600

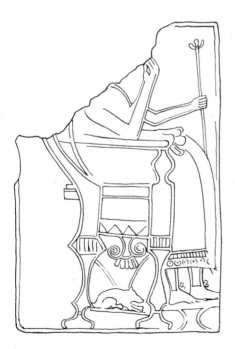
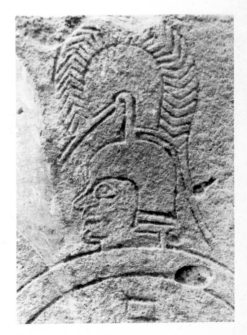

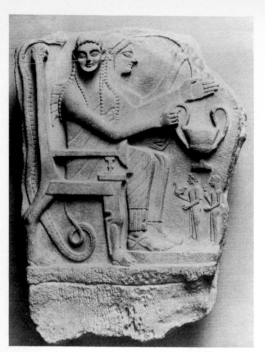

253 Hero relief from Chrysapha (Sparta). The man holds a kantharos, the woman a pomegranate. The worshippers hold a cock and flower. The throne type, with lion legs, is Egyptian. (Berlin 731; H. 0·87) About 550–540

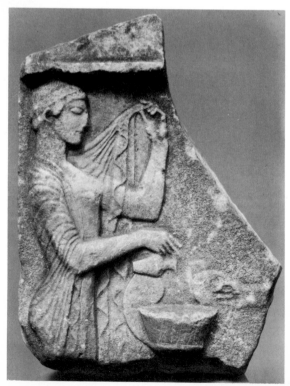

254 Hero relief, Spartan. The kore attendant pours into the kantharos held by a seated figure, missing. (Copenhagen, Ny Carlsberg 23; H. 0·36) About 490

255 Death feast relief from Paros. The reclining 'hero' holds a phiale. Behind him a dog, serving boy and dinos for the wine. Armour hangs on the wall. A companion relief has a lion attacking a bull. (Paros; H. 0·73) About 500

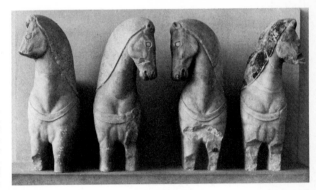

256 Frontal chariot relief, restored, from the Acropolis. Fragments of the horses and perhaps of the charioteer's head are preserved. The bodies are cut off rather than shown in the mock foreshortening of the Delphi metope 208.1. (Acr. 575+; H. about 0·50) Second quarter of the 6th c.

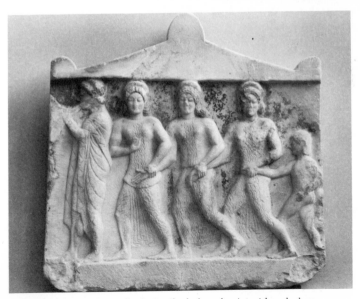

257 Relief from the Acropolis. A piper leads three dancing girls and a boy. The girls wear chiton with himation indicated only by paint. The acroteria of the 'pediment' were painted with palmettes. (Acr. 702; H. 0.39) About 500

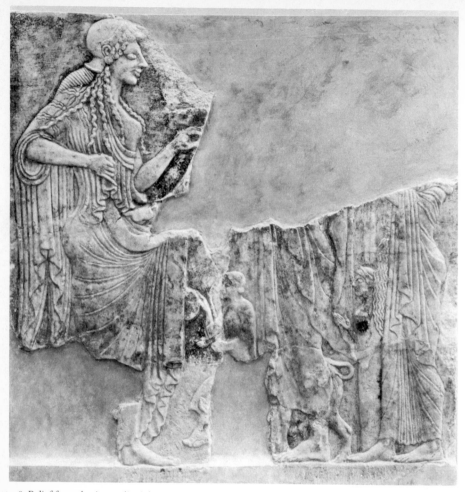

258 Relief from the Acropolis. Athena, wearing helmet, himation and chiton, receives the offerings of a family of a father, mother, two boys (one holds up a phiale) and a girl. The pig is for sacrifice. By the artist of *238*. (Acr. 581; H. 0·66) About 490

259 From an Athenian black figure vase (Beazley, *ABV* 338, 3). The votive picture or relief is on a Doric column and is provided with doors. It shows two horsemen (in white paint, faintly) – the Dioskouroi. (Naples 3358) About 510

260 Relief from Athens, near the Agora. Herakles shoulders the Erymanthian boar, to deliver to Eurystheus (cf. *ARFH* fig. 89). He keeps hold of his club (above) wears his lionskin on his head and hanging from his left arm. The relief overlaps the high pediment which must have been painted. Perhaps from the sanctuary of Herakles Alexikakos. (Athens 43; H. 0·76) About 500

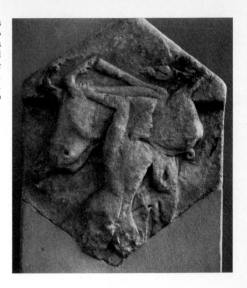

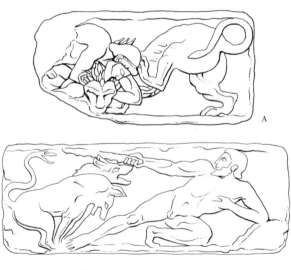

261 Statue base from Lamptrai (Attica). A. Herakles and the lion. B. Herakles and Kerberos. C. Herakles reclines for a feast with club and cup. The base may have been for a statue of the god/hero. (Athens 42+3579; H. 0·19) About 500

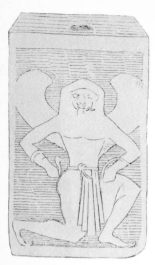

262 Relief from Paros. A gorgon holding snakes. (Paros; H. 0·62) Second half of the 6th c.

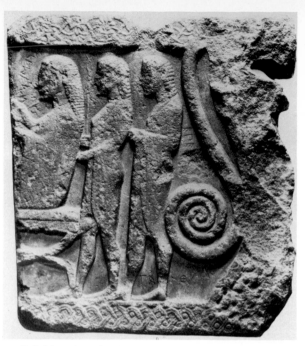

264 Relief from Samothrace. Floral above, cable below. The figures are inscribed Agamemnon (seated), Talthybios with a herald's staff (Greek herald at Troy), Epeſios (inventor of the Wooden horse). At the right a griffin's head (worn away but the gaping beak is clear) with spiral plume, and neck. (Louvre 697; H. 0·46) About 550

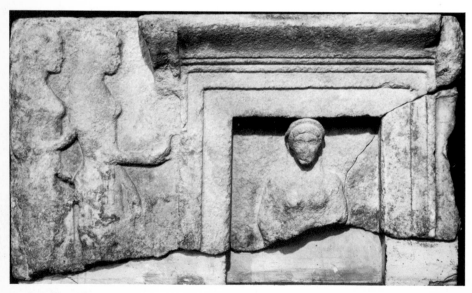

263 Relief from Thasos. Two korai with offerings approach a niche or door in which Kybele is seated. (Malibu, Getty Museum; H. 0·37) About 490

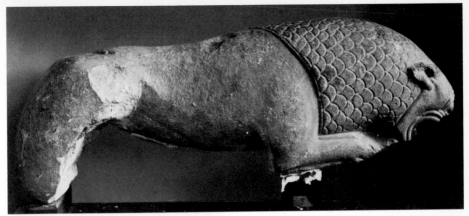

265 Limestone water spout from Olympia. The reversed–scale mane and emphatic ridges around the eyes and mouth are remarkable. (Olympia; L. 0·79) Mid-7th c.

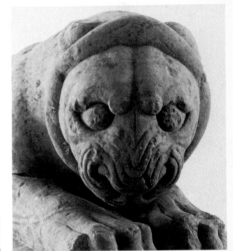

266 Limestone lion from Corfu. From a grave monument, formerly associated with the grave of Menekrates. (Corfu; L. 1·22) About 600

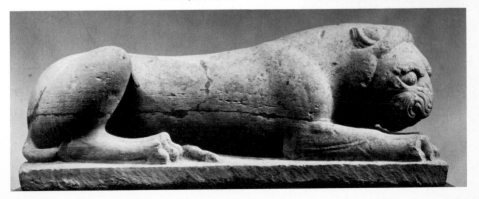

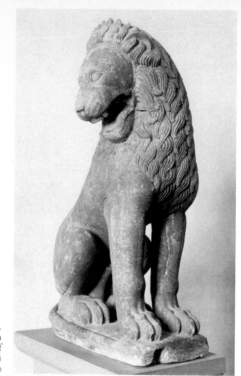

267 Limestone lion from Perachora. The type closely resembles that on Corinthian vases of the first half of the 6th c. (Boston 97.289; H. 0·95) About 570–550

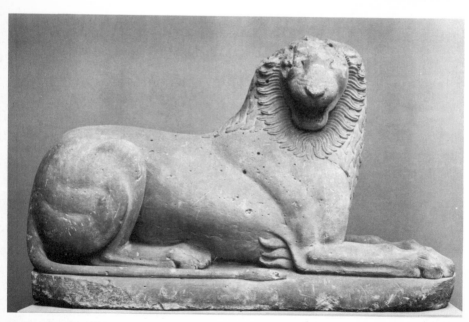

268 Limestone lion from Loutraki, near Corinth. One of an antithetic pair. (Copenhagen, Ny Carlsberg 1297; L. 1·0) Second quarter of the 6th c.

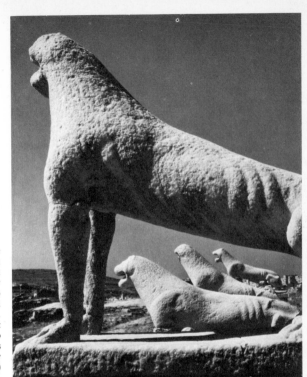

269 Lions on Delos. They flank the approach to the Letoon sanctuary, in an Egyptian manner. Probably a Naxian dedication, deceptively primitive in appearance owing to their worn state and the sleek lion type favoured in the islands. Compare the Naxian sphinx at Delphi *100*. There were originally up to sixteen; one, with a new head, sits outside the Arsenal at Venice (below here). (H. of complete lion 1·72) Second quarter of the 6th c.

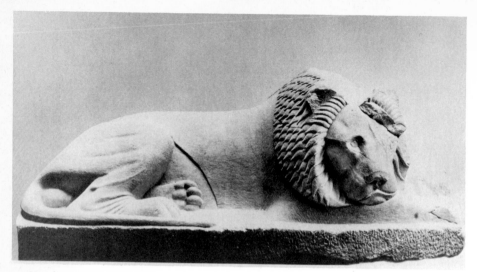

270 Lion from Miletus. Apparently one of a pair. (Berlin 1790; L. 1·76) Mid-6th c.

271 Dog from the Acropolis. One of a pair, possibly a dedication to Artemis Brauronia, as huntress. (Acr. 143; L. 1·25) Late 6th c.

ABBREVIATIONS

c.	century BC
H	height
AAA	*Athens Annals of Archaeology*
ABFH	J. Boardman, *Athenian Black Figure Vases* (1974)
Acr.	The Acropolis, Athens
AE	*Archaiologike Ephemeris*
AGSB	C. Blümel, *Die archäisch griechischen Skulpturen der staatlichen Museen zu Berlin* (1963)
AJA	*American Journal of Archaeology*
AM	*Athenische Mitteilungen*
AMA	H. Schrader *et al.*, *Die archäischen Marmorbildwerke der Akropolis* (1939)
Ann	*Annuario della Scuola Archeologica di Atene*
ARepts	*Archaeological Reports*
ARFH	J. Boardman, *Athenian Red Figure Vases, Archaic Period* (1975)
BCH	*Bulletin de Correspondance Hellénique*
Berger	E. Berger, *Das Basler Arztrelief* (1970)
BSA	*Annual of the British School at Athens*
CCO	J. Boardman, *The Cretan Collection in Oxford* (1961)
Deds.	A. Raubitschek, *Dedications from the Athenian Acropolis* (1949)
Didyma	K. Tuchelt, *Die archäischen Skulpturen aus Didyma* (1970)
FDelphes	*Fouilles de Delphes*
Gravestones	G. M. A. Richter, *The Archaic Gravestones of Attica* (1961)
Ist. Mitt.	*Istanbuler Mitteilungen*
JdI	*Jahrbuch des deutschen archäologischen Instituts*
Jeffery	L. H. Jeffery, *Local Scripts of Archaic Greece* (1961)
Korai	G. M. A. Richter, *Korai* (1968)
Kouroi	G. M. A. Richter, *Kouroi* (1970)
Kurtz/ Boardman	D. C. Kurtz and J. Boardman, *Greek Burial Customs* (1971)
Lacroix	L. Lacroix, *Les reproductions de statues sur les monnaies grecques* (1949)
Lullies	R. Lullies and M. Hirmer, *Greek Sculpture* (1960)
MWPr	*Marburger Winckelmannsprogramm*
ÖJh	*Jahreshefte des österreichischen archäologischen Instituts in Wien*
Payne	H. Payne and G. M. Young, *Archaic Marble Sculpture from the Acropolis* (1936)
RA	*Revue Archéologique*
Ridgway, SS	B. S. Ridgway, *The Severe Style in Greek Sculpture* (1970)
RM	*Römische Mitteilungen*
Robertson	M. Robertson, *History of Greek Art* (1975)
Samos xi	B. Freyer-Schauenburg, *Bildwerke der archäischen Zeit und des strengen Stils* (*Samos* xi; 1974)

241

NOTES AND BIBLIOGRAPHIES

I INTRODUCTION

The relevant chapters in Robertson, *History of Greek Art* (1975) give the fullest and most recent, though selective, account of Archaic sculpture and may be referred to for fuller description and discussion of many pieces treated here. Richter's *Sculpture and Sculptors of the Greeks* (1970) deals with the figures by types rather than historically and is weak for the earlier Archaic period. W. Fuchs, *Die Skulptur der Griechen* (1969) also deals by types, more succinctly, C. Picard's *La sculpture antique* (1926 on) is full but sorely outdated for the Archaic period. An important study of Archaic Greek sculpture by B.S. Ridgway is forthcoming.

Essential monographs (see *Abbreviations*) are Richter's *Kouroi, Korai* and *Gravestones*; and Payne on the Acropolis sculpture; and there are apt observations on style and technique in R. Carpenter, *Greek Sculpture* (1960). There have been no comprehensive collections of pictures other than for the special monographs mentioned since F. Winter's *Kunstgeschichte in Bildern* (1900 on) or, for the eighth and seventh centuries, F. Matz, *Geschichte der griechischen Kunst* i (1950). Minor sculptural work in other materials is noticed in this book where appropriate. For fuller treatment see R.A. Higgins, *Greek Terracottas* (1967); W. Lamb, *Greek and Roman Bronzes* (1929); a new comprehensive study of bronzes is being prepared by D. Mitten; J. Boardman, *Archaic Greek Gems* (1968).

The most useful historical account of the period is L.H. Jeffery, *Archaic Greece* (1976) and for foreign relations and effects on art see J. Boardman, *Greeks Overseas* (1973).

For ancient sources J. Overbeck, *Die antiken Schriftquellen* (1868, reprinted 1971) gives all texts and J.J. Pollitt, *The Art of Greece 1400–31 B.C.* (1965), select translations and commentary.

For the mythological subject matter see K. Schefold, *Myth and Legend in Early Greek Art* (1966) and the iconography chapters in *ABFH, ARFH*, with bibliographies.

II THE DARK AGES AND GEOMETRIC PERIOD

GENERAL

V. MÜLLER, *Frühe Plastik in Gr. und Vorderasien* (1929); E. Homann-Wedeking, *Die Anfänge der gr. Grossplastik* (1950); B. Schweitzer, *Greek Geometric Art* (1969) including [5, 6, 9, 11, 12, 13].

CLAY

R.A. Higgins, *Greek Terracottas* (1967), ch. 5; R.V. Nicholls in *Auckland Classical Essays* (ed. B.F. Harris) 1–37, also on bronzes. Lefkandi centaur [4] – *BSA* lxv, pls 8–10. Karphi [1] – *BSA* xxxviii, 75, pl. 31, and lv, 29. *Kerameikos* iv, pl. 26 [3], stag. Amyklaion – *AM* lv, Beil. 42–43. Piskokephalo [2] – *CCO* no. 472.

BRONZE

N. Himmelmann, *Bemerkungen zur gr. geometrischen Plastik* (1964) [8, 11–13]; H.V. Herrmann, *JdI* lxxix, 17 ff., local workshops; U. Naumann in *Opus Nobile* (Fest. Jantzen), 114 ff. and *Submin. und Protogeometrische Bronzeplastik auf Kreta* (1976); M. Weber, *AM* lxxxvi, 13 ff. and lxxxix, 27 ff. W. Lamb, *Greek and Roman Bronzes* (1929), ch. 2. *Olympia Bericht* vii, 138 ff. [5]. M. Comstock and C. Vermeule, *Bronzes, Boston* nos 3 [9], 15 [10]. Karditsa [7] – S. Karouzou, *AM* xci, 23 ff., as Achilles.

III THE ORIENTALIZING STYLES

EASTERN STYLES IN CRETE AND GREECE

Boardman, *CCO*, 79 ff., 134 ff., no. 378 [18]; *BSA* lxii, 57 ff. for date of [16] et al.; *Greeks Overseas* (1973), 56 ff.; in *Dädalische Kunst* (Hamburg Mus., 1970), 14 ff.; *Korai*, fig. 70–75 [16]. C. Davaras, *Die Statue aus Astritsi* (1972), incl. [14, 15]. R.A. Higgins, *BSA* lxiv, 143 ff., jewellery. P. Demargne, *La Crète Dédalique* (1947) general study. H.V. Herrmann, *Ol. Forsch.* vi, siren attachments [21]; and *Olympia, Heiligtum und Wettkampfstätte* (1972), 80 ff. [20, 22]. Afrati bronze [17] – *ARepts* 1973/4, 37. Ivory girls, Athens [19] – E. Kunze, *AM* lv, 147 ff.; Schweitzer, op. cit., pls 146–8, cf. 149, 150.

THE DAEDALIC STYLE

R.H. Jenkins, *Dedalica* (1936), classification (rather rigid) and chronology of clay and other works. R.A. Higgins, *Greek Terracottas* (1967), 25–29. Davaras, op. cit., incl. [28–33]. Boardman, *CCO*, incl. no. 496 [26]. T.J. Dunbabin, *Greeks and their eastern Neighbours* (1957), ch. 3, and Corinth plaques, pl. 8 [23, 24]. G. Rizza and V. Scrinari, *Gortina* i (1968), incl. [25, 30, 31, 34], also chronology. G. Rizza, *Ann* xlv/xlvi, 212 ff., Axos terracottas [27]. P. Kranz, *AM* lxxxvii, 1 ff., seated figures. Mycenae [35] – F. Harl-Schaller, *ÖJh* l, 94 ff. Prinias [32] – L. Pernier, *Ann* i, 18 ff. and *AJA* xxxviii, 171 ff.; C. Gottlieb, *AJA* lvii, 106 f. F. Grace, *Archaic Sculpture in Boeotia* (1939). J. Ducat,

Les Kouroi de Ptoon (1971), no. 46, signed. New York ivory [*39*] – G. Richter, *AJA* xlix, 261; F. Matz, *MWPr* 1948, 3 ff. *Perachora* ii, pl. 171, A1 [*38*]. E. Karydi, *AA* 1964, 266 ff., jewellery. Thera [*40*] – Kurtz/Boardman 78 f.; F. Poulsen, *JdI* xxi, 188; N. Kontoleon, *AM* lxxiii, Beil. 104. *Dädalische Kunst* (supra), incl. [*36, 37*]. Dating by vase painting – H. Payne, *Necrocorinthia* (1931), 232–5, pl. 1.8–11 [*41*] and 47, and cf. K.F. Johansen, *Vases Sicyoniens* (1923), pl. 35.2 (Macmillan Painter, about 650).

OTHER EARLY ARCHAIC STATUARY

H.V. Herrmann in *Wandlungen* (Fest. Homann-Wedeking), 35 ff. Tanagra [*42*] – *ADelt* xxiv A, pls 43–44. Crete – sphinx [*44*], E. Langlotz in *Corolla Curtius* i, 60 ff.; lyre player [*43*], Schweitzer, op. cit., pl. 203; *kriophoros* [*45*], K. A. Neugebauer, *Kat. Br. Berlin* i, no. 158. Olympia [*46, 47*] – *Olympia Bericht* iv, 105 ff. Boeotia [*48*] – D.K. Hill, *Catalogue, Bronze Sculpture, Walters Art Gallery* (1949), no. 237. Samos wood [*49, 50*] – D. Ohly, *AM* lviii, 77 ff.; G. Kopcke, *AM* lxxxii, 100 ff. Ivories – *Perachora* ii, pt 2, pl. 173, A9 [*51*]; B. Freyer-Schauenburg, *Elfenbeine aus dem samischen Heraion* (1966), incl. [*54*]; A. Greifenhagen, *Jb. Berl. Mus.* vii, 125 ff. [*53*], lyre figures; Delphi ivory [*52*] – K. Schefold in *Fest. von Lücken*, 769 ff.; *AA* 1970, 574 ff.; F. Salviat, *BCH* lxxxvi, 105 (base); E.L. Marangou, *Lakonische Elfenbein- und Beinschnitzereien* (1969).

IV MARBLE AND THE MONUMENTAL

THE FIRST MARBLE SCULPTURE

Marble analyses – C. Renfrew, *BSA* lxiii, 45 ff.; B. Ashmole, *BSA* lxv, 1 ff.; H.V. Craig, *Science* 176, 401–3 (isotopic analysis). Technique – S. Adam, *The Technique of Greek Sculpture* (1966), fundamental, replacing all earlier studies (Casson, Blümel). Quarries – S. Casson, *BSA* xxxvii, 21 ff. (Naxos colossus) and *Technique of Early Greek Sculpture* (1933); A. Dworakowska, *Quarries in Ancient Greece* (1975). Egypt – E. Iversen, *Mitt. Inst. Kairo* xv, 134 ff. (whence the drawing, p. 21); *Journ. Eg. Arch.* xlvi, 71 ff. and liv, 215 ff. (Diodorus); R. Anthes, *Proc. Amer. Phil. Soc.* 107, 62 ff.; K. Levin, *AJA* lxviii, 13 ff.; B.S. Ridgway, *AJA* lxx, 68 f.; Boardman, *Greeks Overseas*, ch. 4; H. Schäfer, *Principles of Egyptian Art* (ed. Baines, 1974); Adam, op. cit., 5 f. Cult statues – F. Willemsen, *Frühe gr. Kultbilder* (1939); E. Vermeule, *Götterkult* (1974), 121 f., 140, 158 f. Funerary use – Kurtz/Boardman, 88 f., 237 ff. Bases – M. Jacob-Felsch, *Die Entwicklung gr. Statuenbasen* (1969). Euthykartidas [*56*] – G. Bakalakis, *BCH* lxxxviii, 539 ff., also legs.

KOUROI

'Kouros', 'kolossos' – J. Ducat, *BCH* c, 239 ff. *Kouroi*, figs 22–24 [*58*] (and on its sex, G. Daux,

BCH lxxxiii, 559 ff.), nos 10 [*68*], 11 [*66*], 14 [*69*], 17 [*59*], 33 [*67*]. Delphi bronze [*57*] – *Kouroi*, figs 14–16; *FDelphes* v, no. 172. Naxian colossus [*60*] – *Kouroi* no. 15; P. Courbin in *BCH* Suppl. i, 157 ff. (its fall) and *Mél. Hell . . . G. Daux*, 57 ff.; N. Kontoleon, ibid., 239 ff. (inscription); D. Pinkwart, *Bönner Jb.* clxxii, 12 ff. and clxxiii, 117 (the holes); *Archaeology* (1972), 213 (the drawing [*60*]). *Samos* xi, nos 29–34. Thera [*61*] – *Kouroi* no. 18B; N. Kontoleon, *AM* lxxiii, 117 ff. Attica – *Kouroi* nos 1 [*63*], 2 [*64*], 3 [*65*], 6 [*62*]; E. Harrison, *Hesperia* xxiv, 290 ff.; Robertson, 45 f. Inscribed Attic bases – L.H. Jeffery, *BSA* lvii, 115 ff. Cretan statue at Delphi – G. Roux, *BCH* lxxv, 366 ff. Kleobis and Biton [*70*] – *Kouroi* no. 12; inscription and placing, Jeffery, 154–6. Cf. the xoana of the Dioskouroi at Troizen by Hermon, which may have been Archaic and shown on coins – Lacroix, 220 f.

KORAI

Nikandre [*71*] – *Korai* no. 1; Adam, op. cit., 44 (pierced hand; others have suggested a bow, for Artemis). *Samos* xi, no. 3 [*72*] – *Korai* no. 21. Olympia Hera [*73*] – *Korai* no. 36; H.V. Herrmann, *Olympia*, 96 f.; Robertson, 47 f.

PERIRRHANTERIA

[*74–79*] – J. Ducat, *BCH* lxxxviii, 577 ff.; G. Hiesel, *Samische Steingeräte* 4 ff. and in *Opus Nobile* (Fest. Jantzen), 77–81; F.W. Hamdorf, *AM* lxxxix, 47 ff., comprehensive; *Hesperia* xxvii, pls 10 f., Isthmia; *Korai*, figs 35, 37–56. Cf. Laconian lions painted and relief on vases, *BSA* xxxiv, pl. 26; and for the style, the Menelaion bronze, Matz, op. cit., pl. 62; Chalcis seated figure, Davaras, op. cit., figs 19–22; K. Schefold, *Meisterwerke* (1960), no. 89. Other Laconian sculpture, *BCH* xcv, 880 f. Stone lamps – *CCO*, 123 f. and especially the lion-head lamp from Brauron, *BCH* lxxiv, 301. Sparta kneeler [*80*] – M. Tod and A.J.B. Wace, *Cat. Sparta Mus.* no. 364. *ADelt* xxiv B, pl. 120.

ARTISTS AND AUTHORS

J.J. Pollitt, *Art of Greece* 3–15; F. Eckstein, *Handwerk* (1974). Daedalus – *Kouroi* 28 f.; G. Rizza, *Cronache di Arch.* 1963, 5 ff.; Boardman, *CCO* 158 f. and *Acta 4. Kret. Synedr.*

V THE MATURING ARCHAIC STYLES

SOURCES

The Acropolis, Athens. The definitive publication of the sculpture is *AMA*. Payne gives an excellent narrative account and pictures. *Deds.* for types of bases, signatures and summaries of artists' careers. On the excavation G. Dickins's introduction to *Cat. of the Acr. Museum* i (1912), the Archaic Sculpture. Also M.S. Brouskari, *The Acropolis Museum, Descriptive Catalogue* (1974). The records are being

restudied. Other problems, Ridgway, *SS* 31; and general, R.J. Hopper, *The Acropolis* (1971). Survivors of the Persian sack – Pausanias i 26.5, 27.7; *Deds.* 456. *Samos* xi; E. Buschor, *Altsamische Standbilder* (1934–61); *Didyma*. J. Ducat, *Les Kouroi de Ptoon* (1971). Local schools – E. Langlotz, *Frühgr. Bildhauerschulen* (1927), somewhat optimistic but a pioneer attempt.

KOUROI

Richter's *Kouroi* is basic. Older studies such as W. Deonna, *Les Apollons Archaïques* (1909) and E. Buschor, *Frühgr. Junglinge* (1950) are still valuable.

KORAI

Dress – *Korai*, 6ff.; Payne, 25f.

EAST GREEK SCULPTURE AND SCULPTORS

Korai nos 37 [*85*], 38 [*86*], 57 [*89*], 68 [*92*], 95 [*90*]. And *Ist. Mitt.* xvi, 95ff. *Kouroi* nos 49 [*101*], 77 [*81*], 86 [*102*], 125 [*83*], 127 [*82*], 124b [*84*]. For other east Greek see *Belleten* xxxi, 331ff.; xxxiv, 347ff.; *Ist. Mitt.* xiii/xiv, 73ff.; xvii, 115ff.; *Antike Kunst* xix, 81ff. *Samos* xi, nos 4–25 (korai; no. 20 [*97*]); nos 35–56 (kouroi); nos 58–63, Geneleos Group [*91–93*]; nos 72[*84*]–75 (dressed kouroi). G. Schmidt, *AM* lxxxvi, 31ff., works of Geneleos and the kolossos master; Robertson, 73–75; Lacroix, 207–16, cult statue of new temple shown on coins, with two peacocks? Cheramyes kore [*87*] – *Korai* no. 55; R. Heidenreich, *Forsch. u. Berichte* xii, 61ff., mounted on column; Robertson, 72f. Reclining figures – *AGSB* nos 66–68, Myus; *RA* 1976, 55ff., Didyma. Aiakes [*96*] – *Samos* xi, no. 67; R. Meiggs and D.M. Lewis, *Selection of Greek Historical Inscriptions* no. 16. Samian head type in alabaster in Egypt – *AA* 1952, 48ff. *Didyma passim* and nos K43 [*94*], K47 [*95*]. Ephesus ivories [*88*] – P. Jacobsthal, *JHS* lxxi, pls 34–36; *Korai* figs 257–62. Cyrene – E. Paribeni, *Cat. delle Sc. di Cirene* no. 6; *AJA* lxxv, pls 6–8. Kyzikos kouros – *Antike Kunst* viii, pls 26–28. Dressed kouroi – P. Devambez, *RA* 1966, 195ff.; K. Schefold, *Antike Kunst* xix, 116. 'Naxian' figures on Acropolis [*98, 99*] – *Korai* nos 58, 59; Payne, 12f. Naxian sphinx, Delphi [*100*] – *FDelphes* iv. 1. 41ff. Cycladic sculpture – N. Kontoleon, *Aspects de la Grèce Préclassique* (1970), 62ff.; *Epist. Epet. Ath.* (1957/8), 218ff. (Melos); *Praktika* (1972), pls 124–7, kouros with bent arms; head. G. Kokkorou-Alewras, *Archäische Naxische Plastik* (1975). Archermos and Nike [*103*] – Jeffery, 294f.; *Deds.* 484–6; *Korai* pl. xiva; O. Rubensohn, *Mitt. Inst.* i, 21ff. Acr. 659 – *AMA* no. 95; Payne, pl. 69. Chronology – N. Himmelmann, *Ist. Mitt.* xv, 24ff. E. Langlotz, *Studien zur nordostgr. Kunst* (1975).

ATTIC SCULPTURE AND SCULPTORS

Kouroi nos 63 [*104*], 70 [*105*], 135 [*106*]. *Korai* nos 43 [*109*], 89 [*110*], 111 [*111*]. Early korai – A. Ioannis

Rentis, *AAA* i, 34f. and *BCH* xcii, 754; followed by *Korai* nos 40 (Attica), 39 (Aegina). Berlin kore [*108*] – *Korai* no. 42; L. Alscher in *Fest. von Lücken*, 697ff., as archaizing late sixth c. It has also been thought false. Kroisos [*107*] – *Kouroi* no. 136; *AAA* vii, 215ff., the base. The Merenda find [*108a*] – E. Mastrokostas, *AAA* v, 298ff., and see below, Aristion. The kouros attributed by J. Frel to the master of the Lyons kore, *AAA* vi, 367ff. New kouroi – *AAA* iv, 137ff. and *ADelt* xxvii B, pl. 53, head, about 560. Scribes – L.H. Jeffery, *BSA* lvii, 151f. Artists' names etc.' – Deyhle, op. cit., 58ff.; *Deds.* 479ff.

PHAIDIMOS

J. Dörig, *AA* 1967, 15ff.; J. Frel, *AA* 1973, 193ff. Calf-bearer [*112*] – Payne, 1–3, pls 2–4; *AMA* no. 409; W. Deyhle, *AM* lxxxiv, 46; Robertson, 94–96. Sabouroff head [*113*] – *AGSB* no. 6; Robertson, 98f.

RAMPIN MASTER

Deyhle, op. cit., 4ff.; Robertson, 96–99. Horseman [*114*] – Payne, 4–9. *Korai* nos 113 [*115*], Peplos kore, and Payne, 18–21; 65 [*116*], 112 [*118*]. Diskophoros stele [*117*] – *Gravestones* no. 25.

ARISTION

Phrasikleia – E. Mastrokostas, *AAA* v, 298ff.; *Arch. Reports for 1972/3* 6f. On the base see also L.H. Jeffery, *BSA* lvii, 138f.; G. Daux, *Comptes Rendus Acad. Ins.* 1973, 382ff.; N. Kontoleon, *Archaiologike Ephemeris* 1974, 1ff.; Robertson, 100f.; C. Clairmont, *AA* 1974, 220–3.

OTHER AREAS

Boeotia – Ducat, op. cit., nos 141, 142, Attic dedications; *Kouroi* no. 94 [*119*]. Corinth – *Kouroi* no. 73 [*121*]; H. Payne, *Necrocorinthia* (1931), ch. 16, 17 (clay), pl. 49. 1–2 [*120*]; K. Wallenstein, *Kor. Plastik des 7 u. 6 Jhdts.* (1971). Laconia – M.N. Tod and A.J.B. Wace, *Cat. of the Sparta Museum* (1906), no. 1 [*123*]; *ADelt* xxiv, B, pls 124–5 two-sided reliefs [*124*]; M. Comstock and C. Vermeule, *Bronzes, Boston* no. 25 [*122*]; B. Schröder, *AM* xxix, 21ff.; E. Fiechter, *JdI* xxxiii, 107ff., Amyklai. Gitiadas – Lacroix, 217–20 [*125*]. Tektaios and Angelion – Lacroix, 202–4 [*126*]. Kypselid gold kolossos – J. Servais, *Ant. Class.* xxxiv, 144ff. Delphi chryselephantine [*127*] – P. Amandry, *BCH* lxiii, 86ff.; Suppl. 4, 273ff. (bull).

PROPORTIONS AND TECHNIQUES

Proportion and anatomy – *Kouroi* 17–25; M. Wegner, *RM* xlvii, 193ff.; L.D. Caskey, *AJA* xxviii, 358ff.; C. Karouzos, *Aristodikos* (1961) 9; A.F. Stewart, *Nature* 262 (1976), 155, scrotal asymmetry; J.J. Coulton, *BSA* lxx, 85ff., mensuration. E. Guralnik, *Computers and the Humanities* x,

153 ff. Technique (stone) – S. Adam, *The Technique of Greek Sculpture* (1966) supersedes all earlier works but S. Casson, *Technique of Early Greek Sculpture* (1933) is still useful and C. Blümel, *Greek Sculptors at Work* (1969) for pictures; B.S. Ridgway in C. Roebuck, *Muses at Work* (1969), 96 ff.; R. Anthes, *Mitt. Inst. Kairo* x, 79 ff., Egyptian guide sketches. Acrolith – C. Blinkenberg, *Die lindische Tempelchronik* C. 29 ff.; C. Blümel, *RA* 1968, 11 ff., prostucco. Meniskoi – J. Maxmin, *JHS* xcv, 175 ff. Colour – G. Richter, *Met. Mus. Studies* i, 25 ff.; P. Reuterswärd, *Studien zur Polychromie der Plastik* (1960). Technique (bronze) – D. Haynes, *AA* 1962, 803 ff.; *RA* 1968, 101 ff.; *Art and Technology* (M.I.T., 1970); A. Steinberg in D. Mitten, *Master Bronzes from the Classical World* (1968); D.K. Hill in Roebuck, op. cit., 60 ff.; H.V. Herrmann, *Olympia* pl. 37, nn. 432–3 [*134*], sphyrelata; Robertson, 180 ff.

VI THE LATER ARCHAIC STYLES

Endoios

Deyhle, op. cit., 12 ff.; *Deds.* 491–5; Robertson, 106–8. Seated Athena [*135*] – Payne, 46 f.; *AMA* no. 60. Kore 602 [*136*] – Payne, pl. 60. 1–3; *AMA* no. 7. Potter relief [*137*] – Payne, 48; *AMA* no. 422; J.D. Beazley, *Potter and Painter in Ancient Athens* 22. Rayet head [*139*] – *Kouroi* no. 138. Piraeus Gate kouros – G. Schmidt, *AM* lxxxiv, 65 ff.; U. Knigge, ibid., 76 ff. Bronze youth [*140*] – *Kouroi* no. 162.

Antenor

Deyhle, op. cit., 39 ff.; Payne, 31–33, 63–65; *Deds.* 481–3; *Korai* no. 110 [*141*] cf. no. 106 [*142*]. Tyrant-slayers – A. Rumpf, *Fest. Mercklin* (1964) 131 ff.; *Athenian Agora* xiv, 155–60; J. Dörig, *Antike Kunst* xii, 41 ff., the Webb head [*143*] and on Roman copies of Archaic statues.

Attic sculpture and sculptors

Kouroi nos 144 [*144*], 160 [*146*], 191 [*148*]. Ilissos [*149*] – Ridgway, *SS* 20, fig. 17. Kritian boy [*147*] – *Kouroi* no. 190; Payne, 44 f.; Robertson, 175 f. Aristodikos [*145*] – *Kouroi* no. 165; C. Karouzos, *Aristodikos* (1961); Athens 4489 head by same artist (?), V. Regnot, *BCH* lxxxvii, 393 ff. Piraeus bronze [*150*] – *Kouroi* no. 159 bis; N. Kontoleon, *Opus Nobile* 91 ff., copy of a marble; Robertson, 182 f. *Korai* nos 116 [*151*], 117 [*152*], 119 [*153*], 122 [*155*], 128 [*154*], 125 [*156*], 126 [*157*], 127 [*158*], 180 [*160*], 182 [*159*], 184 [*161*]; Payne, *passim*. Seated figures (grave) – *AM* lii, Beil. 25, 30; *AA* (1934), 225 f.; Kurtz/Boardman 89, 354. Dionysos [*162*] – W.H. Schuchhardt, *Antike Plastik* vi, pls 1–6; from Ikaria, *AM* xli, 169 (Athens 3897). Rhamnus [*163*] – *AM* xli, 119 ff., pl. 13. Acropolis scribes [*164*] – Payne, pl. 118; *AMA* nos 309–11. Riders (grave) – *AM* iv, pl.

3, Vari; *AA* (1933), 286; *AM* lxxviii, 136 ff. Riders (votive) [*165, 166*] – Payne, 51 f., pls 133–9; *AMA* nos 312–21, and horses. Kallimachos' Nike [*167*] – *AMA* no. 77; Meiggs and Lewis, op. cit., no. 18; E. Harrison, *Greek, Roman and Byz. Studies* xii, 5 ff. Other Acropolis figures – Payne, 43 f., pls 105–6, 107.4, Theseus [*168*]; pl. 121.4, 6 and 124.3, 6, Achilles and Ajax; Acr. 3719, *AMA* no. 306, Eros. Herms – *Athenian Agora* xi, 108 ff.; J. Crome, *AM* lx/lxi, pls 101–6 [*169*]; Payne, pl. 104. Cf. *ABFH* fig. 243, *ARFH* figs 278, 364. Masks [*170, 171*] – W. Wrede, *AM* liii, 66 ff.; Marathon mask [*171*] – ibid., Beil. 23; C. Blümel, *AA* 1971, 188 ff.; Robertson, 177; B. Ashmole, *Proc. Brit. Acad.* xlviii, 215 f. Euenor's Athena [*173*] – *AMA* no. 5; Ridgway, *SS* 29–31; Robertson, 179. Pythis' Athena [*172*] – Payne, 28 f., pls 43.3 and 44; *Deds.* no. 10.

East Greek sculpture and sculptors

Dionysermos [*174*] – P. Devambez, *RA* 1966, 195 ff. Samos xi, nos 138, 139 [*175*], warrior no. 78 [*176*]. Archermos and family – Jeffery, 294 f.; *Deds.* 484 ff. Chios – J. Boardman, *Greek Emporio* (1967) 181–3; *Korai* no. 123 [*177*]; *AMA* no. 68, the Nike. Seated women – von Graeve, *Ist. Mitt.* xxv, 61 ff.; N. Himmelmann, *Ist. Mitt.* xv, pls 2 ff.; *AGSB* nos 50–56, Miletus; *Forsch. u. Fortschritte* xxxv, 272 f., pair. Kyzikos head [*178*] – *AGSB* no. 31.

Other areas

Kouroi nos 145 [*179*], 155 [*180*], 159 [*182*]. *Korai* nos 147 [*181*], 99 [*183*], 120 [*184*]. Cycladic seated women – Berger, figs 47–48, Paros; *Arch. Epigr. Mitt.* xi, 156 f. Corinth, clay at Olympia – *Olympia Bericht* vi, 169 ff. [*186*]; poros kouros, *Hesperia* xliv, pl. 91, Isthmia. Kanachos – E. Bielefeld, *Ist. Mitt.* xii, 18 ff., an eastern pose (?), and *Antike Plastik* viii, 13 ff., Roman copy (?); E. Simon in *Charites* (Fest. Rumpf) 38 ff.; Lacroix, 221–6 [*185*].

VII ARCHITECTURAL SCULPTURE

Placing and character

Pediments – E. Lapalus, *Le Fronton sculpté en Grèce* (1947); W.H. Schuchhardt, *Archaische Giebelkompositionen* (1940), mainly Athens; A. Delivorrias, *Attische Giebelskulpturen und Akrotere* (1974), 177 ff.; M.S. Brouskari, *The Acropolis Museum* (1974). Friezes – R. Demangel, *La Frise Ionique* (1932); B.S. Ridgway, *Hesperia* xxxv, 188 ff. Metopes – H. Kähler, *Das gr. Metopenbild* (1949). Chian architecture – J. Boardman, *Antiquaries Journal* xxxix, 193 ff. Relief types – Robertson, 56 f.

The beginnings: Corfu

Clay revetments – H. Payne, *Necrocorinthia* (1931), ch. 17; E.D. van Buren, *Greek Fictile Revetments in the Archaic Period* (1926). Corfu [*187*] – C. Rodenwaldt, *Korkyra* ii (1939); Lullies, pls 16–19;

K. Schefold, *Myth and Legend* 52ff.; E. Kunze, *AM* lxxvii, 74ff. and J.L. Benson, *Gestalt und Geschichte* (Fest. Schefold) 48ff. on subjects; Robertson, 63–67.

ATHENS

Tyrannenschutt – R. Heberdey, *Altattische Poroskulptur* (1919) 3ff.; but see W.B. Dinsmoor, *AJA* xxxviii, 425. Temple foundations – W.H. Plommer, *JHS* lxxx, 127ff. Gorgon, leopards [*189, 190*] – Payne, 10f.; *AMA* nos 441, 463; Robertson, 48f. Limestone pediments [*190–8*] – Heberdey, op. cit.; E. Buschor, *AM* xlvii, 1ff., 53ff., 81ff.; W.H. Schuchhardt, *Archaische Giebelkompositionen* (1940) and *AA* 1963, 797ff.; I. Beyer, *AA* 1974, 639ff.; Robertson, 90–93. Marble gigantomachy [*199*] – Payne, 52ff.; *AMA* no. 631; the new reconstruction in Athens has yet to be published; Delivorrias, op. cit., 178f. K. Stähler, *Fest. H.E. Stier* (1972) 88ff., dates animal pediment pre-510, gigantomachy (with centre frontal chariot as Delphi) 500. Marble frieze [*200*] – Payne, 47f.; *AMA* nos 474–9. Lower town – *Athenian Agora* xi, nos 94–96; Heberdey, op. cit., 75ff. [*201*]; G.M.A. Richter, *Catalogue of Sculpture*, *New York* no. 7. Eleusis [*202*] – F. Willemsen, *AM* lxix/lxx, 33ff.; N. Himmelmann, *MWPr* 1957, 9ff.; Ridgway, *SS* 26. Politics – J.S. Boersma, *Athenian Building Policy from 561/0 to 405/4 B.C.* (1970), 11ff.; J. Boardman, *Rev. Arch.* (1972), 70ff. and *JHS* xcv, 2, 10.

CENTRAL AND SOUTH GREECE

Delphi, Apollo temple [*203, 204*] – *FDelphes* iii; P. de la Coste Messelière, *BCH* lxx, 271ff.; Robertson, 161f.; west pediment, Euripides, *Ion* 205–18. Eretria, Apollo temple [*205*] – D. Bothmer, *Amazons in Greek Art*, 125ff.; I. Konstantinou, *AM* lxix/lxx, 41ff.; Robertson, 163f. Aegina, Aphaia temple [*206*] – A. Furtwängler, *Aegina* i (1906); D. Ohly, *Die Aigineten* i (1972) 49ff. *Glyptothek München: ein Kurzerführer* (1972) 49ff.; Ridgway, *SS* 13–17, suggests that the bodies of the original east (front) pediment were mainly bronze and that the replacement is of 480–470; R.M. Cook, *JHS* xciv, 171, dating; Robertson, 165–7; Delivorrias, op. cit., 180f. Kopai – *AM* xxx, pl. 13. Corinth, clay – R. Stilwell in *Studies . . . Capps* 318ff. Corfu, Dionysos temple [*207a*] – A. Choremis, *AAA* vii, 183ff.

TREASURIES

General – L. Dyer, *JHS* xxv, 294ff.

DELPHI

Sicyonian and Siphnian [*208–12*] – P. de la Coste Messelière, *Au Musée de Delphes* (1936). Caryatids: 'Cnidian' – *Korai* nos 87, 88; Siphnian [*210*] – *Korai* no. 104; ex-Cnidian [*209*] – G.M.A. Richter, *BCH* lxxxii, 92ff.; *Korai* no. 86. Siphnian [*212*] – inscriptions – Messelière, *BCH* lxviii/lxix, 5ff.; E. Mastrokostas, *AM* lxxi, 74ff.; Jeffery, 102

(Phocian ?). Signature – M. Guarducci in *Studi Banti* (1965), 167ff. (Attic ?); L.H. Jeffery, *Archaic Greece* 185. Pediment subject – B.S. Ridgway, *AJA* lxix, 1ff. and cf. *BCH* lxxxvi, 24ff. M. Moore, *BCH* Suppl. 4, 305ff. Robertson, 89, 152–9; Massalian – *FDelphes* iv. 2, pl. 29; E. Langlotz, *Studien zur nordostgriechischen Kunst* (1975), pls 8–12 and cf. pls 13, 14, 17. Athenian [*213*] – *FDelphes* iv.4; *BCH* xc, 699ff.; *Athenian Agora* xi, 9–11, date; Robertson, 167–71; Delivorrias, op. cit., 181f.

OLYMPIA

H.V. Herrmann, *Olympia, Heiligtum und Wettkampfstätte*, 97–104; *Olympia* iii, 5–25 [*214*]. Megarian [*215*] – P.C. Bol and K. Hermann, *AM* lxxxix, 65ff.

EAST GREECE

General – E. Akurgal, *Die Kunst Anatoliens* (1961). Assos [*216*] – F.H. Bacon, J.T. Clarke *et al.*, *Assos* 145–53. Frieze slabs in Paris (*Enc. Phot.* 142f.), Istanbul (Mendel, *Cat.* ii, nos 257–65), Boston; F. Sartiaux, *Les sculptures et la reconstruction* (1915) (=*Rev. Arch.* 1913–1914). Samos xi, nos 113–37. Ephesus [*217*] – *British Museum Catalogue of Sculpture* nos B86–268; *Didyma* 132–6. Didyma [*218, 219*] – *Didyma* nos K75–81 (columns), K82–4 (gorgons); G. Gruben, *JdI* lxxviii, 78ff., reconstruction [*218.1*]; *AGSB* nos 59, 64 (altar). Pergamum – *AGSB* no. 29, Europa. Kyzikos [*220*] – *Antike Kunst* viii, pl. 28.2; *AJA* lxvi, pl. 100.21; other sculpture, *BSA* viii, pl. 4. Clay revetments – Å. Åkerström, *Die architektonischen Terrakotten Kleinasiens* (1966). Chariot reliefs – Kyzikos [*221*] – M. Schede, *Gr. und Rom. Skulptur des Antikenmuseums* (*Meisterwerke, Konstantinopel*, 1928) pl. 4; Myus [*222*] – *AGSB* no. 65 and *Ist. Mitt.* xv, pl. 29; Iasos – *Ann* l/li, 397ff. Thasos [*223*] – *Études Thasiennes* i, Les Murailles.

VIII RELIEFS

GRAVE RELIEFS

Athens and Attica: Richter, *Gravestones* is the prime source; see *Gravestones* nos 3 [*225*], 11 [*226*], 12 [*227*], 38 [*228*], 20 [*229*], 23 [*230*], 27 [*231*], 37 [*232*], 31 [*233*], 45 [*234*], 67 [*235*], 77 [*236*], 59 [*237*], fig. 174 [*238*]. Further on Attic: E. Harrison, *Hesperia* xxv, 25ff.; L.H. Jeffery, *BSA* lvii, 115ff. on all inscriptions and 149f. on stelai; Kurtz/Boardman, 84–86, general and on legislation; F. Willemsen, *AM* lxxxv, 34ff., broad stelai, 'metopes'; Aristokles [*235*]; F. Hiller, *MWPr* 1967 18ff., dating and Ionia; G.M.A. Richter, *Mél. Mansel* i. 1ff., Alkmaionid ? *AA* 1963, 431ff., incised youth; *AAA* ii, 89ff., warrior stele, Eleusis; D. Ohly, *AM* lxxvii, 93ff., gorgon on stele; Robertson, 108–12. 'Marathon runner' [*239*] – M. Andronikos, *AE* 1953, 4.2, 317ff.; K. Wiegartz, *MWPr* 1965, 46ff.,

dancer. Bases [*240–3*] – F. Willemsen, *AM* lxxviii, 104 ff. Man-and-dog stelai [*244*] – B.S. Ridgway, *JdI* lxxxvi, 60 ff., claims origin for Ionia; *Antike Kunst* xix, pl. 17. Aegina: stele crown – *AA* 1938, 30; *dexiosis* – Berger, fig. 132; marble sphinx, now with head – *AAA* viii, 227 ff. Corinth: stele crown – *Corinth* xiii, pl. 82.X120; marble sphinx – *BCH* xcvii, 284 ff. Boeotia: *Gravestones* nos 28, 68, 75; *AM* lxxxvi, 67 ff., stele crown, Thebes; W. Schild-Xenidou, *Boiot. Grab- und Weihreliefs* (1972). Samos: E. Buschor, *AM* lviii, 22 ff.; J. Boardman, *Antiquaries Journal* xxxix, 201 f., date; *Samos* xi, 174 ff. Two-sided – Berger, figs 133–4. Chios rider metope – Berger, fig. 38. Syme stele [*245*] – Berger, fig. 58. Kalchedon stele [*248*] – *Ist. Mitt.* xix/xx, 177 ff.; *BSA* 1, 81–83; Jeffery, 366. Kos – C. Karouzos, *AM* lxxvii, 121 ff. [*249*]; Berger, fig. 140 [*248*]. Crete [*246*] – A. Lembessi, *Antike Plastik* xii, 7 ff. General non-Attic: *Gravestones* 53–55; K.F. Johansen, *Attic Grave Reliefs* (1951) 65 ff.; Berger, 36 ff., 102 ff.; H. Hiller, Ion. Grabreliefs (*Ist. Mitt.*, Beiheft 12, 1975); *Antike Plastik* vii, 77, Ios, Tenos; *ARepts for 1962/3*, 49, Phanagoria; *AAA* vi, 351, Amorgos.

VOTIVE AND OTHER RELIEFS

U. Hausmann, *Gr. Weihreliefs* (1960); Berger, 98 ff., 102 ff. Paros – *ADelt* xvi.B, pl. 215 [*250*]; *AGSB* no. 24; Berger, fig. 126; *Arch. Epigr. Mitt.* xi, 153, pl. 5 [*262*]. Thasos [*251*] – Berger, fig. 52 (51, 53, later). Prinias [*252*] – Johansen, op. cit., 80 ff.; A. Lembessi, *Steles tou Prinia* (1976). Laconia [*253, 254*] – M. Andronikos, *Peloponnesiaka* i, 253 ff.; A.J.B. Wace, *AE* 1937. 1, 217 ff., Chilon (Jeffery, 193; Pausanias iii, 16, 4); Johansen, op. cit., 82 ff., and fig. 39; K. Chrestou, *AE* 1955, 91 ff., Dioskouroi; *AGSB* no. 16 [*253*]. E.Guralnik, *Journ. Eg. Arch.* lx, 175 ff., on

Egyptian connections of [*253*]. *Totenmahl* – Tegea, Athens 55; Paros [*255*] – N. Kontoleon in *Charisterion Orlandou* i, 348 ff.; Kurtz/Boardman, 234. Seated men – Berger, fig. 120, Rhodes; Johansen, op. cit., fig. 56, Lebadea. Seated woman – Berger, fig. 27, Thespiae. Chian Kybele – Boardman, *Antiquaries Journal* xxxix, 195 f. Samothrace [*264*] – *Enc. Phot.* iii, 235; Jeffery, 299. Attica – Payne, pls 126–30; *AMA* nos. 418 [*256*], 424 [*257*], 430 [*258*]; Herakles and boar [*260*] – F. Brommer, *Herakles* pl. 14a; Lamptrai base [*261*] – *AM* lxvi, pls 62–65; M. Moore, *Getty Journal* ii, 37 ff., youth with horse, 'Cottenham relief'; J. Frel, *AA* 1973, 193 ff., on [*238, 258*].

IX ANIMALS AND MONSTERS

H. Gabelmann, *Studien zum frühgr. Löwenbild* (1965), for all lions cited; F. Hölscher, *Die Bedeutung arch. Tierkampfbilder* (1972). Olympia [*265*] – H.V. Herrmann, *Olympia* 237; J.F. Crome in *Mnemosynon Wiegand* (1938), 47 ff. Corfu [*266*] – Crome, op. cit., 50 ff.; C. Rodenwaldt, *Korkyra* ii, 176 ff. Corinthian lions [*267, 268*] – H. Payne, *Necrocorinthia* 243 f. Delos lions [*269*] – *Expl. Arch. Délos* xxiv, 26 ff. Acropolis animals [*271*] – Payne, 51 f., pls 16, 131–40. Siren – *Acta Arch.* v, 49 ff., playing kithara.

X CONCLUSION

Comparisons of sculpture and vases – G. von Lücken, *AM* xliv, 47 ff. Potters' dedications on the Acropolis – J.D. Beazley, *Potter and Painter in Ancient Athens* (1946), 21 ff.; *Deds.* Euthymides/Pollias – J. Boardman, *JHS* lxxvi, 20 ff.

INDEX OF ILLUSTRATIONS

Italic numbers refer to figures

248

LONDON, British Museum

2728, *143*; B90–91, *217*; B118–19, *217*; B121, *217*;
B215, *217*; B271, *94*; B278, *95*; B475, *182*; coins, *125–6*,
185

LYONS, Museum

—, *110*

MALIBU, J. Paul Getty Museum

—, *263*

MUNICH, Glyptothek

74–85, *206*; 168, *121*; 169, *106*

NAPLES, Museo Nazionale

3358, *259*

NAXOS, Museum

—, *55*

NEW YORK, Metropolitan Museum

11.185, *232*; 17.190.73, *39*; 32.11.1, *63*; 36.11.13, *234*;
42.11.42, *11*

OLYMPIA, Museum

B1700, *47*; B4600, *5*; T6, *186*; —, *20–22, 73, 76, 134,
214–15, 265*

OXFORD, Ashmolean Museum

AE.211, *18*; AE.403, *26*; AE.1102, *2*

PARIS, Louvre

686, *87*; 697, *264*; 2828, *216*; 3098, *28, 71, 128*; 3103,
251; 3104, *114*; CA931, *41*; MA3600, *174*; MND910, *36*;
—, *216*

PAROS, Museum

—, *250, 255, 262*

RHODES, Museum

—, *77, 83*

ROME, Conservatori Museum

—, *205*

SAMOS, Tigani Museum

H41, *49*; M285, *96*

SAMOS, Vathy Museum

68, *84*; 69, *81*; 77, *175*; 768, *93*; I.95, *72*; I.217, *97*; —,
12, 50, 91

SPARTA, Museum

364, *80*; 1658, *79*; —, *78, 123–4*

THASOS, Museum

—, *69, 223*

THEBES, Museum

3, *119*; —, *42*

THERA, Museum

—, *40, 61*

VENICE, Arsenal

—, *269*

Acknowledgments

The publisher and author are indebted to the museums and collections named in many of the captions for photographs and permission to use them. Other important sources of illustration have been (brackets indicate the source for *one* of the views shown):
German Institute, Athens 5, 6, 12, 46, 47, 49, 50, (54), 72, 78, 79, 80, 81, 84, 85, 86, 93, 96, 97, 98, 109, (111), 116, (123), 134, 136, (137), (148), 149, 156, 161, 163, 167, 169, 170, 173, 175, 184, 186, 187, (191), (194), (195), (199), 201, 202, 214, 215, 230, 231, 237, 240, 243, 244, 247, 249, 255, 265, 266; German Institute, Istanbul 218.2; American School of Classical Studies, Athens 23, 24; French School at Athens 52, 56, (127), 213.1; E. Akurgal 220; J. Dörig 143; A. Frantz 64, 66, (226), 227, (235), (241); M. Popham 4; Hirmer Verlag 3, 7, 35, (70), 88, (100), 103, 112, (115), 118, (121), 145, 147, (148), (150), (151), 152, 154, 155, (158), (160), 162, 177, (193), 205.(2)–3, 206.1–3 & 6, 212.1–2, 242, 257, 258; Arts of Mankind 1, 16, 32.1, 65, (70), 73, (100), (104), (111), (115), 141, 142, (151), 153, 157, (158), 159, (160), 166, 168, 174, (194), 200, 204, 209, (210), 212.3–4, 213.2–4, (226), 233, 271; G. M. Young (Oxford) 57, 62, 67, 68, 101, 102, (104), 107, 110, 117, 119, 140, 144, 146, 179, 180, (188); F. von Matt (121); Edwin Smith 182; N. Kontos 108a; Author 29, 30, (31), (32.2), 55, 58, 59, 71, 76, 77, 85, 120, (137), 164, 165, 172, (188), (190), (193), (195), 196, 197, 198, (205.2), 206.4–5, (210), (211), 216.4, 252, 256, 260, (269).

INDEX OF ARTISTS

Italic numbers refer to figures; the bracketed are uncertain or for comparison

GENERAL INDEX

Italic numbers refer to figures and captions

251